Praise for Nicole Chabot's previous book, *Kowloon: Unknown Territory*

"*Kowloon: Unknown Territory* is surprisingly rich, and like the side of the harbour it seeks to document, this book rewards more detailed perusal." — *South China Morning Post*

"There are reasons to cross Victoria Harbour to Kowloon, and venture beyond Tsim Sha Tsui and Temple Street. *Kowloon: Unknown Territory* tells why." — *China Daily*

"As a Hong Konger with a lineage reaching all the way back to a Song dynasty emperor, Chabot has a unique window on Kowloon… Also guiding Chabot in the production of the book was a mixed Eastern and Western ancestry, placing her at a nexus of two cultures… Those seeking out a piece of Kowloon to call their own have this book to start them off." — *Time Out Hong Kong*

Street Life Hong Kong

Outdoor workers in their own words

Text by Nicole Chabot

Photography by Michael Perini

BLACKSMITH BOOKS

Street Life Hong Kong
ISBN 978-988-16138-5-1

Published by Blacksmith Books
5th Floor, 24 Hollywood Road, Hong Kong
Tel: (+852) 2877 7899 – *www.blacksmithbooks.com*

Cover design by Catherine Tai

Supported by

香港藝術發展局
Hong Kong Arts Development Council

Contents

Introduction

Street Life Hong Kong: Outdoor workers in their own words is a collection of oral testimonies of some of the people who make a living on the streets of Hong Kong. The testimonies of two dozen interviewees are organised into six sections: Building & Environment, Transport, Wholesale & Retail, Entertainment, Services and Health & Safety. As well as text, black and white portraiture takes the reader yet closer to the lives of the outdoor workers on the streets of Hong Kong. Some additional photography provides further context to the working lives of the interviewees, and introduces what I hope will be new insights into the city for Hong Kongers and those living abroad. This book attempts to bridge linguistic, cultural, and socio-economic divides so that there can be a better understanding of what a wider cross-section of people in Hong Kong is doing.

Local context

Hong Kong has always had a reputation as a place where people work hard, and, today, long hours are commonly worked in frequently overly air-conditioned offices. Meanwhile, the workplace of outdoor workers is the backdrop of the public sphere. Their 'offices' range from the street, and the city as a whole, for recyclers, gas canister delivery men, those holding up signs and handing out flyers, and so forth; or, in the case of food delivery men, and other transporters, mobile forms of transport such as bicycles, motorbikes and trams. Meanwhile, extensions of the street such as beaches, typhoon shelters, and the sea are the offices of lifeguards, sampan tour guides and fishermen.

According to Hong Kong government statistics, at the end of 2013, 3.8 million of the city's 7.2 million population made up the labour workforce. The unemployment rate stands at 3.1 per cent. Unlike many other countries including Mainland China, there is no cap on working hours in the city. The average working hours of people in full-time employment in Hong Kong is 49 hours per

week compared to the 40-hour working week suggested by the International Labour Organisation. According to some estimates, one in every 10 employees in Hong Kong has to work more than 60 hours a week to make ends meet.

Of the jobs recorded by the government, there are: Persons engaged in Import/Export, Wholesale and Retail Trades (820,526); Social and Personal Services (466,088); Financing and Insurance (213,490); and Transportation, Storage, Postal and Courier Services (171,620). The median monthly domestic household income for 2012 was HK$20,700; however, the biggest group, 12.8 per cent of domestic households, has a median monthly income of HK$10,000-HK$14,999, and 22.7 per cent of the population of Hong Kong, almost a quarter, has a median domestic household income of less than HK$10,000 a month.

'Office' politics and challenges

To a large extent, the outdoor workers of Hong Kong are invisible. On one hand, this is because they are adept at doing their jobs and Hong Kong doesn't have a tradition of worker strikes, and on the other, because 'polite' society ignores many of them.

While it would be hard to find a member of the general public who wouldn't acknowledge the valuable contributions of someone such as ambulance driver Amy Yuen Pui-Yin, many would rather 'not know' when it comes to the gritty work of toilet attendants and pest controllers like Cheng Mui and Danny Chan Yui-Ping.

This book is a chance for them to tell their stories.

Though the jobs featured in *Street Life Hong Kong* cover a spectrum of occupations with many differences including public awareness and perception of them, in most cases outdoor work provokes new interpretations of office politics due to the varying interests of its factions: pedestrians, motorists, and other users of the street, as well as tenants of different industries.

Big challenges that outdoor workers face are high temperatures and humidity, rain, and typhoons, which make it harder for them to do their work, and lead to loss of earnings for those who are self-employed. Meanwhile, outdoor workers who are employed, and outdoor workers who are self-employed to varying extents, suffer the same stresses as their indoor counterparts which the World Health Organisation categorises as 'work content-' and/or 'work context-' related.

The changeability of Hong Kong and the flexibility or temporary nature of outdoor work, depending on how it's perceived, is another factor for outdoor workers. The circumstances of a staggering number of our interviewees changed during the production of *Street Life Hong Kong*.

The stall of newspaper seller Bessie Lee closed on Queen's Road Central; bouncer Paul Garvis was forced to leave his post at Joe Bananas due to the rising rents that forced the Wan Chai bar to shut its doors after 28 years. He now works in Central. Security guard Arhin Francis Mensah unexpectedly left Hong Kong for Africa; and the pizza company that delivery man Harinder 'King' Singh works for relocated from Mid-Levels to Sai Ying Pun.

Another movement that is impacting outdoor workers, according to interviewees including fisherman Kwok Shu-Tai, hawker Wong Pui-Lam and flower seller Chan Ngoi-Lam is the phasing out of their trades due to a lack of a younger generation to pass their torches to. However, this is no bad thing, they believe for the most part, due to the low pay, long hours and physical demands of their jobs.

Meanwhile, in other professions, such as that of sampan woman Chu Yin-Ping, workers are cleverly tweaking their business models to cater to tourists, in Hong Kong a growth industry, to extend the relevance of their skills and working lives. In the course of our interviews, we learned that the Star Ferry Company and Hong Kong Tramways, two of Hong Kong's longest established companies which are rightfully proud of their heritage and contributions to Hong Kong, are also moving in this direction due to the development of other faster forms of transport that they must compete with.

Ethnic minority outdoor workers

As well as giving voice to Hong Kong Chinese who work outdoors, *Street Life Hong Kong* also ushers to the podium some of the city's ethnic minorities from Indians and Filipinos to Thais, Africans and Caucasians in proportions representative of their presence in the city. Hong Kong's ethnic minorities are often reported about in the local media, yet so rarely do we hear own-mouth versions, be this due to language and socio-economic barriers, or that lamentable disease that is endemic to cities – a real or imagined lack of time.

In fact, Hong Kong's ethnic minorities are vital to this book due to their notably high level of participation in Hong Kong's labour force – 86.9 per cent compared to the 59.7 per cent participation of the whole population, according to the Hong Kong Government's *Hong Kong 2011 Population Census Thematic Report: Ethnic Minorities*. More recent government statistics place the labour force participation rate of the whole population at 60.7 per cent.

According to the 150-odd page report, the number of ethnic minorities in Hong Kong has substantially increased over the last decade – a visible fact to long-time residents. The report cites a total of 451,183 mostly 'Usual resident' (as opposed to 'Mobile resident') ethnic minorities to be living in Hong Kong. Of these, there are Indonesians (29.6 per cent), Filipinos (29.5 per cent), Whites (12.2 per cent), Mixed (6.4 per cent), Indians (6.3 per cent), Pakistanis (4 per cent), Nepalese (3.7 per cent), Japanese (2.8 per cent), Thais (2.5 per cent), Other Asian (1.6 per cent), Korean (1.2 per cent), and Others (0.3 per cent).

Though the head count of ethnic minorities is small in the panorama of Hong Kong, just 6.4 per cent of the city's 7.2 million population, minorities certainly diversify and enrich the territory's socio-cultural fabric with their cornucopia of mannerisms, languages, customs, cuisines and religious beliefs. Their influence is substantial and far-reaching. One literal example of their reach: while the ethnic minority interviewees of *Street Life Hong Kong* all work on Hong Kong Island, many are unable to live there due to the cost. This is the same for their Hong Kong Chinese counterparts.

Poverty in Hong Kong

Street Life Hong Kong is not a book about unhappy people, but people who work hard and take pride in working for a living. A positive perception of the jobs of outdoor workers that repeatedly arose during the interviews was autonomy; the freedom that many outdoor workers experience in their jobs on the street, whether they are employed or self-employed, which mitigates many of the negatives for them. Other pluses include being self-employed and one's own boss where applicable, the ability to choose work days and times, working in inspiring surroundings, and social interaction. However, it's notable that most of the interviewees had not been able to afford to continue their education beyond secondary level, which some expressed regret over, and it's uncertain whether the freedom of the street that many of them experience would be enough incentive for them, had education provided other options, to forgo working indoors.

As you will read, job satisfaction varied across the people we interviewed. Just as working indoors is no guarantee for happiness, nor is working outdoors. Some of the negatives that were communicated included discrimination, rising rents, the crowdedness of working spaces, physical demands, pollution and low pay.

With regards to low pay, a connection is often made between outdoor workers and poverty. In fact, the earnings of the outdoor workers we met varied vastly, but some of the outdoor workers do meet the Hong Kong Government benchmark of poverty, that is, people who live 'under a monthly income less than or equal to half of the median income of all other households of equal size': one person (HK$3,000); two persons (HK$6,400); three persons (HK$8,000); and four persons (HK$9,800).

Poverty in Hong Kong is in fact on the rise. According to the government, this is due to an oversupply of low-educated and low-skilled workers, and an over-demand for well-educated and high-skilled workers. Critics of the government say that it neglects the poor, focusing on wealth creation instead of wealth redistribution, while certain governments around the world claim that the poor are a necessary by-product of capitalist societies.

The question 'Does money equate to happiness?' is an important one to ponder in Hong Kong where so much emphasis is placed on money and status, and where advertisements bombard us at every glance about what we need to be 'happy'. Nonetheless, poverty is not solely about income, but poor experience situations related to basic necessities such as employment; and a sense of hopelessness, powerlessness, humiliation and marginalisation.

My personal story

Street Life Hong Kong was partly inspired by my previous book, *Kowloon: Unknown Territory* (2012), which was, likewise, a celebration of street culture, and which provided an overview of facets of the peninsula from the perspectives of Community, Consumerism, Art, Food, Fashion and Sex. During the writing of that book, many story-worthy characters crossed my path, but the retelling of their tales was beyond its scope. *Street Life Hong Kong*

takes on this objective by moving closer to focus on outdoor workers. During the first phase of this book, the streets were our workplace, giving us a taste of its politics and heat, rain, crowds, dust and blaring sounds.

Outdoor workers, such as the ones featured in *Street Life Hong Kong,* are the backbone of the city. Through their custodianship of Hong Kong, and observation of it in all its lights and temperaments, they're also rich in stories – and what is a city if not for its storied people?

Nicole Chabot
September 2014

BUILDING & ENVIRONMENT

Tony Tam Kwok-Chiu – Assistant foreman
Shiu King-Lung – Scaffolder
Lam Yuk-Gwong – Recycler

"I think the city has to change as time moves on; it has to improve."

— Tony Tam Kwok-Chiu, 62, Assistant foreman

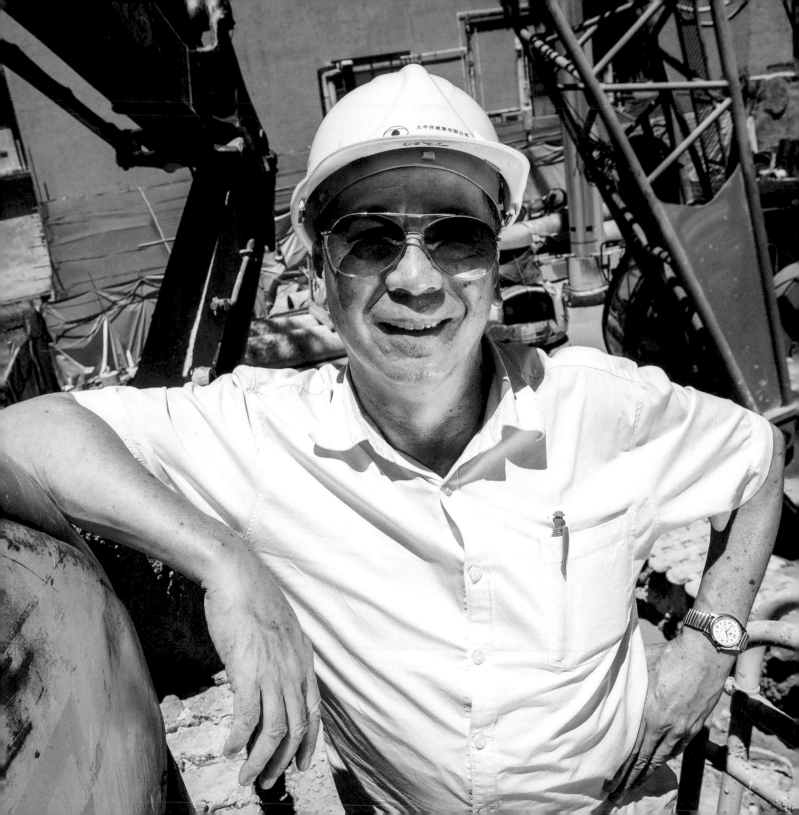

Tony Tam Kwok-Chiu, Assistant foreman

I went to primary and secondary school here – up to Form 4. Then, I went straight out to work, stocktaking spare parts for a car company for four to five years. After this, I changed jobs to work in construction, for the better income. I joined in 1980-something, so I've been in the industry for about 30 years.

When constructing a building, there are two groups of responsibilities: one's piling, while the other's to build the cover of the building that people see. Our job is driving the piles into the ground – we leave after the foundation's done. After the foundation is laid, bamboo scaffolding needs to be put up, and then electricity, plumbing, and air conditioning sorted out. There are more than 10 stages in getting a building ready for use.

Who's the boss?

I'm not the boss, but I supervise the guys. In fact, I started in a supervisory position, because I had some experience in this from my previous job. The organisation is the same in every company of this type in Hong Kong. There's a project manager, site agent, foreman, general foreman, and assistant foreman plus the workers. At the moment, the foreman is based at another construction site, but comes to this site three to four times a week. Once this project is finished, I may be promoted to foreman on the next one.

Management is important. I have to be on site full-time. I have to make sure the workers are doing all the things required to finish the job, which include reinforcement fixing, positioning, and securing steel reinforcing bars, nailing planks, and pouring concrete.

I'm in charge of the workflow – if the company sets a deadline, say 10 months, and I see that we're running behind, I have to make sure we catch up, and manage the workflow efficiently.

Doing this is easy, because there are company guidelines. If they tell us we need to drive one pile into the ground every three days, and I realise on the second day that we

haven't made enough progress, I allocate more resources for it and have the workers do their jobs quicker.

In solid company

I'm working on Mosque Street, but the company has five jobs going on across Central, Aberdeen, Chai Wan and Repulse Bay. All the jobs happen to be on Hong Kong Island, but we also do jobs in Kowloon.

There are usually about 10 to 12 people working on the site. If there aren't enough hands, we call the job site to ask for more. Normally, we use the same people every day until the job is done. On this particular project, there are two workers, two welders, a guy operating the machines, and a supervisor under me; but we work as if we're all on the same level, like friends. If I was to order them around, they wouldn't listen to me. There is friction at times, but I listen to both sides before trying to come up with a solution. I have fired people, but fewer than 10 in my 30 years of work.

There was one guy who wouldn't listen to me. If I wanted him to nail two planks, he'd only nail one. Also, we get off work at 6 p.m. and are supposed to wash our hands at 5.45 p.m., but he'd go ahead and wash his hands at 5.30 p.m. He was careless and lazy, and messed up the routine. In fact, he wanted me to fire him. He didn't want to work here, because the pay was lower than at another construction site where he wanted to be. If he quit on his own, he'd have needed to give a month's notice, but if he got fired, he'd be able to be gone in just three days.

The engineer who is 29 is the youngest guy on the

site, but we also have workers in their 40s, and 60 is the normal age to retire. Some people work until they're 70 though. There are physical exams for employees over the age of 60 that are required to be done once a year. We pay half of the cost, and the company pays the other.

Workers from Mainland China

Of our eight workers on this site, four of them are from the Mainland; and other sites have more – maybe seven or eight out of 10. In fact, there are more and more Mainlanders entering the profession each year.

There's no resentment about this. It's not as if Mainlanders are fighting Hong Kong people for the jobs. These days, with the MTR [Mass Transit Railway] expanding, there are a lot of jobs – there's also a tunnel being built in Central, and the development of the residential area around the old airport. The cruise terminal there [at Kai Tak] needs an expansion of its facilities, and malls. Also, most youngsters don't want to do construction work because it's very physically demanding, and you're always in the sun. In Hong Kong, there's a demand for employees in many other professions, and a lot of people prefer to work as security guards in residential and office buildings or at hotels and restaurants – they're indoors, so it's not so tiring. Hong Kongers who do want to work in the industry need to have the right certificates for certain positions – the law requires licences for welding and operating machinery.

Mostly, the Mainlanders are from Guangdong Province, but some are from the north of China. The Mainlanders have to have been in Hong Kong for seven years and have ID cards to work in construction. They speak Mandarin, though they normally learn Cantonese when they come to Hong Kong. We can always write things down if we need to communicate. It's easy to solve problems… In the past few years, we've even had some Filipinos. At the moment, we have a girl from the Philippines who's an engineer.

Up close and personal

Our job site is very busy. We start at 8 a.m., break for lunch, and then 'go, go, go' up until 6 p.m. After work, I go home, take a shower, and then go to sleep. Every day, we wake up about 5 a.m. or 6 a.m. depending on where we're working. It could be in Aberdeen or the New Territories… I don't get to choose which projects I work on. For this current job, I wake up at 6 a.m. and take the MTR to Admiralty, and then a minibus here. It takes about an hour to get here from my home. Our working days are Mondays to Saturdays 8 a.m. to 6 p.m., with a one-hour break from noon to 1 p.m.

Most of our wives also work, because we have one or two children. My wife used to work as an office runner, but is now too old to work. We have two sons of 30 and 34 years old; both are also in the construction business and the oldest has a child.

I was born in Hong Kong, and I live in Kwun Tong. Kwun Tong is no good. There are lots of people, lots of cars, air pollution… The only reason I still live there is because the apartment I own is there. I've thought about moving, but can't make enough money to make it happen.

Show me the money

Rates of pay depend on the market price. Today, a worker earns HK$600 a day, which is the lowest rate. The highest rate is for the welders – HK$1,400 a day. A welder's job is to connect every beam. They spend a lot of time wet and dirty, but it's well-paid work. Years of experience make a big difference to pay, so a lot of people stay on in the industry; and what other job could they go to? For me as an assistant foreman, the HK$14,000 a month is too little. With my experience, it's not really enough. Payment is calculated by the day, but paid monthly into our bank accounts, by autopay. Our company doesn't usually pay for travel – only the basic salary, but, if it's very far, the company will pay about HK$50 a day, though this doesn't take into account travelling time.

Accidents happen

Raw strength is more important than intelligence on a construction site. We draw and plan out everything prior to building, so all the workers have to do is follow the designs; they don't really need to think. But, things do go wrong at times.

Sometimes when you're heaving large objects, the wires can break and cause the objects to fall. Some objects are very heavy, for example, over 500 pounds [227 kg]. If we're injured on the job, we can claim money from the government; and some workers have received HK$100,000 from the government in damages. But, it's not such dangerous work – as long as you're careful. Usually, the accidents are only minor ones...

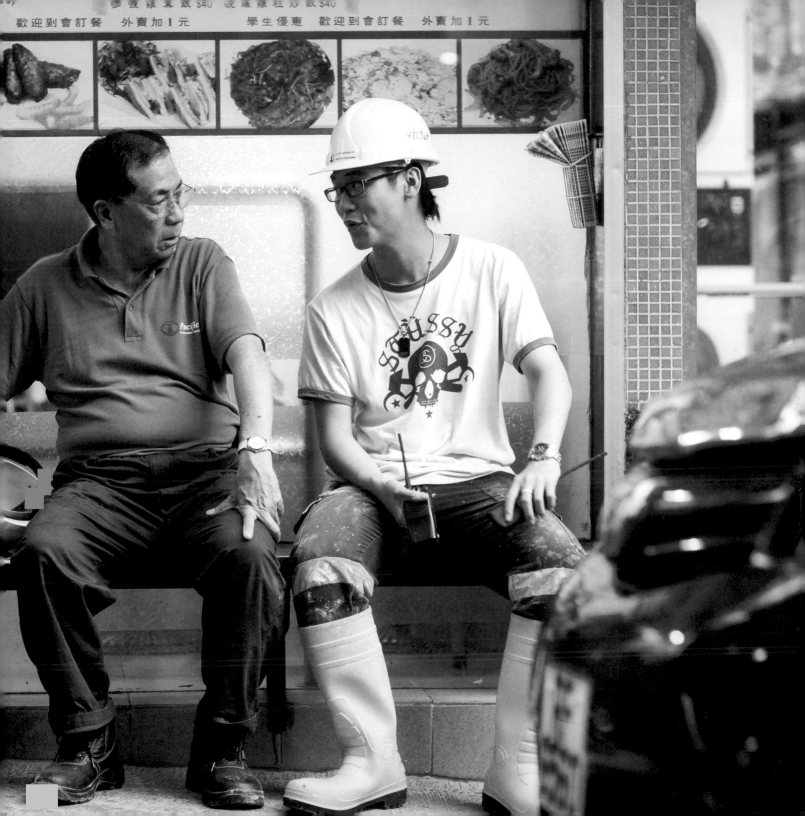

One time in Yuen Long, after several storeys of a building had been built, it was discovered that there was a cave underneath the foundations, so the building needed to be dismantled. The surveying of the land hadn't been done thoroughly enough… Another time, the entire project needed to be stopped, and the development company had to compensate the buyers who'd already purchased units in the residential block.

Past portfolio

I've worked on about 20 projects during my career. I've done hotels, hospitals, residential and office blocks… I worked on the police headquarters in Wan Chai. It took about 18 months of work to lay the foundations, and at its peak, there were about 100 guys on the project. I also worked on the Exhibition Centre [Hong Kong Convention and Exhibition Centre], and the new airport.

Between 2006 and 2008, I worked on projects in Macau. The culture is very different there. In Hong Kong, everything is so tight timewise, so urgent, whereas there, people are very slow. Sometimes, we would go for breakfast in Macau… Three minutes after ordering, we'd ask where our food was, because we had to go. 'You're rushing us!', they accused us, angrily. Hong Kong is a little too fast, but this makes Hong Kong people perform very well.

Change is good

There are so many construction sites in Hong Kong because it's changing. Some people feel that construction creates noise pollution and makes everything dusty, while others think that everything's renewed, and that it creates more usable space. So, opinion is divided. I think the city has to change as time moves on; it has to improve.

Change is a good thing, and I'm happy with the direction of Hong Kong. I was born in about 1950, when Hong Kong people were very poor and had nothing to do. 'Change, change, change' – I like the changes. I think the quality of life here is good.

We only build, we don't demolish – but, if something's old, it needs to be changed. It's 2014, and you need to make improvements. You can't be stuck with buildings that are from the 1930s – they're an inefficient use of space. I agree with demolishing older buildings, to make way for newer more efficient buildings, but it depends on which district we're talking about too. If it's a residential area like Sai Wan [Western District], you should definitely tear down the old for the new.

Who knows when it'll stop? It's non-stop. We build something new, say in Sham Shui Po, but in 30 years' time, it'll be old.

The happiest part of my job is the completion of projects. I have a real feeling of accomplishment when I pass by the finished buildings. They started off as just empty holes in the ground. ■

"Seeing the city from a birds-eye view is like watching a film, but being up there on the scaffold is different, because you can feel the wind."

— Shiu King-Lung, 32, Scaffolder

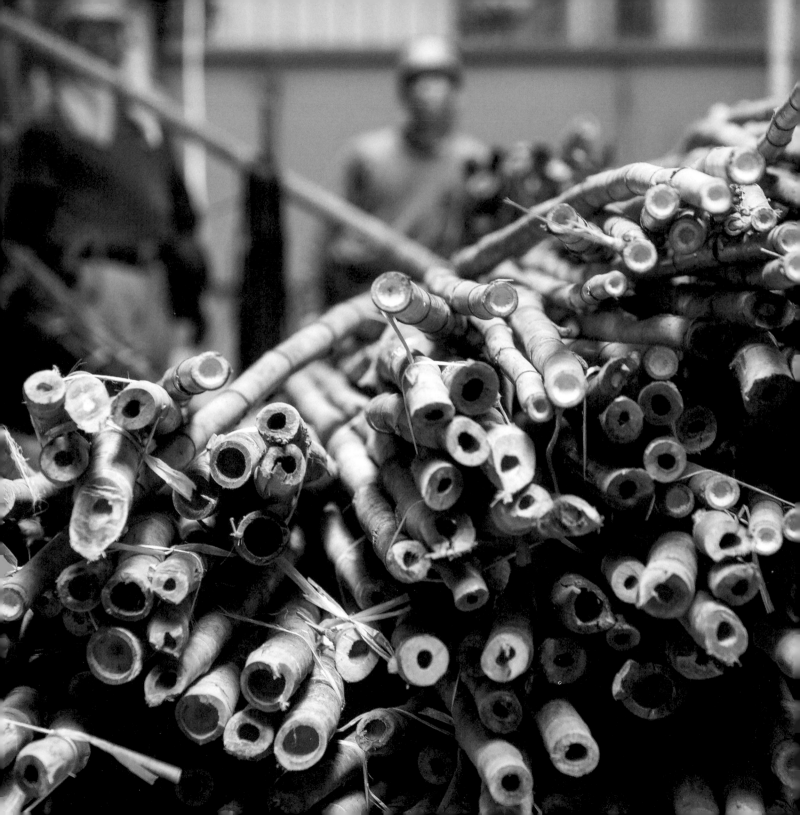

Shiu King-Lung, Scaffolder

After I finished Form 3, I wasn't admitted to Form 4. I just wasn't study material, so I learned trades instead. Perhaps it was because I wasn't afraid of heights, and had never been, that I ended up choosing this profession. Back then, there weren't any real requirements.

The first time I went up, I was really young. I must have been about 14… I was an apprentice for a year, and after this, I got a certificate saying I could work, even though I was under 18. I'm 32 years old now, so I've been working for more than a decade. My younger brother's also in the trade, though we don't work for the same company. This may have been my influence, because when I first started working, I used to use my salary to buy him things. Neither he nor I are study types, so he probably thought it was a good way of making money.

A fair trade

The companies in our industry are usually small with only about three to five staff. We're hired to do building maintenance, change window frames and shop signs, and waterproof walls. For example, if your window frame at home is leaking water, you call a plumber who refers us to you. Scaffolders who work at the big companies usually work at large construction sites.

In small companies, you get paid daily. It works out to about HK$20,000 [per month], which I think is fair for now, because a lot of fresh graduates only make about HK$13,000 to HK$14,000. In large companies, scaffolders receive a monthly salary, and receive a commission. The slowing economy hasn't affected our pay that much, but our boss makes less money, so from a business perspective we profit less as a company.

Level by level

You build a scaffold in mid-air. How long it takes to build and take down is hard to say, because this depends on how big the scaffold is, and how many people are working on

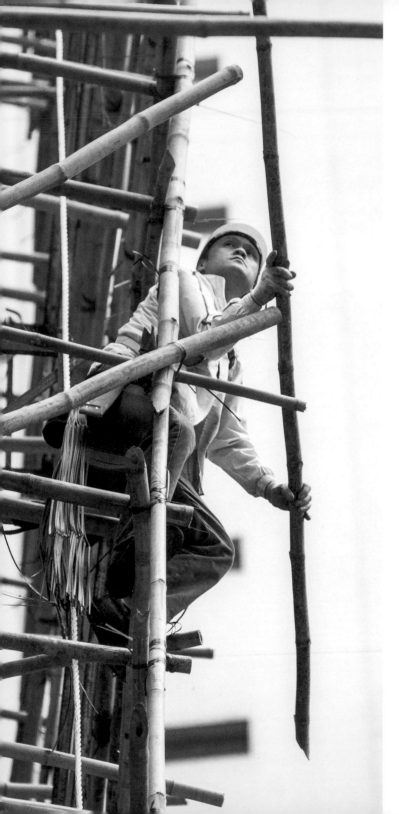

it. But the shortest time is about an hour for changing the window frames on high-storey buildings. These types of scaffolds are called 'eight-foot scaffolds'. They only take an hour to build, and half an hour to take down.

As for the longest times – it could take a year to complete a scaffold when a tall building is being built. You don't build one big scaffold immediately, but construct it level by level as the floors of the building go up. Dismantling takes much less time – probably about 20 per cent of the time it takes to construct the scaffold. It also depends on how many people there are working on it.

Knowing your material

The bamboo comes from the Mainland. It's shipped here or comes by land, but usually it's the first.

The difference between using bamboo and metal for scaffolding is that bamboo is more flexible, and very adaptable. We can cut the bamboo to any size we like, which is very convenient. There was an incident the other day when a hanging sign collapsed on Nathan Road. In this type of situation, bamboo is ideal because it's quickly put in place, and poles of different sizes are needed, which you can only achieve with bamboo. The greatest benefit of bamboo over metal though, is the cost.

Bamboo is a light green colour when it's newly chopped down. It retains a lot of water, so it's also especially heavy at this stage, and very tough and long-lasting – whereas metal rusts. How long the bamboo lasts depends on where you store it. If it's left in the sun, then it keeps for half a year – but, if it's not, it can last double this time.

The more the bamboo dries up, the more it's likely to crack or snap. You can see if it's drying out if it's a yellow or grey colour; but, you need to have experience to know when it's time to throw it away.

One way of knowing is its weight – a bamboo pole should have a certain weight which you can feel. If it's too light, then it's drying out… Another way of knowing is if the insects that eat at bamboo have made too many marks on the poles.

Memorable gigs

People who usually hire us are businesses or households, but sometimes we get other assignments. For example, we're hired for jobs in sports grounds – when stages need to be put up for Cantonese opera. They look like giant houses, and we build a small, old-fashioned stage inside…

Other big jobs? You know the giant screen in Times Square, Causeway Bay? Ten years ago, around the New Year, we built a scaffold in front of it, because maintenance work needed to be done on the panels. As we worked, a lot of people were watching us, and it was nerve-wracking. There were quite a few foreigners, who were curious because they'd never seen bamboo scaffolders before. They found us interesting and took pictures. It was quite a unique experience.

On top of the world

You have to climb up and down, and so there is, of course, danger. It's most important that we stay mentally alert, focus, use our experience, and not rush things. Accidents usually happen when people are inexperienced or if they're doing things in a hurry… We have helmets and safety harnesses, and, if we work close to the road, we wear reflective vests.

There is a 'head'. He is the person who interacts with the 'hirer'. As far as his role in scaffolding is concerned, he does pretty much the same things as the other workers, but needs to do some extra work as well. This might include answering concerns, managing the workflow, and logistics. One worker on the ground selects the materials, ties them together, and sends them up; and on the scaffold itself, there's another worker who's responsible for receiving the materials, and delivering them to the corresponding areas, and to other scaffolders. The allocation of work depends on your aptitude. If there are eight to nine people, then your role is usually the same as it always is, because you're experienced in that particular role, and so can work quicker.

Everything looks so tiny from up there. When you're on the ground, and looking up, you think that all the buildings are so tall; but, when you're actually up there, you realise that many of the buildings are relatively short. Seeing the city from a birds-eye view is like watching a film, but being up there on the scaffold is different because you can feel the wind.

Many buildings in Hong Kong are really high though… Once, I was in Wan Chai, and the building I was on was about 60 to 70 storeys; the light panels needed repairing, so they needed a scaffold. It was quite exhilarating – we

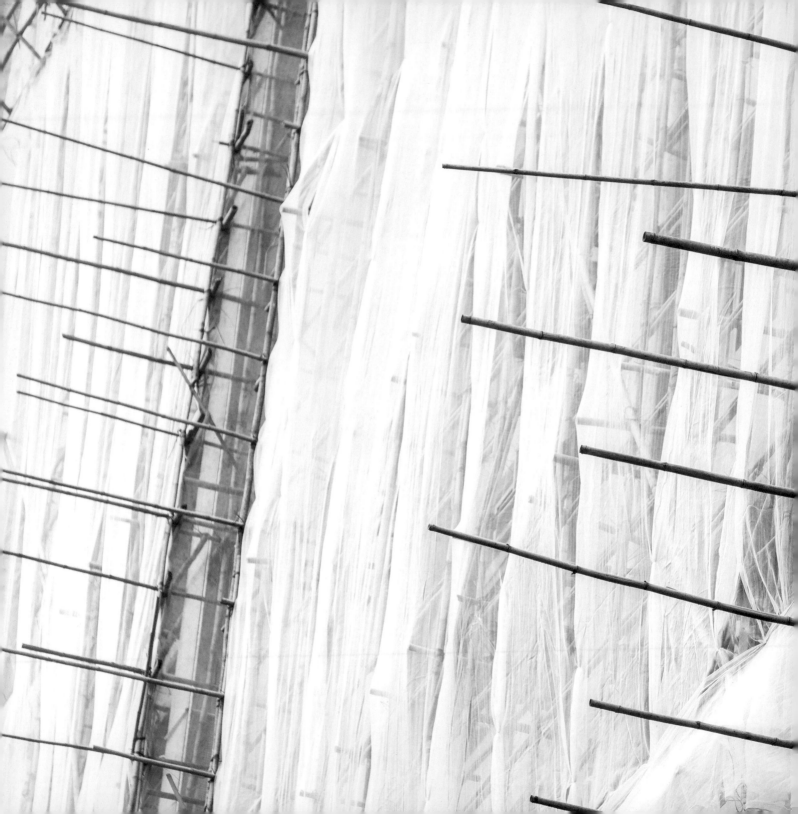

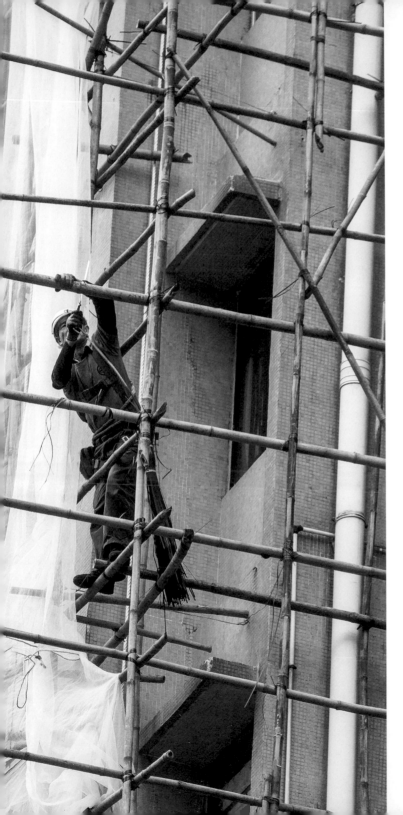

were across from Victoria Harbour, and it was very windy up there. We could see the cars on the streets below, and being a business district, there were many high-end cars, chauffeuring CEOs and other bosses around. It was exciting, but I had to be extra careful…

I haven't personally experienced or seen any major accidents. I mean, people have bruised their arms and legs, yes, but nothing like a fall. In the past six or seven years, though, it feels as if accidents have become more common. The accidents usually happen to younger workers, because they're less experienced.

My home is your home

Usually, when we're on assignment at residential blocks, we have little contact with residents. We're busy working, and, also, when there's scaffolding work, residents close their windows, in case burglars use the scaffold to climb into their units.

But, if a particular household needs maintenance work on either their air-conditioning units or windows, we have to enter their homes. Some residents really enjoy having visitors, and can be really nice – offering us water and food. Ten years ago, when the economy was doing better, people would sometimes buy cakes and soft drinks for us – or even cook us lunch.

Others give *lai see* [small red envelopes containing money] to us as a blessing, before we begin to work. The really rich residents of Mid-Levels were known to occasionally give HK$100; but, nowadays, this seldom happens.

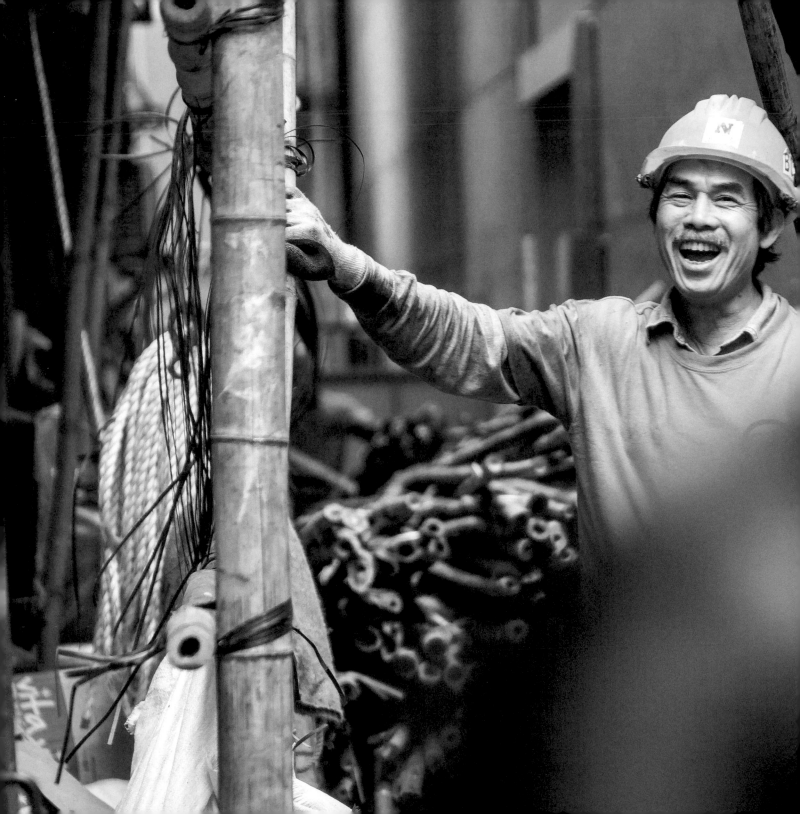

A traditional Chinese trade

Whenever we go to a site, even if it's the same one, the atmosphere is different. The environment varies too: there might be an obstructing object at a site one day; but the next day, it might be gone.

Every time we build a scaffold, we need to think about the best way to build it. Unlike an assembly line, there's no one set way of building. Every situation demands a different building approach to make sure the structure is safe and efficient. For example, some people want to build extensions to their homes, and need you to erect scaffolds for this. But, after a few months, the owner might decide to 'close' the extension down. This means that we then need to build a new scaffold, but differently – because the shape of the building has changed. A few years ago, we usually erected scaffolds to build extensions, but, nowadays, we're usually tearing them down…

Sitting in an office is, of course, better and not as tiring, but I don't regret going into this profession. Scaffolding is quite challenging and fulfilling. It's a very complex, traditional Chinese trade. ■

"I need people who are agile, have strength, and who are smart. When you have a smart and agile person, they do their work quickly."

— Lam Yuk-Gwong, 68, Recycler

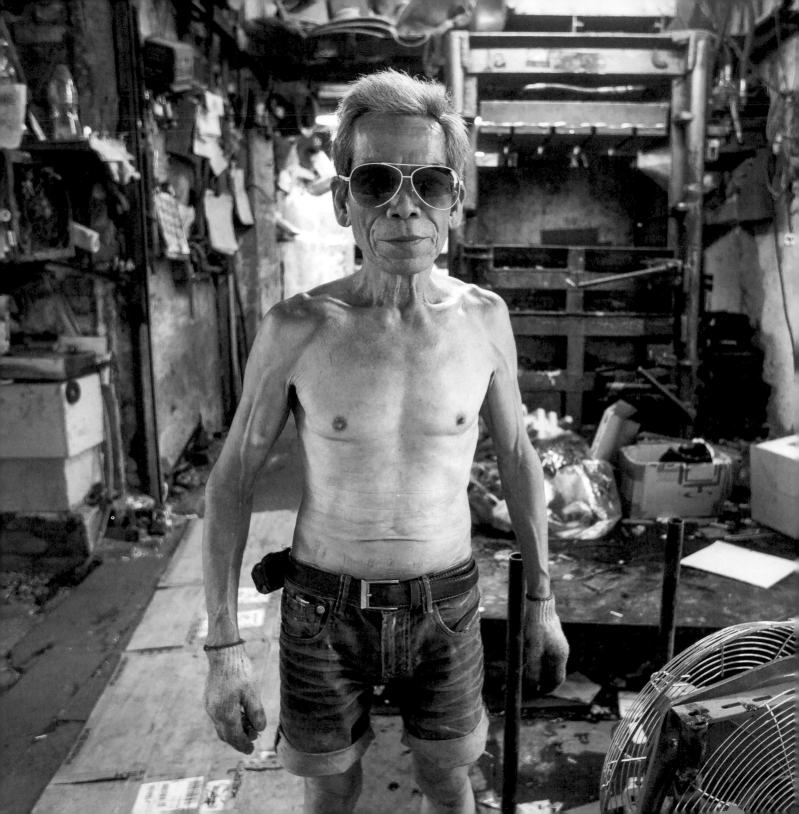

Lam Yuk-Gwong, Recycler

I started in this business in the 1970s. In the beginning, I worked for other people in places like Aberdeen, Sai Wan, Chai Wan and Kowloon – learning and getting experience in the job. Then, I found this space in Central and opened up shop here in the 1980s.

None of the places I worked at then were as good location-wise as this spot. In no other place has there been fewer competitors close by... Here in Central, there's only me and a big guy up the hill who collect scrap; and I don't have any other neighbouring businesses getting in my way or complaining about the state of the alley.

A little bit of this and that

I get to work at 7.30 a.m. because that's when the trucks come. At that time, compressed paper and cardboard from the previous working day is taken to a collection truck. There's also another truck that collects compressed newspapers.

There are lots of free daily newspapers that are handed out in Central in the morning. People going to work in the morning will grab them, but usually just read them during breakfast, or skim through them really fast, before throwing them in the bin. Sometimes the old ladies who sell us cardboard retrieve the newspapers from the rubbish to earn some extra money. But, even if they don't, street cleaners who empty the rubbish bins at night sell me the newspapers for cash.

I take these newspapers on the giant carts [cage-like trolleys] and roll them out of the alley. If we didn't do this in the morning, we wouldn't have enough space to accept new loads of scrap during the day. After 8 a.m., the roads are designated for buses, and it would be illegal for the trucks to still be parked there after this time – there's a sign on the street that says, 'No parking after 8 a.m.'

People clearing construction sites also find paper, cardboard, wire and metal objects, which they sell to us. After the sale, they have money for the bus, a meal, and so on. The rest of the stuff like wooden boards, and other

types of rubbish, go to a rubbish collection station in North Point.

During the day, everything is separated because everything goes to different places. The metals are collected at 7 p.m., and the last people to sell us scrap come at around 8 p.m. After this, I'm able to leave.

When the market is good, we sell the scrap to exporters, and we receive a good fee for it. When it's less of a good market, the factories in the Mainland pay less to the exporters, and we get paid less as well.

Right man for the job

In this business, a lot of us know each other. If you need more helping hands, you can contact others in the business. If they don't require any additional new workers, they'll send on anyone who's looking for a job our way.

If someone has no experience, they are trained for two weeks; and, if they are smart, perhaps just for one week. In terms of the qualities I look for – I need people who are agile, have strength, and who are smart. When you have a smart and agile person, they do their work quickly.

Risky business

The compressing machines are actually quite simple to operate – it's just up and down. But a lot of people who work in the business are very uneducated, and they don't know much about machinery. You need to know the machine inside-out, its speed and functions.

Some people aren't very good at controlling the machines. They lose their balance and fall into the compressor. Accidents happen – crushed hands, crushed feet, even crushed bodies. All of these have happened. We have to buy labour and medical insurance – I buy it for myself and two of my employees. We can't afford to be held liable if accidents happen.

There are guys whose hands are still in the door when the machine is coming down. There are just a few inches of difference… Some people now have advanced technology with inbuilt sensors in the machines to prevent these things from happening, but not us.

Hostile elements

The weather definitely affects our work, for example, getting your feet or body wet during rain or a typhoon slows down operations. Also, at times like these, people don't want to come to the alley. If they have the space, they save up their scrap and bring it in when the weather's better.

In this trade in Hong Kong, working indoors is difficult or impossible, because land is scarce and rent is expensive. In our line of business, we need a lot of space, and we need to get dirty.

Unless we use industrial buildings, there just isn't enough room indoors; and if we were located in an industrial building, it'd be difficult for us to transport the scrap on the upper floors to process, before bringing it back down to load onto the trucks.

It's impossible to have so much indoor space in the inner city area. We need a large enough space – and no one interfering.

Exchange rates

There have been so many changes in Hong Kong since the 1970s when I started work. Back then, the salary was just a few hundred Hong Kong dollars a month. Nowadays, it's a few thousand, even tens of thousands… But, back then, you could do a lot with a few hundred dollars. You could get a meal for a Hong Kong dollar, or a dollar twenty.

Back then, going for *yum cha* [dim sum] cost a bit more than a dollar – congee, dough fritters, maybe just five cents. Now it's 20-something dollars, 30-something dollars, 40-something dollars. How many increases is that? A few hundred, back then, is like HK$10,000 today. A salary of a few hundred dollars then went further than a HK$20,000 salary today.

Change has been big. The 1970s and now are two totally different things – technology, for example, is improving at a galloping pace each day. Back then, it was only a few dollars for a 'block' of paper; and it was good if you earned

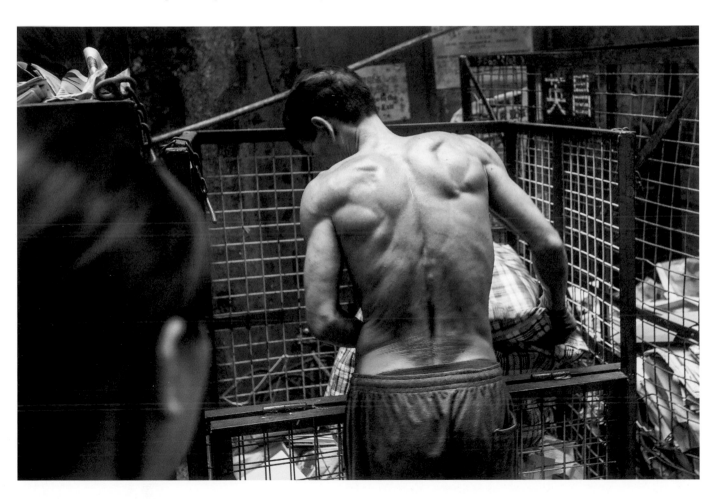

a profit of a hundred or so Hong Kong dollars a day. Since the salaries were low back then, this was enough for business. Nowadays, the economy is good, and I have to pay everyone around HK$20,000 a month.

Those were different times… the Mainland hadn't yet been liberated. It was only in the 1980s that Deng Xiaoping opened up the market. Before the 'opening up', there was no route to the Mainland market.

A determined breadwinner

When you're doing your job, you don't have time to think of other things, or doing other kinds of work. Diversity is just for big corporations, not for us small businesses. You can't jump from one job to another, and I'm not accustomed to other jobs. If I were to cook, it probably wouldn't taste very good, so no one would eat my food. Chefs have to learn how to cook first – and, this is true for

every business. You can't do something without learning it first.

If you want to, you can take the time to learn something new, but by the time you've done so, *'dou mun fun'* [a saying about the passing of time; literally, 'even flies will have fallen asleep'].

If you grow up in this business, are willing to work hard in it, and are not afraid of getting dirty, you can earn some money; and this is true for all businesses. You can then put food on the table. I only need a job that will cover my living expenses. Whatever job that can earn me enough to put food on the table. This is the only thing I care about.

Family ties

I have two kids. One of them is in Form 4 [15 years old]. The other is doing a Hong Kong Institute of Vocational Education course in hotel management. The one who receives the newspapers, metal and cardboard at the front of the shop is my wife.

I've always lived on Hong Kong Island. We live on Bonham Strand West [in Sheung Wan, close by the alley]. I bought the place during the financial crisis of 1997 – 600 sq ft for only HK$1.88 million. We bought it mid-year, but there was still a tenant renting it. So, we bought it and waited for two months before moving in.

I've been in this profession for the last few decades, from early morning to night. Maybe in a year or sometime soon I'll retire to the Mainland, to my *heung ha* [native village], and live a more leisurely life.

I don't really like the city… It's not for me. People are too stressed here. I'd love to go back to my village and breathe cleaner air. ∎

TRANSPORT

Chan Tsu-Wing – Chief coxswain
Yiu Chau-Leung – Tram driver
Sit King-Wah – School bus driver

"The harbour has become narrower and narrower due to land reclamation, and the two sides of the harbour have changed drastically."

— Chan Tsu-Wing, 58, Chief coxswain

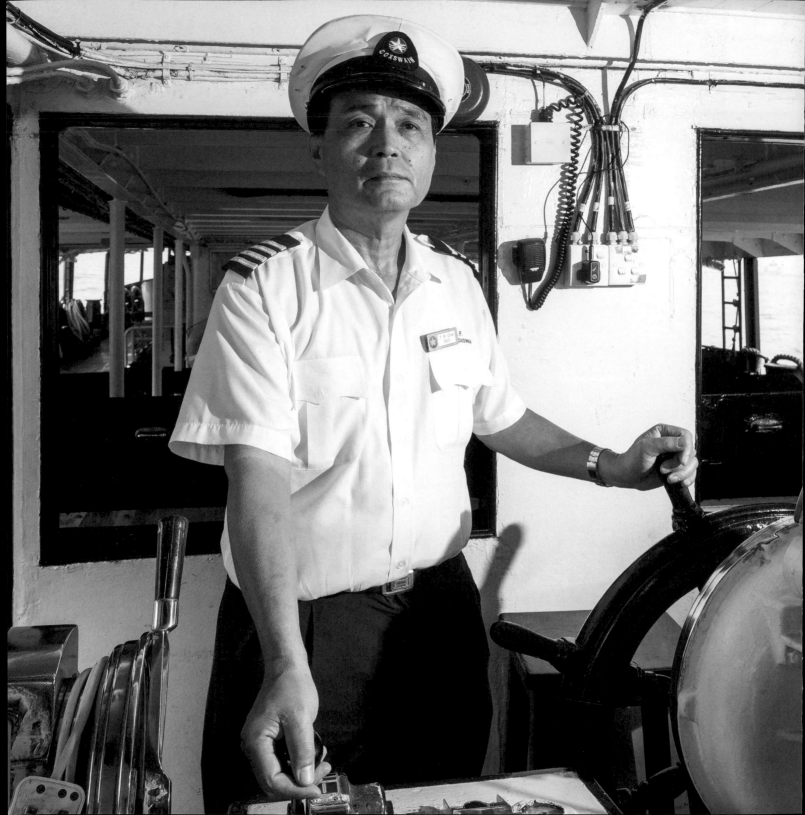

Chan Tsu-Wing, Chief coxswain

I've been working for the Star Ferry Company for 30 years. I hold the highest ranking on the ferries. Under me are all the coxswains [captains] and sailors. There are about 35 coxswains, but I am the only chief. We're all in the same line of work; I just have an extra word in my job title.

I'm responsible for the entire deck. When I come to work, I find out if we're missing anyone, and fill in those spots. I also decide which boat needs to go for maintenance. After 10 a.m., peak hours are over, and I decide which boats to stow away, and have people go for lunch. Every evaluation, promotion and holiday leave for every member of staff falls within my domain, as well as the allocation of resources and duties, and maintenance, big and small. From the little to the large, my job is everything to do with the ferries and the staff.

I am less on the boats these days, but 10 years ago I was on the ferries daily. These days, when I pilot the ferries, I am usually towing the boats, for example, if there's been an accident on a boat or a malfunction. Also, when there are typhoons, the general manager has me directing ferries into the typhoon shelters. This involves everything from the arrival and departure of the ferries, to where they park within the shelters, and so on.

En route to 'Star Ferry-dom'

Thirty years ago, I was an immigrant fresh from the Mainland. I came from Guangzhou, and was referred to the Star Ferry by the Labour Department. I was 27 or 28 years old at the time, and it was my third job – which I began six months after arriving in Hong Kong.

Back then, the Mainland was still very impoverished and the standards of living were nothing like they are today. Another reason I moved was because my parents were here and I needed to take care of them. I wanted to stay here forever – work here, have a family here, take root here, so I came here with a one-way pass. Once I was at the company, I felt that the salary, workload and level of

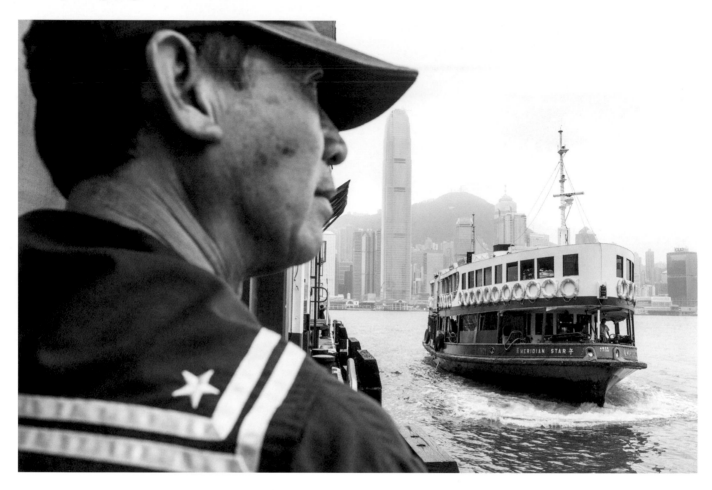

challenge were right for me. I've worked here ever since.

My predecessors and I started from the bottom. I started as a sailor for three years and eight months. After this, I tested for the licence to become a 60-ton coxswain, and then I was promoted to deputy coxswain. One year, I was promoted twice, and ended up as a 300-ton coxswain. I then worked as a 'Gold Star Ferry coxswain'. Finally, I became chief coxswain.

In the past, the Star Ferry had many more routes. It had services from Tsim Sha Tsui to Central, Tsim Sha Tsui to Wan Chai, from Hung Hom to Wan Chai and Hung Hom to Central. Only two lines are left: from Tsim Sha Tsui to Central and to Wan Chai. There are also rentals. Right now, there is a ferry at Tsing Yi Island, and the company plans to expand further into tourism.

Running a tight ship

Right now, there are seven people working on a ferry at

one time. When the ferry docks, there is someone at the front and someone at the back of the ferry who help the process – this means two sailors on each level of the boat. The coxswain controls the boat, and the assistant coxswain assists him. As the ferry arrives, one of the sailors ties the front of the boat to the dock to stabilise it, and then goes to the back of the boat to do the same thing.

In operations, we are flexible, and look for equality – so we all rotate. There were previously 12 ferries, and now there are 11. My favourite boat has been sold... It's the one I used to pilot – the 'Gold Star'. It was my favourite because I worked on it for a very long time, and formed a bond with it. In fact, I worked on the Gold Star for over a decade.

When there were 12 boats, we would each rotate once a month, which was fair to everyone. Even the daily shifts of the coxswains would be rotated: one person would do the morning shift, another the afternoon, and yet another, the night shift. As for the routes going to Central and Wan Chai, those crews rotate among themselves. On the Victoria Harbour tours, everyone gets rotated after two to three years. Our Shining Star special touring ferry has a specific crew which works on it for two to three years at a time.

Keeping things buoyant

The passenger capacity per ferry is around 500 persons. It used to be 577, but now it's 511 to 520 on the top and bottom deck. Of the 11 ferries in our fleet, there are two boats that are parked. The other nine are usually in operation; eight of these are officially in operation, and the ninth is a spare – because there's one boat in maintenance every month. All of the ferries are the same, though one is a little bigger than the others. The boats consist of main parts from England, though they were made in the Hung Hom shipyard 50 to 60 years ago – where Li Ka-Shing now lives.

Maintenance is carried out at the Leung Wan Kee Shipyard in Tsing Yi. How long the process takes depends on what needs doing. There is 'daily maintenance' for things like broken benches, and there is 'monthly maintenance', where parts are taken off and cleaned, and then re-installed. There is also 'semi-annual maintenance', when the boats are taken to the shipyard for 12 to 14 days. The parts are inspected, and the ferries are hoisted and cleaned of moss and oysters. In the 'annual maintenance', all of the boat parts are disassembled and checked to see if they are faulty or ageing, before the boat is hoisted up again to scrape off the moss and oysters, and repainted. It normally takes about 15 to 21 days to complete this process.

Even still waters run deep

It's hard to say if the work is exciting or not. You have to plan each route very well, like what time to reach each stop – though for the touring routes it's more laid back. Touring ferries only dock two to three times in an hour, whereas for the regular routes, the times aren't as strict but the stress is greater. We dock the regular ferries six times every hour.

I don't want to put anyone down, but driving a ferry is much more challenging than driving a motor vehicle on the road. With a car, for example, once you get a licence, it's quite simple – you just have to follow the rules of the road, and the police. Driving a ferry is different because you have to pay attention to the water and the tide. You have to be especially careful during high tide. Also, when two boats meet, you have to stick to the right side, according to the international rules for preventing collisions at sea. As you can see from the Lamma Island disaster, if you're not alert and have no sense of responsibility, horrible catastrophes can happen. The danger is way more than it is for motor vehicles, and the sea is much more dangerous now, and the possibility of accidents is much higher than it used to be.

Every year, there are one or two incidences where someone 'falls' off the boat. But, the guard rails are quite safe so these aren't really accidents – people jump off because they mean to. If someone trips and falls on the boats, we used to just help them up. But, now, we make sure they're okay, and might even call an ambulance for them.

We're consistently trying to improve our customer service for the many different kinds of people who use the ferry. There are commuters, there are people from the Individual Visit Scheme [tourists from the Mainland], and there are people from overseas. There are a lot of different people, and they each make up 10 or 20 per cent of the entire demographic. It's very diverse.

We no longer have much of a relationship with

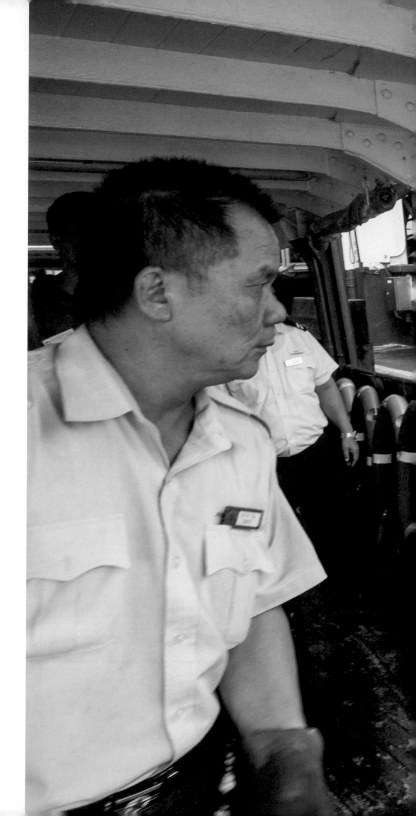

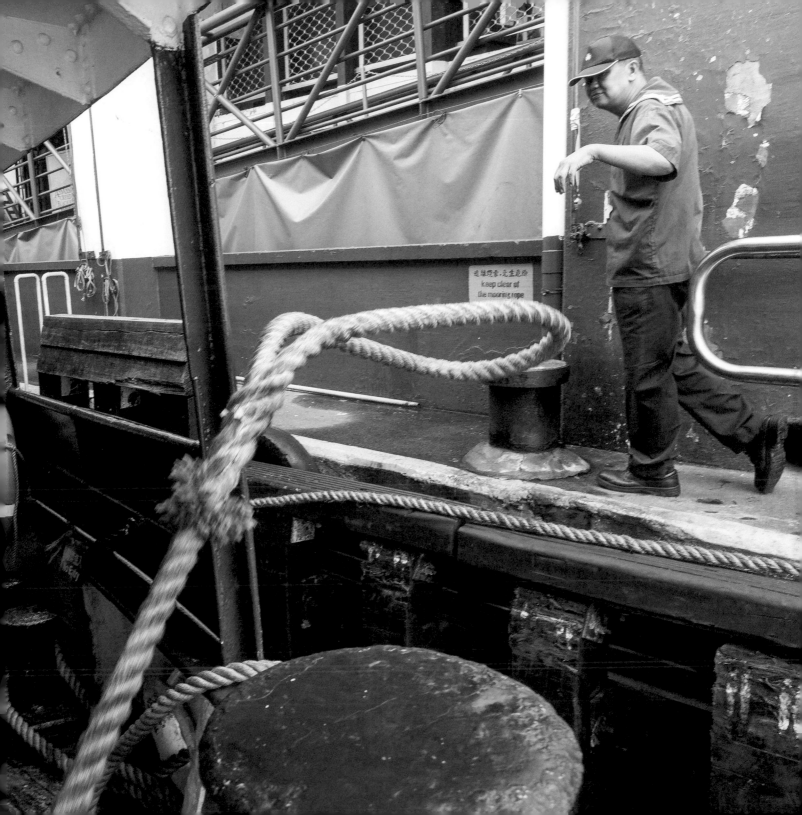

passengers. The coxswains on the bottom level are in close contact with the passengers there, so more so. When passengers alight, the coxswains have to be at the front of the boat. But, with passengers on the top level? Not so much... People come, and people go. Over the years, people leave. It's impossible for people to keep taking the ferry for so long. For example, there were people who were 40 years old when I'd worked here for 10 years – they couldn't still be here. After a while, they naturally go away. That said, there did used to be people who took the ferry each day.

Changes to a many splendoured thing

There have been changes in passengers, and also in Hong Kong, in terms of daily living, and policies. I've experienced the handover of 1997, the 2005 WTO [World Trade Organisation] protests, and the moving of the pier in 2006.

Hong Kong used to be governed by the British, but now it's Chinese. Thirty years ago, the standard of living was not as good as it is today, but under British rule, I can honestly say that the workload, salary, and benefits at the Star Ferry were much better than now. Perhaps I shouldn't say this… but, nowadays, things are less lenient… we used to have residences before. On the other hand, Chinese people did not have as much status in society then. Today, it's different, and you do see Chinese in high positions.

I was really sentimental about the closure of the former pier, and really miss it. We felt very helpless about it, because on one hand we'd miss it but on the other hand, society needs to keep developing. You have to accept reality. You can't dismiss a plan purely for sentimental reasons. The government thought it through before they demolished it... I like to think optimistically about things, and have become very accepting of new things.

I've also witnessed the changes in Victoria Harbour itself. Back in the day, there weren't so many high-speed boats. There were lots of sampans and fishing junks on the waters, but these are increasingly disappearing. In the current environment, it's become very dangerous for sampans, so there are almost none of the old boats any more. The harbour has also become narrower and narrower due to land reclamation, and the two sides of the harbour have changed drastically. The environment used to be much better, but, recently, it has improved again. Now there are a lot of skyscrapers, and it's a beautiful sight.

Previously, ferries, including the Star Ferry and Yau Ma Tei Ferry, were the dominant form of transport across the harbour. But, now, there are the cross-harbour tunnels – the Eastern Tunnel, Western Tunnel, and Hung Hom Cross Harbour Tunnel, and three MTR lines going across as well. The MTR has had such a big impact on us. We've ended up in a position where it makes no difference if we're still here or not – our ferries are now auxiliary forms of transport and, in our company as in many others, there is no younger generation to pass the torch to. There are very few youngsters applying. This is not only the case with the Star Ferry, but the Yau Ma Tei Ferry, Hong Kong ferries, and other Kowloon-Hong Kong ferries as well.

You see, the MTR is fast and convenient. For example, to get from Yau Ma Tei to Central, it takes about 15 minutes by MTR. The Yau Ma Tei ferries have a much lower fare, but it takes 40 minutes or even an hour to reach Central. You have to wait for the ferries, and you have to walk 10 to 15 minutes from the new pier to the core of Central. The walk is the reason why passengers have dwindled.

The company has made inroads in the tourism industry, because if we still focused on our former business model, we'd have reached a dead end. Since we've focused on tourism, the company has been continuously improving the quality of its customer care, to attract more travellers from the Individual Visit Scheme, and make guests feel welcome.

Star struck

I have the feeling that the Star Ferry is more prestigious than other ferry companies in Hong Kong. Every day, we

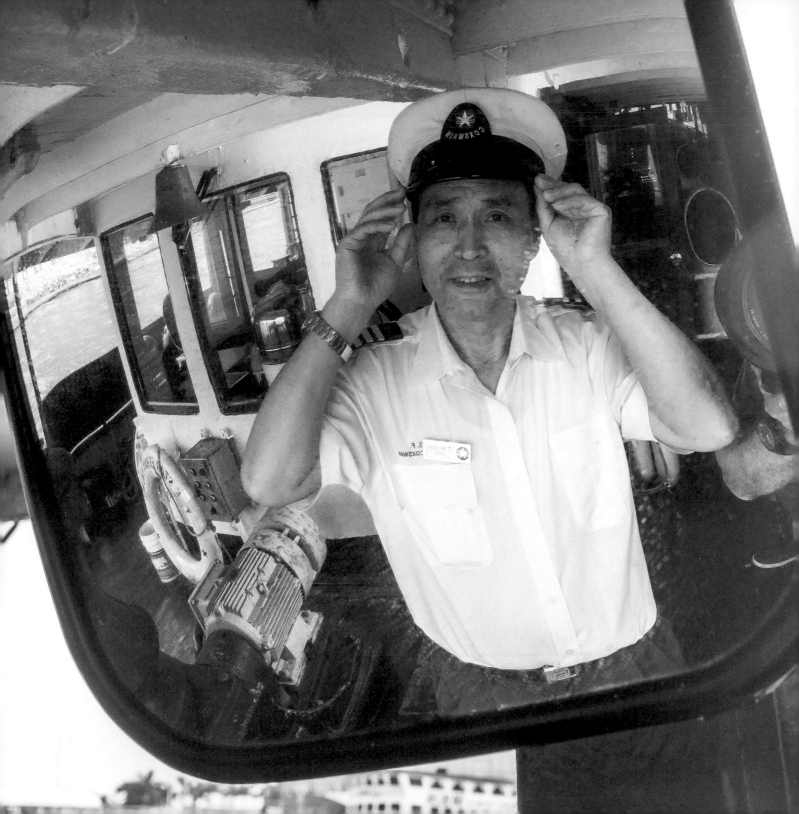

work in an environment which offers a spectacular view, and which is a landmark of the city. When people visit Hong Kong and want to take a ferry, they always think of the Star Ferry.

Among the various ferry companies, there are differences in the scheduled times, routes, and the ferries themselves, as well as the staff benefits. Star Ferry routes are all in the harbour, while other ferries go all the way to Cheung Chau or Lamma Island... The working hours are also different. The staff of other companies might work for 12 to 24 hours a shift, whereas every day, we go home after eight hours of work. Also, for every 15 days of work, we get five days' rest. Elsewhere, you might have to work for 24 hours, and then have only a single day off.

There's a Chinese saying: 'Each successive house is a better one', and I really feel at home in this company. I started as a sailor, then assistant coxswain, then 300-ton coxswain, then deputy coxswain, and today I am chief coxswain. The company has treated me well, so I feel like I should serve it to the best of my ability. ■

"You have to approach driving a tram with the right attitude. What's most important is patience, because every other vehicle on the road bullies the tram."

— Yiu Chau-Leung, 45, Tram driver

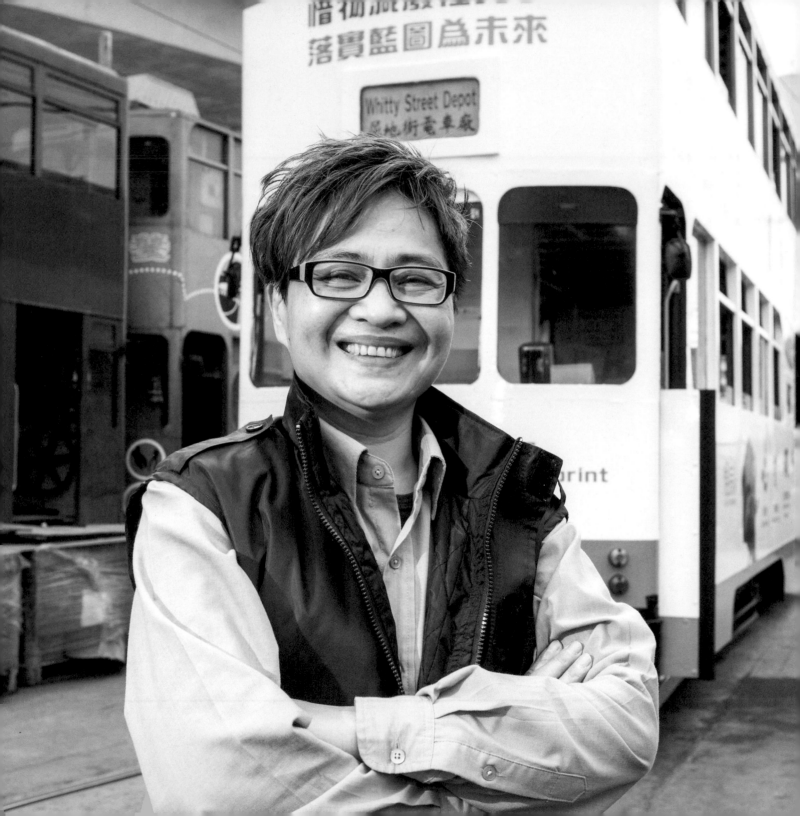

Yiu Chau-Leung, Tram driver

I live in Shau Kei Wan, but, I mainly start at this depot [Whitty Street tram depot], not Sai Wan Ho. Every week is different, because the working times vary every week. The route that I drive depends on my scheduled hours of work.

I drive to North Point, Causeway Bay, Happy Valley – and Sai Wan, as well. I have one day off every week, either a Saturday or Sunday. I get off work at around 7 p.m., and have a break in the middle of the day. This kind of duty is called a 'split-shift'. There's a split in the middle of the working day, with a long resting time.

This midday break is not always the same, but it can be about three hours. Back when I used to live nearby, I'd go home. Now, if there are enough of us, we go for *yum cha* [dim sum], or to look around the shops. Sometimes, during the break, we drop off the trams to be cleaned. If the trams don't have to be cleaned, we hand them over to other drivers who have just finished having lunch.

Once the break is over, I drive a different tram. There's no set place to pick up the tram – sometimes it's at the depot, at other times it's on the street. Everything depends on the schedule. Depots are different from tram stops – depots are for workers, whereas stops are for passengers. At a terminus, there's a station head and toilets.

We are family

There are about 300 drivers in the company, from 20- to 60-year-olds, and there are about 30 of us females. Perhaps the ratio is like this because there are fewer females with drivers' licences, which is a requirement to drive a tram. In all occupations that involve driving, not just trams, there are very few women – there's a bigger market for women to work in offices.

In terms of physical aptitude, male tram drivers are superior to their female colleagues, but women are more careful on the roads than men, and we're more patient. Drivers wear a blue long-sleeved uniform in the winter and a short-sleeved version in the summer. We can also

wear this vest [points to her torso], and if it gets even colder, a jacket over it. We have to wear black pants and black shoes, and I carry a water bottle, a pair of gloves and a tool bag.

Learner drivers

To become a tram driver, you need to do eight weeks of training, and you have to have your driver's licence, because you need to know how to read the signs of the road. An instructor teaches you how to operate the tram in a special practice tram. Once you finish learning how to operate the tram, you shadow the instructor. First, you go on the morning shift, then the night shift, and then the morning shift again.

The hardest thing to learn is the steering. The steering is very limited, unlike driving a car, which you can steer freely. In fact, operating a tram is totally different.

As well as drivers, there are also station heads in the company, who make sure there are enough trams on each tram line. If there aren't, they might pull a tram driver off one line and tell him to drive on another. The station head has to make sure the frequency of trams is maintained. There's a new system in which detectors are laid down on the track, letting the control room see how many trams are on a line at any time. When they discover tracks that are too slow, they simply communicate with the drivers.

The control room is at the Whitty Street depot, and the drivers communicate with the controllers through a device which sends short messages. Being a controller is totally different from what I do as a tram driver. I'm only a high school graduate, so I don't think I have the ability to work as one. You need to be better with computers than I am!

Easy rider

How to operate a tram is simple. When you enter, you change the destination displayed on the front. For older trams, you need to change the display manually, but with the LED displays you just punch in a code. Then, you let passengers on board, and transport them to each of the tram stops along the route. You use your hands to operate the vehicle – except for when you sound the horn, or '*ding ding*' [this is also a colloquial term for 'tram']. One hand is used for accelerating, while the other is used to brake. To accelerate, you pull the handle into first gear. If you want to accelerate more, you pull down to the 'lower levels'. After this, the speed is no longer controlled by the driver… If there's a clear path in front, then the tram continues to accelerate until it's reached the speed limit.

Older and newer trams are very different to drive. When I first got the job, the driving was really tricky. I literally had to work out at the gym to be strong enough. You needed a huge amount of strength to pull the manual controls, and, sometimes, if I couldn't pull the control down with one hand, I'd have to use both. It was more of a masculine job back then. Nowadays, though, everything is electronic, so driving doesn't require a lot of muscle. But, it's not as if you can drive with one finger – you need to press on a button as you pull down the accelerator, or the tram won't go. This is a safety mechanism which stops

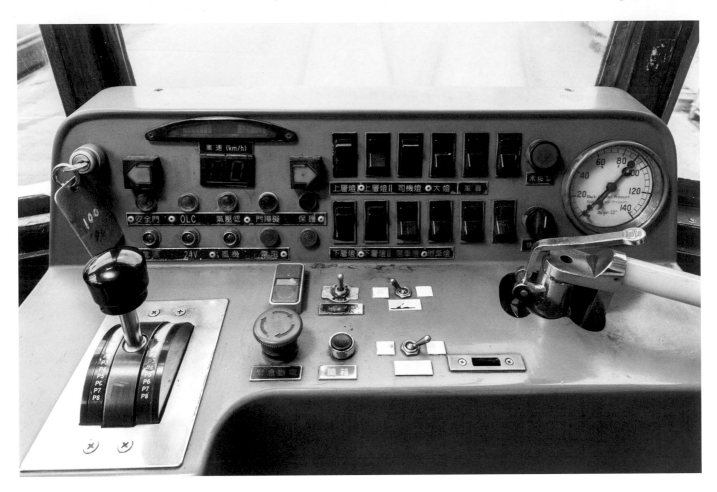

the trams in case the driver passes out or falls asleep.

If you ask me which my favourite tram is, it has got to be the 120 model. We only have one of them; a model from 1954 and very beautiful – but driving it's a pain, because it's not as fast as the newer trams. I like it because it's old-fashioned. Even the ads on it are purposely old-fashioned. Simply put, it's an antique…

There have been a lot of changes to the trams, but the closed-circuit TV isn't one of them. They've been there a long time. The sign on the front of the tram has been changed, though, into an LED display, which makes it clearer to read and better looking. There's also an automated stop-announcement system, and more ads on the trams than there used to be. How long the ads run depends on the contract the advertising company has with us. The ads are a kind of wallpaper, with a plastic coating that makes them durable. Outside contractors use heat to affix the ads onto the bodies of the trams.

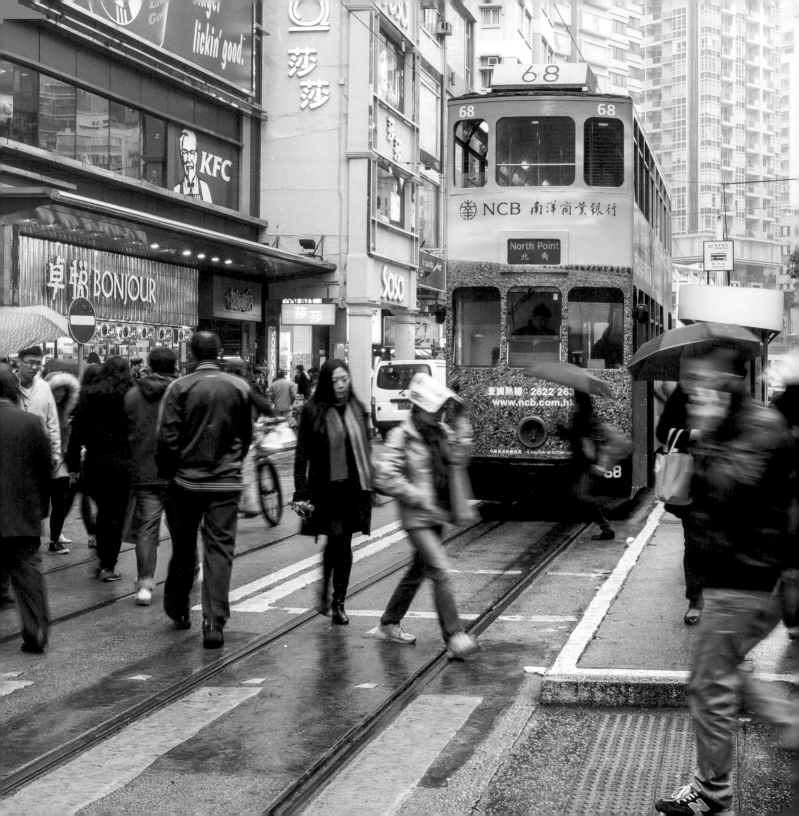

More than fare

The adult fare for any journey is HK$2.30, whether you travel one stop or all the way to the last stop. For seniors, it's HK$1.10, and for children it's HK$1.20. Why do you pay when you leave the tram, instead of paying when you get on? I think it's because it's easier than refunding passengers should they be unable to reach their destination – if, say, a tram were to break down in the middle of the route. With buses, it's different because if one bus were to break down, another one can pick up the passengers at no extra cost. The Octopus card makes alighting more efficient. But passengers who don't know they have a negative balance on their card until they try to pay, need to look for change at the last minute, which slows things down for everyone else.

Nineteen years ago, when I started as a tram driver, the fare was about HK$1.00 or HK$1.20. Trams have raised the fare by very little since, whereas fares for buses and other forms of transport have seen a much bigger increase. The cheap fares may be because it's very cost-efficient to operate and maintain the Hong Kong Tramways. Maintenance is quite simple: once a week, the trams are checked by company staff, which takes a few hours; and the tram tracks are also checked every night. There's a tram that's specially modified for cleaning, and the tracks are checked section by section. Usually, they're looking for oil, which causes the trams to skid, and rubbish.

The cheap fares are the reason we're called a *jun-zi* corporation ['noble' company]. This year, we received a 'Good Business Award', for the second time – the first

time was in 2012. There are five criteria that are required to receive this award. These indicate that you operate your business in a very ethical way.

Crowd puller

I don't think there's been an increase in the number of trams since I started working, but there's been no decrease either – there are about 163 or 164 trams, and we have more and more passengers. The capacity of the trams hasn't changed in terms of numbers of seats, but the aisles are wider now.

Our main customers are locals. There are young people, old people; civil people, less civil people… and, trams are a tourist attraction. The tourists on the trams take photos with their phones and digital cameras non-stop. There are more people now that the weather has become colder, and our busiest times are around Christmas and Chinese New Year.

The trams are quite busy throughout the day; there are people throughout the day shift – and the trams are packed even at 3 or 4 p.m. We're different from other forms of public transport. For example, people go to and from work by bus, but with the tram people don't just take it to go to a particular destination – they hop on for a few stops, while walking around or going shopping.

I haven't been on the night shift for a long time, but it's always busy in the daytime. It gets most busy in Causeway Bay, but places like the graveyard around Happy Valley are very quiet. There are very few people there. But, mostly, even stops that were less busy in the past are busy these days.

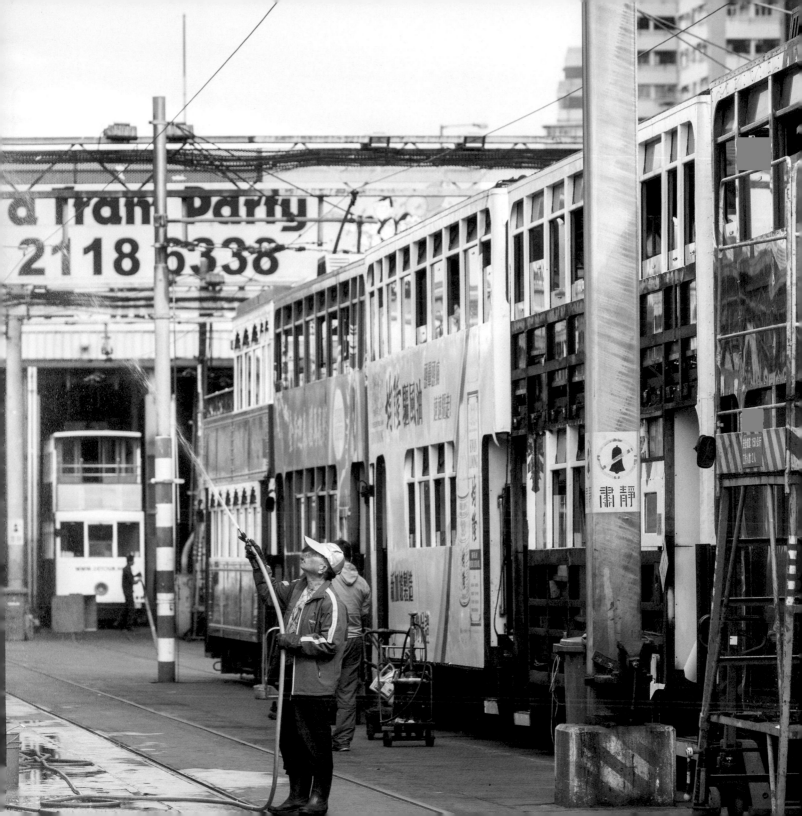

As well as normal business, we also do party trams which I sometimes drive. Usually, we go to Causeway Bay and Happy Valley on the tours which are a minimum of two hours. The company provides the food and drinks, and it's quite fun – sometimes you have little kids, at other times Westerners who're drinking. I also feel the excitement.

Usually, we tell passengers before they get on that they won't be able to get off until the last stop. We can't let them go to the toilet in the middle of the journey, because it would block the route for all of the other trams behind us. Luckily, no one has thrown up on any of the trams I've driven. Though, if anyone did, there's a cleaner at the final stop.

Kings of the road

You have to approach driving a tram with the right attitude. What's most important is patience, because every other vehicle on the road bullies the tram. Car drivers seldom look out for us, so we have to be able to guess what it is that they want to do – otherwise it's too late. Motorists never seem to consider that we can't veer away.

A long time ago, a car in the opposite lane drove into me. I was going westbound and he was going eastbound. He tried to overtake the car in front of him by going over to my side of the road.

Pedestrians and motorcyclists are also hazardous to trams. Pedestrians have a really low awareness of danger, so we have to be very cautious. A tram driver has to be meticulous in their driving, observant, patient, and be able to see things before they happen.

Of all of the users of the street, though, it's actually the trolley operators who are the 'Kings of the Road'. They aren't afraid of anyone, and act as if they're almost challenging you to hit them – if you have the guts. They push their trolleys around very, very slowly.

The outside world

Pedestrians used to be faster. Nowadays, they're a lot slower – maybe because they're in their virtual worlds. Increasingly, there are passengers who rush to the front and ask to get off after we've passed their stop, shut the doors and started moving. These days, we experience this at almost every single stop.

Nowadays, you see a lot of shops that have been very nicely renovated. Even the street lamps are a lot better looking than they used to be – they used to be very ugly. There's also a lot more light from the traffic than before. In the old Hong Kong, there were big, busy streets and quiet back streets, but now there's none of that. There are lots of people everywhere these days.

If the tram was to disappear, it'd be a real pity. Travelling by tram is a really cheap way to travel, and very suitable for browsing the streets because of the closeness of the stops. Trams are cheap, and a great way to get around. ■

"I bought this lawn chair so I can sit out here and read the Oriental Daily. *All the drivers around here are friends. Sometimes we eat lunch together."*

— Sit King-Wah, 71, School bus driver

Sit King-Wah, School bus driver

When I was young I got all the licences: a bus licence, taxi licence and minibus licence. I tested for them when I was 18 years old. I knew they would come in handy when I retired, as a back-up job – so, I just kept renewing them.

I am what's called a 'Nanny bus' driver [a colloquial term for school minibus driver], and I became one after I retired. Usually, the salary isn't all that high for this type of job; and since the pay is not much, you can't feed your family on it, which is why young people don't want to do it...

Before this, I worked in labour-intensive jobs, which I can't do now that I'm older. I was the boss of a company that renovated homes. For bosses like us, we had to keep an eye on everything. I can't begin to tell you everything I had to do. There were as many as 15 to 16 staff.

The company's no longer around, but it used to be in Kowloon. In those days, we took whatever project came up, whether it was on Hong Kong Island, Kowloon or the New Territories. Today, driving the bus, I only cover parts of Hong Kong and Kowloon. Our company has contracts with many different schools, though, so occasionally the schedules change and you're shifted to another school.

Nowadays, I actually enjoy my job, whereas before, I would feel stressed at work. Being a boss and being a driver are totally different. Driving a minibus doesn't require as much effort, and isn't as physically demanding.

A perfect day

My work hours are 6.30 a.m. to 6.30 p.m. I need to get up at around 6 a.m. to pick up the students at 7 a.m. My first stop is at Ho Man Tin, then Jordan. There are only four stops... We pick up the kids at their door and arrive here at 8 a.m.

This is a Band One school [St. Paul's Convent School for Elementary] for girls only, so the parents are willing to have their children travel to get here. I finish work at 4.30 p.m., but by the time I get home, it's about half six. I pick

up and drop off the bus in Tai Kok Tsui, in Kowloon. I live nearby, but it's still a 20-minute walk.

Morning classes start at 8.30 a.m. and end at 12.30 p.m., while afternoon classes start at 1 p.m. and end at 4.30 p.m. There's also the primary school which has a full day of classes that ends at 3 p.m. There aren't really any differences between 'morning' and 'afternoon' kids. But, the morning class kids come on to the bus as if they still aren't properly awake – especially in the winter. They have to be on the bus by 7 a.m., so get up a little after 6 a.m.

Mostly, the children are very polite – the school teaches them well. They usually greet us, but we can't really have a conversation with them because we need to focus on the road. I also need to listen to traffic updates on the radio, to find out if there are traffic jams. So, the kids usually talk with the nanny [a statutory presence on each school minibus]. The ones I am driving at the moment are two- and three-year-olds. They like to talk on the bus, because their teachers don't let them talk a lot in class. So, of course they want to talk as much as they can during the ride!

When I'm on a break, I simply wait. I bought this lawn chair so I can sit out here and read the *Oriental Daily* newspaper. Where I live in Mong Kok is so loud and busy compared to here… All the drivers around here are friends. Most of us are retirees, and sometimes we eat lunch together.

How the nanny bus came about

School buses in Hong Kong are yellow and purple. There are other ones too, but they can also do other types of business whereas the yellow and purple buses can only give rides to students. The colours are regulated by the government, and go way back as far as I can remember – at least to the 1980s and 1990s…

There's no rule about certain buses being only for younger passengers such as kindergarteners. The only rule is that you can't give rides to anyone other than students. Having said that, a nanny is on board. The kids are so young and small that someone needs to help them to get on and off the vehicles.

Usually, passengers are all students from the same school, but there are other outsourced school buses which pick up students from different schools. There are seatbelts on the buses, and the buses are checked for safety issues annually. If the buses don't pass, you can't drive them.

We don't need no education

When I was a child, things were very different. People were really poor, and started working at a young age. I was only 11 years old when I got my first job. What's more, we went to school at night and there weren't school buses – it wasn't like it is today. If someone hired you, you'd do anything. The conditions weren't good, especially because we were kids. We had a really low wage – less than a Hong Kong dollar a day.

In those days, you were doing well if you earned HK$10 a day. Most people only earned HK$5 to HK$6. Working conditions were not nearly as good as they are now, and we pretty much worked in shacks. When I was 11, I worked

in a place where wooden floors were made. The tradesman wouldn't teach me his trade, so I was mainly responsible for cleaning and tidying the place.

My story is not unique. It was not uncommon for 11-year-olds to work in the 1950s. Most people had a low standard of living. Companies sometimes outsourced their work, and people would bring the work back to do in their flats. Some mothers watched over their children as they worked.

In the 1950s, only wealthy families had toys. We'd wander around aimlessly and play in the streets. Sometimes, we'd go to sports fields and play football. We also kicked *yin tse* [small, round, bits of cardboard tied together, with feathers sticking out of one end] around. I lived around Tai Yuen Street ['Toy Street'] in Wan Chai, but, at that point, they didn't sell toys there. They only started selling them a lot later on.

It wouldn't be possible to work as a child in today's

Hong Kong. We have free and compulsory education up to a certain age, and so of course there's a huge difference between the way we were and the kids of today. Children nowadays need only study and play. They aren't burdened now, because they don't need to bring money home. Hong Kong is a much better place now that kids don't need to work. People are more cultured now.

Happily ever after

I've been a school bus driver for 10 years, and have watched the kids grow. You see them change from being babies in K1 [the first year of Kindergarten]. I also have two grandsons in Primary 1 and 3 [ages 6 and 8]. Traditionally, old Chinese people love being around children.

I don't make much money in this job – just HK$8,000 a month. It's just something I do to kill the time. I enjoy it, but it's not my dream job… I have a low level of education, so couldn't possibly work in an office.

On my days off, I hang around with my colleagues, play mahjong with my friends, and see my grandchildren. My wife looks after them full-time, and volunteers at her church. She's a churchgoer, but not me. We've been married for 40 years – we had our wedding banquet in Mong Kok, close to where we live now, when I was 28 years old.

If I have time, I do voluntary work as well, but you basically have to pay to volunteer, whereas I get paid to do this job. For minibus drivers, there isn't an upper age limit, so as long as the boss continues to hire me and I'm healthy, I can work. ■

WHOLESALE & RETAIL

Kwok Shu-Tai – Fisherman
Bessie Lee – Newspaper seller
Wong Pui-Lam – Hawker
Chan Ngoi-Lam – Flower seller
Lai Siu-Fan – Sign holder

"There are plenty of good things about being a fisherman, like the better air quality we enjoy compared to people working indoors."

— Kwok Shu-Tai, 50, Fisherman

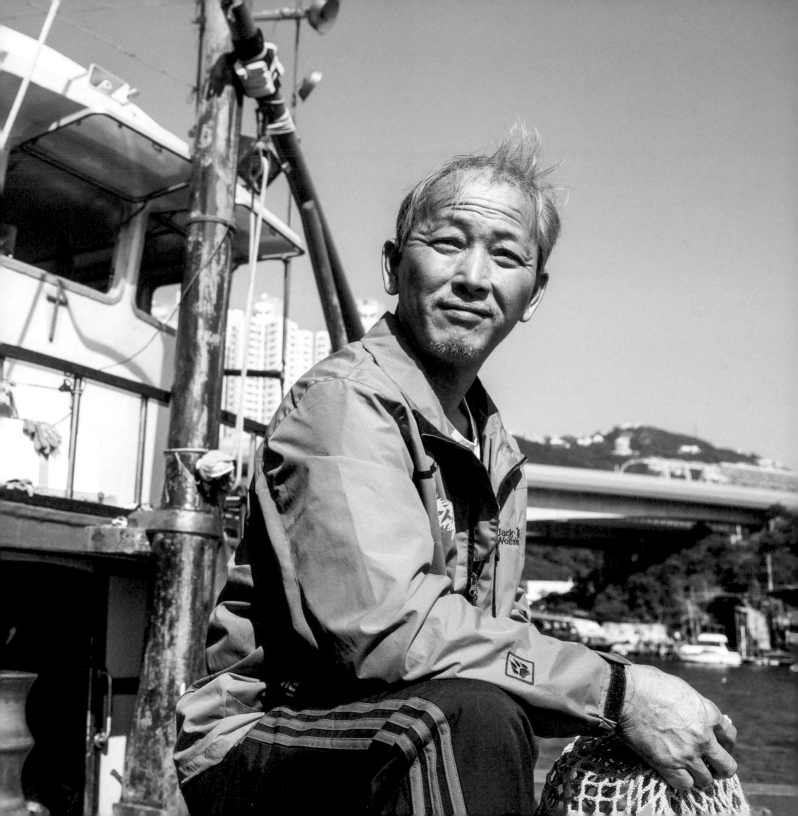

Kwok Shu-Tai, Fisherman

I know everybody in Aberdeen and everybody here knows me. They call me by a nickname – 'Ah-Q', after the character in the old TV series, 'The True Story of Ah-Q'… It's a funny story: my hair was very thin back then and someone told me that if I cut it, it'd grow back thicker. My older brother began cutting my hair, but, part of the way through, I changed my mind, which left me with bald patches. My new 'do' made me look a lot like Ah-Q, and I've been called the name ever since.

Like a fish to water

I've been a fisherman since I was a child, and all the generations that I've known have been fishermen too. In fact, I was born on a boat and used to live on the water, though we went to a primary school on land.

During the school holidays, we'd swim to the rocks and catch oysters and sea snails to eat; and we'd also fish. After primary school, I didn't study any more. I was apprenticed by my father, and when I was of age, I took the boat exams to get my licence, which allows you to operate many different types of vessels. You also need to have boat licences for Hong Kong and the Mainland, and there's a 'mass fishing licence' which you need to catch fish.

After you marry, you have to have a place to live – you don't want to have your wife and children living on a boat, right? Actually, in my case, even before I was married, I had a home on land, though I mostly slept on the boat. My wife used to live on the water in a boathouse like me, because her mother and father were fishermen as well. Even today, I prefer being on the boat because I'm used to it. If I'm ashore, I never turn on the air conditioning.

This is a fishing boat, and it's co-owned between the 'brothers'. We had it made in the Mainland four years ago, simply by giving the dimensions we wanted to the shipyard. We share the labour. I drive the boat; my brothers cast and pull the net; and, in the Mainland, we've another five workers.

The Mainlanders are responsible for the nets. We pick them up from Lingding Island [in the Pearl River estuary in Guangdong], and, while there's no rule about how long they stay, they usually go home for festivals and holidays. Right now, it's Mid-Autumn Festival so they're back home. Once it's over, they'll come back out. For Chinese New Year, they go home for longer. When they're away from home, they live on the boat.

Mapping the schedule

Most of the time, we stay close to the shore to fish. This could mean a day trip, or sailing just outside this bay in Aberdeen, but sometimes we're more flexible and go for two or three days, depending on the destination. If we go to places nearby, such as Po Toi Island [3 km off the southeastern tip of Hong Kong], then we leave at 4 p.m. and return the next day. If we go further, it could take seven to eight hours just to get out there, so we stay away for two to three days.

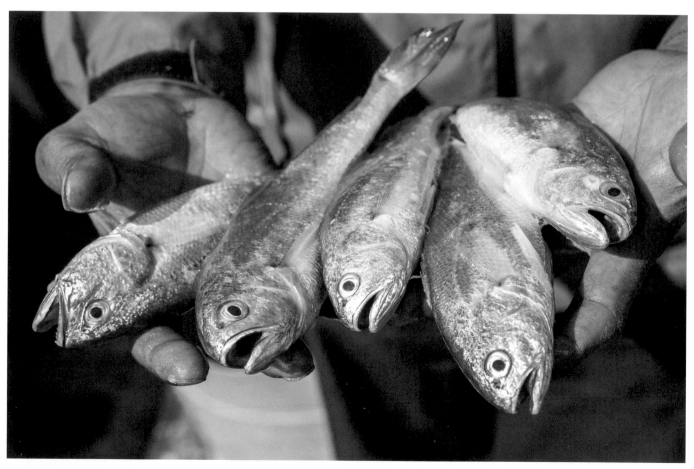

How often we go depends on the weather and season. In the summer, we go out more – it's less windy; and unless there's a typhoon, we go out most of the time. In the winter, it's quite windy… It depends on the geography as well. Certain areas are less windy and have a greater yield. If there's likely to be only a low yield, we won't go out...

Mahjong is a very popular form of entertainment which is used to kill time. In the past, people would round up and play *pai kau* [a group game played with domino pieces with a minimum of two people] in the holidays; but my generation doesn't gamble any more because it hurts morale. On land, we play football; and, in the summer, we dragon boat. I used to win a lot of awards for dragon boating. I've represented Hong Kong three times at international dragon boat competitions, though my athletic prime has now passed.

Catch of the day

In the past, we would lure the fish to the side of the boat with our lights, but, over the past 20 years, we've been detecting them with radars. We mostly catch fish, and the catches are seasonal.

Right now, we're starting to catch Yellow Croaker and Lion Head Croaker. In the summertime, we catch squid, and other fish. The biggest fish I've ever caught was about 260 catties heavy [286 lbs]. It was a kind of mackerel. In Sai Kung seafood restaurants, you can see plenty of big fish on display, mackerel included. There are a few different mackerel species, and the biggest can weigh as much as 300 catties [330 lbs].

After we catch the fish, we put them on ice, though this depends on the type of fish, because the smaller the fish the quicker it spoils, which means we need to sell them the next morning. We can keep larger fish for longer. We sell the fish to vendors we know.

There are a lot of products related to the sea such as oyster sauce and shrimp paste, but we don't play a role in making them. We do catch oysters, but we won't make them into sauce. As for shrimp paste, my mother used to make it… She'd sun-dry the shrimps for at least 10 days, and then grind them into a paste using a mortar and pestle…

Leaps of faith

I'm a little different from most fishermen in Hong Kong, because I'm a Christian. In fact, the past few generations of my family have all been Christians, which is quite rare for fishermen here. Usually, they worship Tin Hau [the goddess of the sea] or their ancestors.

Hong Kong fishermen usually have a lot of superstitions, whereas Christians have few. For example, in *baak si* ['white events', or deaths], when someone's family member dies, a Tin Hau or ancestor worshipper won't let family members of the deceased onto their boat.

Also, although we're supposed to eat fish at Chinese New Year, because it's said to encourage a surplus of food, which is auspicious [*nihn nihn yau yu*, a saying which translates as 'having fish every year'], we don't just eat it at New Year; we eat it all the time.

Other superstitions about fish…? Everyone used to

have smaller boats, and fish would sometimes leap aboard out of the water. This is known as 'dragon headed carp'. Legend has it that carps become dragons after jumping through the 'dragon's gate' at the top of a river, and is considered very lucky. However, if you catch one of the fish, then the saying 'pick up a dragon carp, and a man will die' applies. We've never had this unlucky situation happen before.

Beliefs are an individual choice, and people don't hold our faith against us. In fact, we Christians are quite popular! I have a cross here [points below the windscreen on the other side of his boat], and a bible in my room, but I seldom go to church as it's hard to find time on Sundays. Sometimes we've taken the boat out, you see, and are not always back in time for the service. Faith is a strange thing – some people are more devoted, and others less so.

Making waves

You have to be able to swim to be a fisherman, and you have to have a good memory, because you need to know which fish to catch each season, and which types of nets to use.

I'm not afraid of the water, but in the typhoons of the past, living on a boat could be extremely scary. The boats were small – nowadays they're much bigger – and back then, the typhoons were a lot more powerful because there weren't as many tall buildings. The youngsters would take safety ashore, while the adults would stay on the boats, anchoring them down.

But, the scariest thing I've ever experienced at sea?

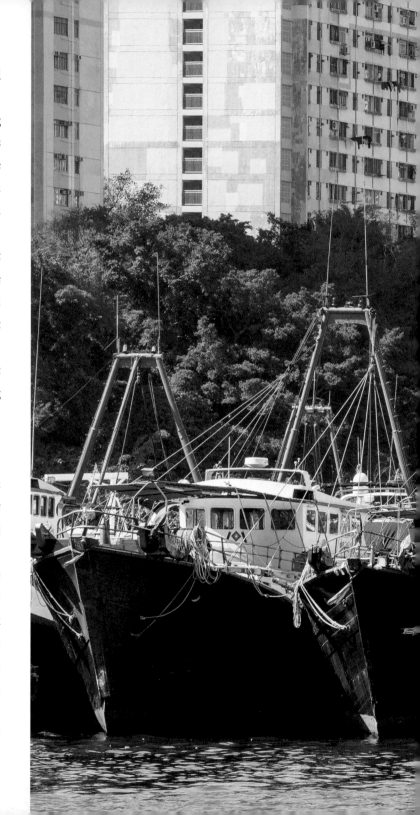

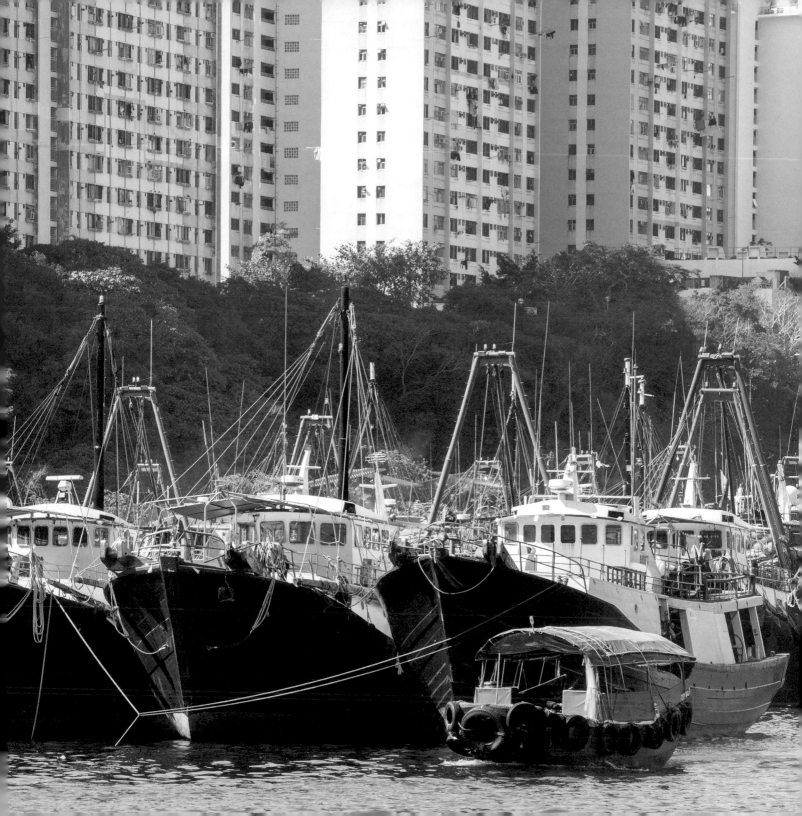

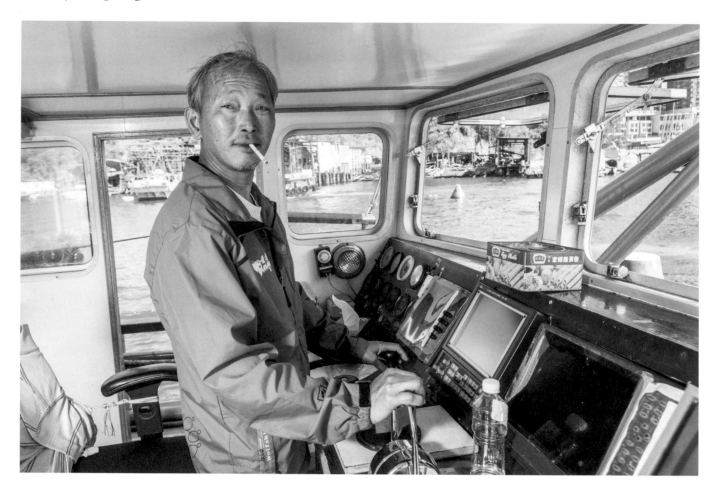

Once, a fishing net got stuck in the engine of the boat, and I had to dive underneath the boat to cut the net. The waves were strong, and it was hard to tell where the boat was moving. When I surfaced, I was hit by the boat. It was a minor injury, but if I'd been hit on the head, I might have fainted. I wouldn't have died, though; I had my 'brothers' up on the boat, and had taken safety precautions – I was tied to a rope, and had scuba gear on with a tank of air.

Another challenge to fishermen used to be land people's discrimination towards us, here in Ap Lei Chau. People on the land would call us 'Tanka'; and the Tanka were considered a lower class. Today, though, everyone's culture is more alike, and being a fisherman is considered to be just another profession. Boat people and land people are the same. The relationship depends on how you carry yourself. If you're always angry and hateful, then no one's going to like you, but if you're jovial, you'll have friends…

What's most dangerous at sea is a tired person. If you're driving a boat and you're tired, it's easy to crash. The Lamma Island boat incident was a catastrophe… For driving, we comply with the British standard, whereas at sea we use the international standard. In the Lamma disaster, the boat which hit the other boat should have given way. In my view, and from my experience, the boat that was hit was in the right, while the one that hit it was in the wrong.

A sunset industry

Aberdeen is a famous place in terms of boats and fishing, but in the last few decades, lots of high-storey buildings have been built and there are fewer shipyards. It's less scenic now, because they keep on landfilling and narrowing the bay.

In the past, there were spots that were very beautiful. There weren't so many buildings and there were streams that would run down from the mountains, which you could drink from. Now, you don't dare drink it, and there's much more flotsam and plastic bags on the water… There's so much packaging these days. If people are disciplined, they throw their rubbish in the bins, but if not, they throw it in the sea.

As for human waste, we have a really nice toilet downstairs, but the waste is actually drained out to sea. Bodily waste doesn't at all affect the sea, because it's bio-degradable and eaten by small fish – in fact, I often swim in the water, especially in the summer. Pollution-wise, most comes from the Mainland. The waters in the southwest are polluted because of the rubbish in China, and it's the same with the air pollution as well.

Hong Kong's fishing culture is disappearing, and after my generation it'll be gone, because there won't be anyone to take the lead. I come from a long line of fishermen, but am not sad to see it go. I would never wish my children to be fishermen, because it's a difficult life.

Having said that, though, there are plenty of good things about this life, like the better air quality compared to people who work indoors. At our workplace out at sea, there isn't much dust. There are also the sunrises and sunsets, which are beautiful out on the water, though we're a little desensitised because we're so used to seeing them. I'm actually very satisfied with the life that I lead. ∎

"We give out free tissues and plastic bags to complement purchases, and we also sell ad space to sponsors. This way, we counter our losses."

— Bessie Lee, 56, Newspaper seller

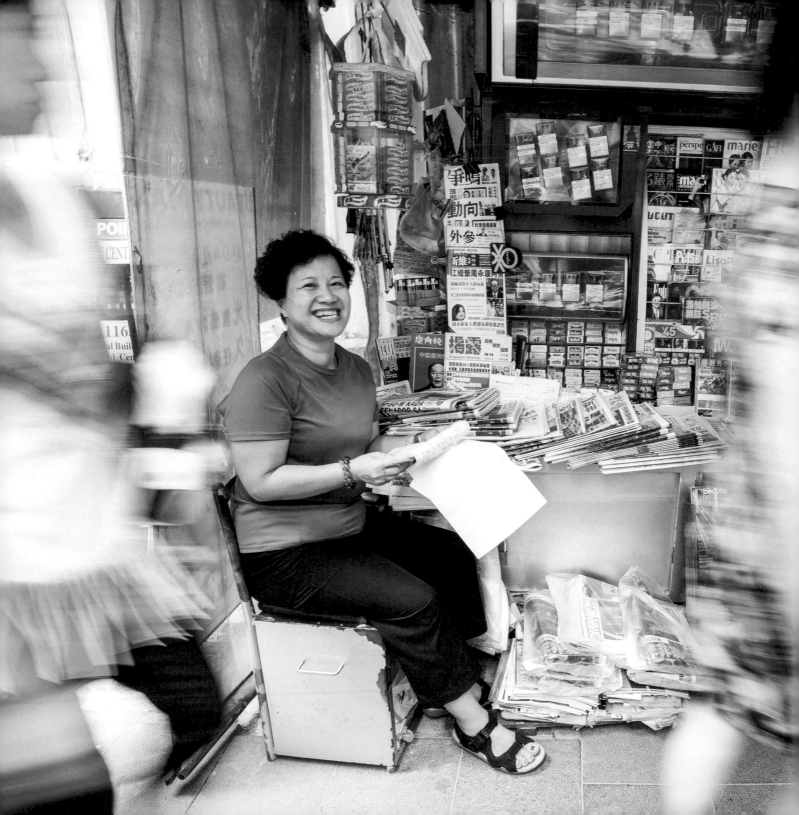

Bessie Lee, Newspaper seller

This news-stand belongs to my mum and dad, and has been operated by our family for 45 years. My four siblings and I were raised on the takings of the business.

Family paper round

Dad had previously worked as a labourer on Stone Slabs Street [colloquial name for Pottinger Street], but the money he earned wasn't enough to feed the family. Luckily, the previous owner of the news-stand, who was almost 70, asked dad if he wanted to take over his business.

That's how they got the news-stand. As for me, I started helping by delivering newspapers when I was eight years old. It was back in the days before 7-11s or Circle K shops, and my brothers and sisters and I delivered to every one of these buildings around here [on Queen's Road Central]. Once we'd finished the deliveries, we went to school; and when we'd finished school, we'd go home to do our homework. We made the deliveries to earn a little bit of extra money for the household. A great-grandmother also helped out.

I know Central well. I lived here until I was 30 years old, but once I married, I moved to Kowloon. Mum and dad still live near the escalators in Central, while I live in Wong Tai Sin. The government subsidises the building in Kowloon, but it's getting more expensive now.

My husband works with the MTR, as a train operator, and sometimes drives the maintenance vehicle at night; and I have two kids – one daughter and a son. One is 25, and the other, 23. My daughter works at Zara as a coordinator, and my son is graduating from university. He hasn't found a full-time job yet, but works part-time.

I started back here on the news-stand more recently, because the factory I was working at closed down. The work was outsourced to the Mainland – also, I needed to help my mum who was getting old.

What's the story, morning glory?

We start work really early, as early as 4 a.m., when the newspapers are ready for collection at the Star Ferry... Whereas other news-stands hire people to pick up the newspapers, we're different. In our case, it's my younger brother who goes. He picks up the magazines, after which he leaves because he's got his own work to go to. Mum arrives at the news-stand by 5 a.m., and watches over the magazines, while my brother goes back and forth. She leaves, and I arrive at 7 a.m. Around 3 p.m., mum comes back to take over from me, and I get an hour's break. I don't like her staying out in the dust, because she's old and has heart problems.

Our news-stand is also a bit different, because most news-stands have two people looking after them, who are normally man and wife or sisters, not just one like we do. Among other things, this means that when we need to go to the toilet, we have to find *hong ga* [other people in the business] to look after the stand for us, while we go across the road. We have a key to a private toilet there.

The busiest times are in the morning, when people are going to work – around 8 a.m. to 10-ish, and lunchtimes. Central is quite unique, because while most people lunch around 1 p.m. to 2 p.m., there's a second wave of sales people who have their lunch between 3 p.m. to 4 p.m.

Some people tell me about their difficulties at work, and get pretty upset, but basically, I think people are fairly happy in Hong Kong. When they come out for lunch, they're talking, talking, talking, and they light up when they see something on our magazine covers that they want to gossip about... During SARS [in 2003] and the financial crisis [2007 to 2008], it was a different story. You could see that people were unhappy. Everyone had to wear a mask, and I could tell that people were really scared. I wasn't, though! I didn't even wear a mask back then; I just drank more water, and tried to stay hygienic. I always washed my hands after going to the toilet. I was working in an open space, and could take a good shower when I got home, before eating my dinner. If I'd been indoors, with poor ventilation, it would've been easier to fall ill.

Read all about it

We have lots of titles on the stand, perhaps more than 100. We have three suppliers who each supply different types of publications – for example, education, entertainment, or comics... The three suppliers are Kun Lek Tak, Tung Tak and Ching Yeung. Right now, it's horse racing season, and there's even a horse racing newspaper. It's very broad; maybe we carry more than 100 titles...

The magazines are different every day. On Mondays, there's *Oriental*, on Wednesdays, there's *NEXT*, while some are out monthly... On Saturdays, there are finance guides for investors.

We have *fung shui* books in September. People usually come to buy them in the last two months of the lunar calendar, for the year ahead. There are about 20 of these books, but we don't sell all that many. People usually go to specialist shops, which sell the books throughout the year. More and more people seem to believe in *fung shui*.

Reading is important, but people don't read much in the way of actual books. They read on their computers instead. Unless people are very interested in something, they won't buy a book. People do seem to like travel guides, but even then it depends on the destination. No one buys ones on Europe... Japan, Korea and Taiwan are the ones that most people want.

I personally like to read books with pictures, and books about history. For instance, a book which introduces an occupation, like yours... I really like these kinds of books! I also like to read about people – biographies, mostly, about famous people throughout time, for example, Bo Xilai [a Chinese official sentenced to life imprisonment in 2013]. I'd like to read about his wife, why he became corrupt, and about his relationships with people – if possible, in not too many words. I like attractive pictures to help describe a story. If it's only a book with words, I get really tired. I have no brains – I don't think about things that are too complicated.

Free papers, big losses

Free newspapers have very much affected us; our sales have decreased by 50 per cent... There are seven free newspapers, which are given out near the escalators [close to her stand]. Sometimes I see elderly people grabbing four of them at once, and then just flipping through or skimming the articles. But some people continue to buy newspapers, because they think the freebies don't provide the same insights. These are people who want to have a deep understanding of current affairs... My son reads the *Hong Kong Economic Journal*, and my husband reads the *Hong Kong Economic Times*, and some of the writers in the *Apple Daily*, for example, have a following – which is why people continue to buy these papers.

The *Hong Kong Economic Times* is HK$8, and sales haven't dropped at all because it's a very specialised paper about finance, and the articles are about very practical things like buying stocks and Hong Kong's economy.

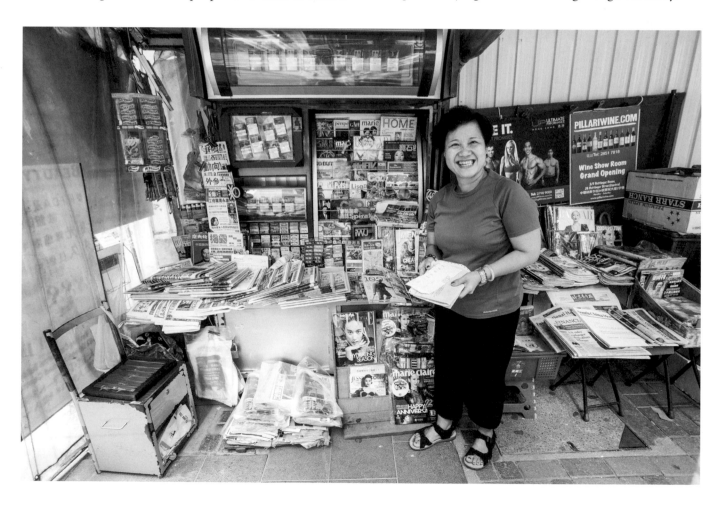

We give out free tissues and plastic bags to complement purchases, and we also sell ad space to sponsors. This way, we counter our losses. You really can't profit much from selling newspapers these days. There's also the internet against us. You can read the *Apple Daily* or *Oriental Daily News* online – though I've a friend who tells me that you can't see some of the sections. You need to pay for it.

The end

I'm not sure when I will retire... There's construction going on next to the news-stand, and the real estate companies want us to move; so, we're asking the government to arrange another spot for us close by, to continue doing business.

If we don't get a place, I don't think we'll continue any more as my mother is getting old. This location is convenient for her, but I worry that work might be too dangerous for her to get to if we move too far away. I'm also afraid we won't be able to find loyal customers elsewhere. We've been in this area for 45 years. ■

"There are only about 25 hawker stands left in the whole of Hong Kong, including Kowloon and the New Territories."

— Wong Pui-Lam, 65, Hawker

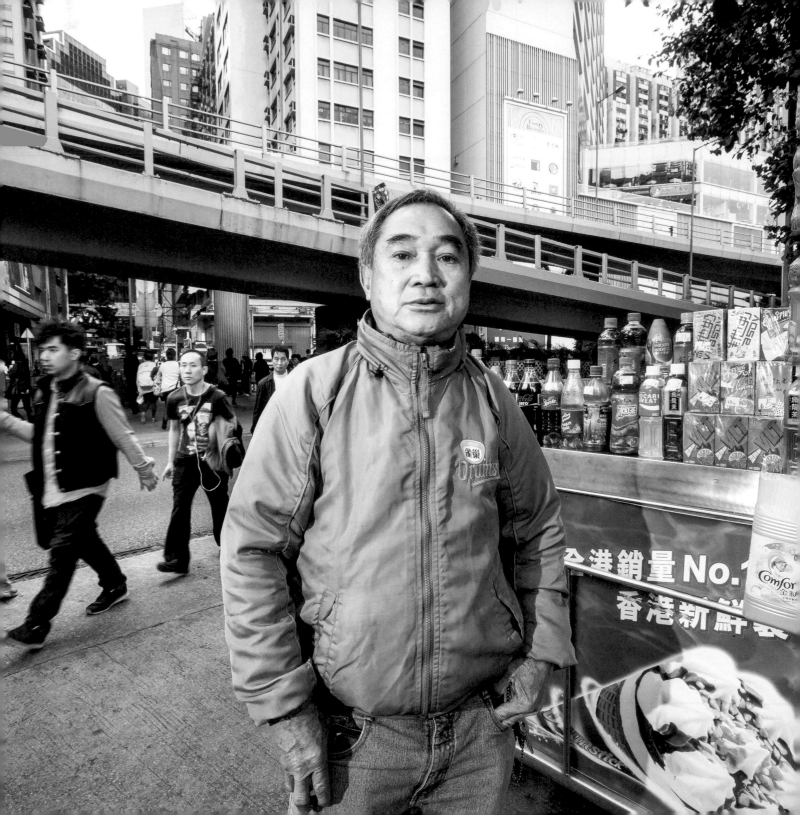

Wong Pui-Lam, Hawker

I've been doing this job for 50 years, but not always from the same spot. The hawker licence allows us hawkers to move around, as it's a mobile licence, but being here has been alright. This is the biggest park in Hong Kong [Victoria Park in Causeway Bay] with the most passers-by, and you can make money here, and give directions. If people don't know the way, I think I should help them! In this business, most hawkers are located in touristy areas like Golden Bauhinia Square [in Wan Chai], Central and Tsim Sha Tsui…

None of my family members are hawkers. A friend introduced me to the profession, saying that I could earn a living doing this. The income here is more than a salaried worker of my age; we earn about HK$8,000 a month – and there's freedom in the job. I can come if I want, or not come if I don't want. Most importantly, I can earn a living.

The day-to-day

I live in Sai Wan Ho [in Eastern District], and work every day of the week from noon to 7 p.m. I eat lunch while I'm at work.

I get more business on Sundays because of the Indonesian domestic workers who come to buy drinks and ice-cream, and have occasionally made as much as HK$3,000 in a day. But the busiest times of all are during festivals and protests. During the July 1st protests [in 2005, in support of freedom of speech], there were more than 500,000 protesters here…

What's hot and what's not

Water is the best seller, and I estimate I'll sell about 30 boxes of water today, it being Mid-Autumn Festival. Each box has 24 bottles in it, and we usually sell several a day.

We're not allowed to sell anything hot, as the Government thinks it's a fire hazard, and I'm only allowed to sell things from authorised suppliers with a brand.

I sell for Nestlé, but back in the day, there were six different ice-cream vendors, who have been eliminated one by one… Rent is expensive in Hong Kong, and if there aren't enough sales, people go out of business. Rent is several tens of thousands of dollars, so you have to sell a lot of ice-creams to survive or turn a profit. Brands like Haagen-Dazs are too expensive for us to sell – HK$30 a cup! People won't buy it. If I bought a box of Haagen-Dazs ice-creams they wouldn't be sold. Look here, these ice-creams are only HK$8 [he points at one of the samples in his display].

The suppliers for Coca-Cola and Vita deliver the goods to us once a day; they even deliver ice, while others come once every two days. Cigarette companies deliver once a week. We don't chat and we're not friendly with the suppliers. They're in a rush to do what they need to do. They have their work and need their commissions, so they want to finish unloading the supplies as quickly as they can.

If there are health and safety concerns about the merchandise, the companies recall the items because they need to safeguard their reputation. This has happened in the past, though it happens rarely. The suppliers exchange the bad items for those that are good.

You can rent storage in a basement, but it's really expensive, so at the end of the day we put our things under the bridge over there [points across the pedestrian crossing].

Now you see it, now you don't

Previously, there were a lot of ice-cream trolleys in Hong Kong. The government issued licences, because it was hard for people to earn a living in other ways. But, these days, people can earn about HK$50 per hour, so why would they want to hawk?

The hours are long, the job is repetitive and troublesome, the income isn't that much – plus, you're forever outside in the sun. It's not very stable work either, because if there's a typhoon or heavy rain, then your income's gone. As a salaried worker, on the other hand, you always have a stable source of income.

There are only about 25 hawker stands left in the whole of Hong Kong, including Kowloon and the New Territories, but I don't pity the fact that the hawkers are disappearing. Like news-stands, they get in people's way, and obstruct the streets. A 7-11 can do the same things that we do. If you have the money, then you should have

a shop – not be a hawker or news-stand owner, which blocks the walkways.

While there are less and less hawkers in Hong Kong, there are still quite a few in other countries. Usually, the higher the unemployment rate is, the more hawkers there are. In that kind of situation, you're prepared to work for a low income – even a few thousand Hong Kong dollars.

I'll be working for another five years before I retire. After I do, the stall will be gone, because you're not allowed to pass it on to anyone. You need a licence for this profession, which is issued by the licensing office, but they aren't issuing any new licences for hawkers or news-stands. In any case, no one wants to do this job; children don't want to do it. Even if we were to tell them to, they wouldn't! Hawking is a business that's phasing out. ■

"I think it's precisely because Hong Kong's such a concrete jungle, that people want to give and receive flowers as gifts."

— Chan Ngoi-Lam, 48, Flower seller

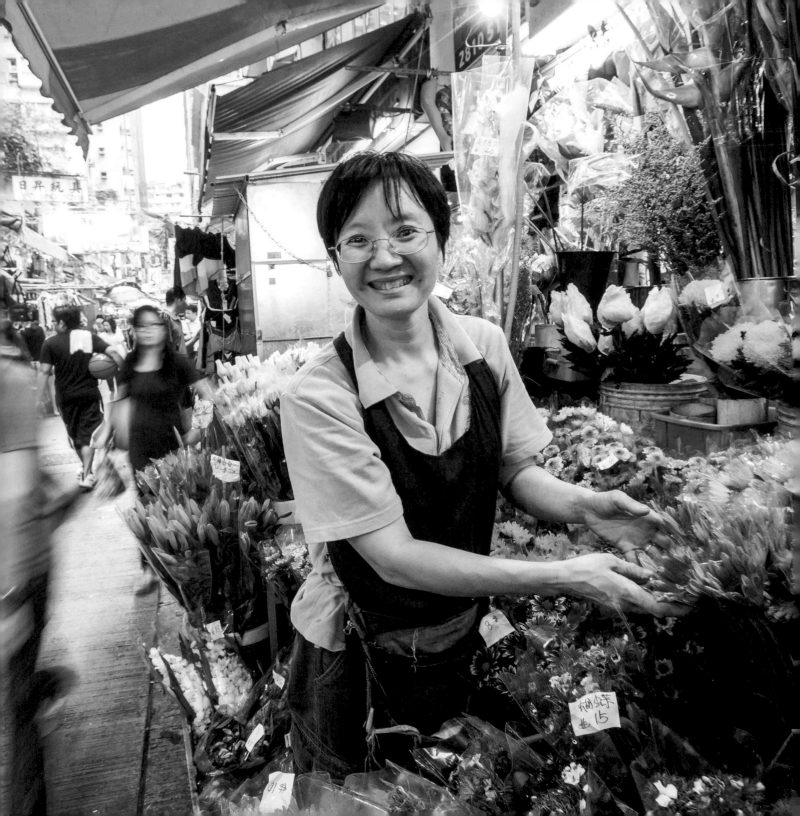

Chan Ngoi-Lam, Flower seller

I've been working at the flower stall since 2003. I used to work in a toy factory, but during SARS they laid off a lot of workers; as did lots of other companies. At that time, I was already in my late 30s, and so it was difficult for me to find other work. Because of this, I decided to help out my father – he was also getting old.

My father was an immigrant from the Mainland. Back then, no registration was necessary to come to Hong Kong. The year was about 1950, around the days of Mao. When dad came to Hong Kong, he tried a few jobs. He worked as a labourer, but said he couldn't stand people bossing him around, and, so, he decided to open his own shop selling fruit. We had a friend from the same village who was selling flowers. He introduced the trade to my dad, and soon my dad started to sell his own flowers instead. Dad's been doing this ever since – from the time that I was born…

There's a big difference between what I was doing before, and what I do now, but, it wasn't a drastic change because I'd been helping my dad from a young age and was familiar with the work. The hardest adjustment was having to stand to wait for customers, for long periods of time, because in the factory, I'd been in an office… I could, of course, sit down, but then when a customer comes I'd have to stand up again, which is even more troublesome. Also, we need to stand to arrange the flowers.

My brain definitely doesn't get tired from this work; it's my body that does – my feet and my back. I'm actually a university graduate. I studied 'Business Admin' at Shue Yan University [Hong Kong Shue Yan University]. In a company, there are also people with higher and lower education levels – it's not much of a difference. My degree doesn't help with the job. How you get on depends on your personality. If you like the job, you can do it.

A family affair

Right now, it's me, my younger brother, and parents taking care of the stall. In the morning, around 10 a.m.

to 11 a.m, my parents open shop. Then, my brother and I go to work, to ease some of the workload from my parents. During special days like Valentine's Day or Chinese festivals, when there are many more customers than usual, our other siblings also pitch in to help out. It's not too bad in terms of space; we're used to it. It's not like the New Year's market, where the booths are right next to each other.

Where have all the flowers gone?

When my father started out, farmers in the New Territories would grow the flowers, and sell them at Mong Kok train station. We'd go there by boat at night. There were certainly no MTR lines then. Very few of today's flowers are grown in the New Territories. These days, we buy our flowers wholesale from the flower market in Prince Edward, and retail them here. There are a lot of suppliers there. Anyone can purchase flowers at the Flower Market, because due to the rising rents they have been forced to do retail as well.

The flowers that we buy at Prince Edward mainly come from China – Chrysanthemums, Sword lilies, Roses, Lilium, in four to five colours... They're imported from Shenzhen, Guangzhou, and Kunming. There are also flowers that we import seasonally. At Chinese New Year, we import 'Chinese Sacred Lily'. We import Orchids and Tulips in the winter. Overseas imports come from countries like Holland or Singapore. All of the imports come to Hong Kong by air, because flowers have a short shelf life. They're loaded onto trucks at the airport.

A blooming district

When I was little, people who bought flowers from us would buy them for their home. Peak hours were after people bought groceries, which was around 9 a.m. to 11 a.m., and after this, we wouldn't have many customers. Because of this, we'd only purchase flowers each night; and would leave work quite early. By around 8 p.m., the merchandise would be sold, and we'd pack up and go home for dinner. It was very routine.

We lived in Wan Chai above the stall in old buildings that have now been torn down. Today, our stall is close to the end of the street [Tai Yuen Street at the junction with Johnston Road], but, it used to be in the middle, and there was an old building there, where we lived on the fourth floor. If there was anything the stall needed from home, my mum could easily let us know. After the building was demolished, we moved to where the Jockey Club [the Hong Kong Jockey Club] is today. It's not good for business to live too far from the stall.

Having lived around Wan Chai for 47 years, I've seen a lot of changes. For example, the population has aged a lot. In the old days, a lot of families lived here. In terms of flowers, the former buildings had a lot of room, where people could put numerous flower pots. The buildings of today, don't have much space, so people buy flowers and put them in a vase.

A lot of the residential area has been demolished to make way for commercial buildings. Wan Chai today is a 'semi-commercial' area, rather than a fully commercialised one like Central. There are fewer residents today. Most

people just work here instead. Ever since the MTR station was built, there have been a lot more people coming in from other districts.

The 'shop floor'

Tai Yuen Street, where our stall is, is known as 'Toy Street'. In the old days, it was a marketplace for everyday items, and at one point a lot of toys were sold which is how it got its nickname… A lot of factories had to move their manufacturing up north, and needed to clear their inventory, a lot of which was old toys. A store called Hung Hing Toys, among others on the street, started selling them; and collectors of old toys came here to buy them. That's how it became famous. After the toys were sold, though, the frenzy was over and everything went back to normal. They no longer sell the toys on Toy Street that made the street famous.

People sold clothes, flowers, fish, shoes, stationery –

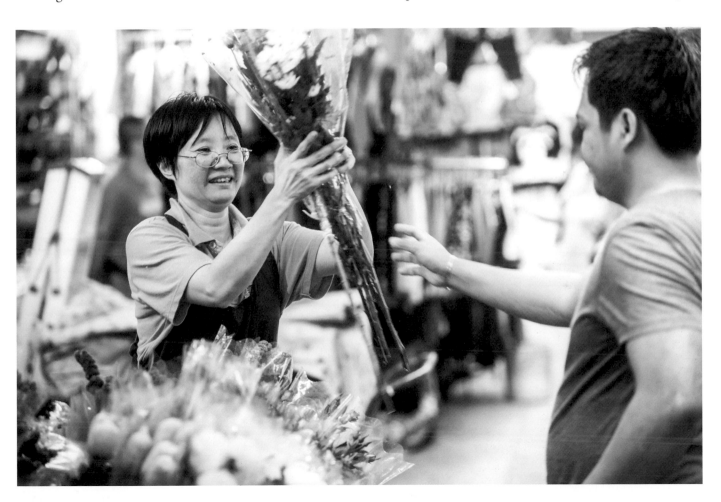

anything you needed for everyday living. Meanwhile, Cross Street was the actual market, where food and groceries were sold. You could buy dried goods on Tai Yuen Street; and the section of Tai Yuen Street that extends past Cross Street sold groceries.

In later years, the MTR station opened, which brought the arrival of hygiene officers. Before this, there'd been no zoning of the market. After the zoning, everyone had to be repositioned due to hygiene reasons, because those selling 'wet goods' made the ground slippery and wet.

Wet goods had to be relocated into the indoor market. For example, the first shop on Tai Yuen Street used to sell gold fish, but, because of the rezoning, no one who sold 'wet goods' was allowed to do business on Tai Yuen Street. Because of this, the license holder changed from selling gold fish to dried goods. Those little turtles he sells are only allowed because he sells so few of them. Because of the rezoning, we were moved from the middle to the end of the street.

People often happen across us in the streets and then decide to buy flowers. But, if they had to take the initiative to go into the indoor market to find us, they probably wouldn't. We have a lot of 'random customers', as we call them, who merely come across us by chance. Also, outside, they're more lenient with space than indoors, where they're very strict. 24-hours a day, there are security guards to make sure you don't 'go over'. Out here, though, they don't ticket you immediately. If you go over the line, they might give you a warning.

It's mostly Chinese people here. The zones we talked

about have got to be rented to a licence holder. The licence holder can't loan it or give it to anyone else, and people can no longer apply for a licence. Even though there are lots of other races in Hong Kong, it's not possible for them to have a stall. They can be hired as assistants though – each license holder is permitted to have up to two assistants, but most Chinese licence holders don't know any non-Chinese people.

Tai Yuen Street doesn't share the same sense of community as Temple Street. Perhaps this is because of the shortness of its history; it was only when the MTR station opened that we started being mentioned in travel guides, whereas the history of Temple Street goes really far back. There isn't much camaraderie between the vendors on this street, and, frankly, I won't particularly miss them if I have to leave. It's not like colleagues in an office.

Closing the deal

Though the vendors are Chinese, there are a certainly a lot of non-Chinese customers, like the Filipinas, who we speak English to. I learned my English at school, whereas Mum never spoke it, and can't even read Chinese, but has started learning English too. We sell the same thing to locals as we do to foreigners. But, in the market, there are stores that sell really cheap goods, for HK$2 to HK$3, where a lot of Filipinas go to.

There are a total of four stalls that sell flowers here. Each has its own pricing strategy. They look at their costs, and simply mark up the price a little. Prices depend on what the flower is, and where it is from. For example, there are Mainland varieties and American varieties of Roses, and American roses are a lot more expensive – about HK$20 apiece.

We offer quite a bit of variety when it comes to the flowers we sell, dating from when our stall was in the middle of the street. If people were to see the same old Chrysanthemums, Sword Lilies, or roses, then we wouldn't stand out. To attract customers, we sell rarer flowers. As well as flower type, packaging can also make flowers pricey. At 'brand name' flower shops, like those in IFC, or city'super, prices are, at least twice as much as ours!

When I was young, it was the case that foreigners were charged more than the Chinese. This was partly because the vendors didn't know how to say 'cents. They only knew how to say 'two dollars' or 'three dollars', for example. This is no longer the case. We use price tags to make things easier for everyone because sometimes foreigners feel too embarrassed to ask. This makes things very fair; everyone's treated the same way.

We treat our customers really well, so they return. When a customer doesn't know what to buy, I ask them what kinds of flowers they like, and how long they're planning to keep them. If they want a long shelf-life, I suggest Liliums or Carnations, but, if they don't like either of these, I ask them who the flowers are for, what their budget is, and so on. There's nothing more we can do about our pricing – we already have only a very slim mark-up margin.

Local scents

There's a Chinese saying, *mai fa goo leung chap juk yip*, 'a girl who sells flowers, adorns herself with bamboo leaves'. I don't usually put flowers at home; I see enough of them at the store, but, during Chinese New Year, which is a very important time of year, we do have flowers at home.

Flowers can represent many things. Apart from love, they can symbolise friendship. Also, nowadays, many people already own all the gifts you might give them.

Some presents, such as alcohol, are not for everyone, but, if you give flowers, it's a nice gesture. People are happy, and look good with flowers in photographs. I think it's precisely because Hong Kong's such a concrete jungle, that people want to give and receive flowers.

Chinese people have a long tradition of putting flowers in their houses to make them livelier, but the practice of putting flowers in the home, actually comes from the west.

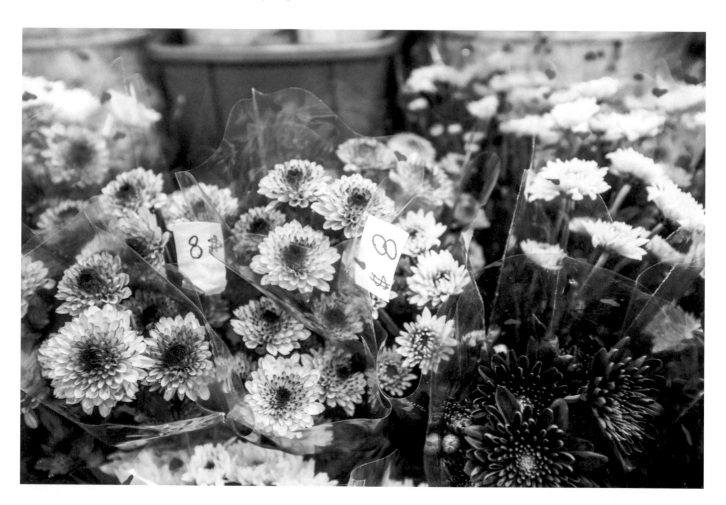

Traditionally, we use incense to worship our ancestors, but today more and more people are using fresh flowers instead. Chrysanthemums are used because they're cheap and long lasting; those, and Carnations, are our best sellers. Because of this, the Chinese don't like Chrysanthemums for other occasions. When foreign customers ask for a bouquet of Chrysanthemums, I ask them about the occasion. If the flowers are for Chinese friends, I tell them Chrysanthemums aren't right; and nor are white flowers.

To the Chinese, '8' is a lucky number, while a 'not good' number is '7'. If a customer wants to buy seven flowers, I want to know why. You see, Chinese people are very sensitive when it comes to the number seven. When a person dies, we talk about the seven days before, and the seven days after the death... On the other hand, '8' in Cantonese sounds like the Chinese character for getting rich [pronounced *'faat'*], which is why we like the number. The numbers 10 and 12 are not a problem, because they're even numbers. In fact, any number apart from the number seven is okay.

Bouquet of challenges

Challenges to us flower vendors? Sales volumes are decreasing at our stall. They're definitely not increasing, because more people are selling flowers than before, and, generally, people's buying power is not too high. Look at it this way – a lunch can cost HK$40 to HK$50, and people would rather eat than buy flowers. Flowers aren't necessities, they're luxuries.

Also, if you're a flower seller, you can't suddenly take leave. Unless it's raining hard or there's a typhoon, you usually have to be at work daily. The reason for this is that every single day we bring in flowers, which we have to sell off by the following day. We really have to plan our holidays. If we're going to go on leave, we buy fewer flowers to sell so we suffer fewer losses. You also need to be very careful when handling the flowers.

Sometimes we do think about changing our business, but we won't do it. Our stall is more likely to close down, before we make a transition to selling anything else. Besides, the mark-up isn't high for any types of products, so it's not worth it. I do have children. My daughter is 18, and my son is 15. Right now, they're studying, but I don't think they have much interest in continuing the family business, because they rarely help out. If other people were interested, we could let them try it out. But, they'd need to be able to stand for 10 hours.

There's nothing really special about being a vendor; it's just another job. But, I am proud when I do a good job – if I make a bouquet for a customer who appreciates it, for example... My parents are around 80-years old now, and quite content. Dad's only activity is going to work. In fact, he doesn't much like going on holiday and doesn't have other hobbies – like going for *yum cha* or hiking. The routine of doing the same thing every day makes him happy. ■

"I don't know if I have confidence in the watches we sell, but I do see a lot of foreigners and celebrities posing as models in our ads."

— Lai Siu-Fan, 48, Sign holder

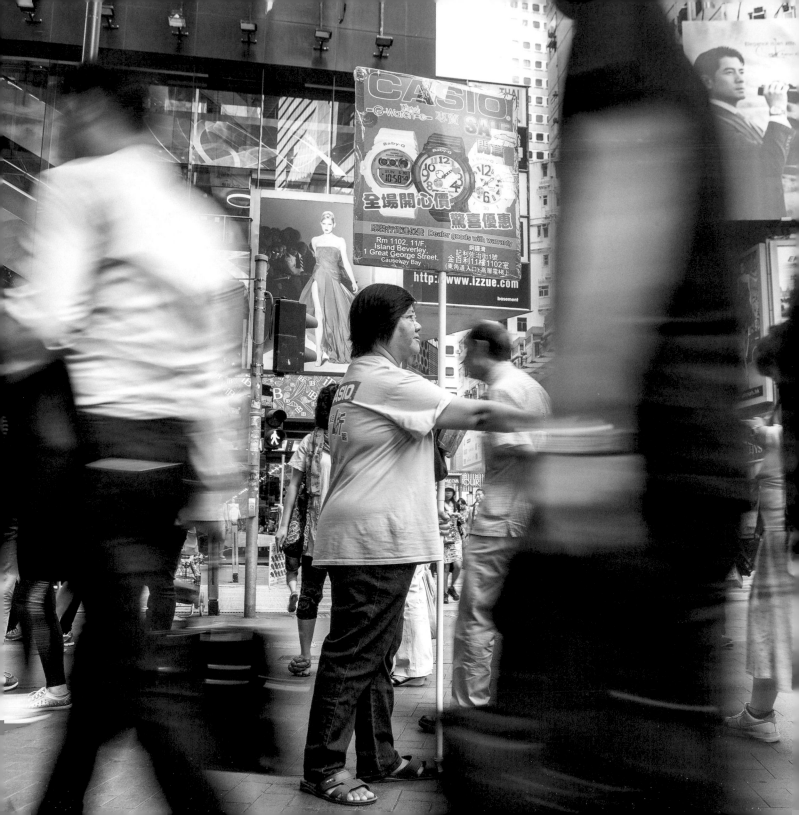

Lai Siu-Fan, Sign holder

For a job like this, there are no interviews. If you're able to stand, have the time, and want to do the work – you apply. Some companies only have us hold signs because they don't want to waste paper, but others also like us to hand out flyers. I hold a sign advertising a watch company, and hand out flyers to potential customers.

I don't know whether I have confidence in the watches we sell, but, I do see a lot of foreigners and celebrities posing as models in our ads. Also, lots of people do go up to the shop to actually buy the watches, and, from what I can see, sales are quite good. In fact, I myself wear one of their watches. I had to buy it myself – though they gave me 10 per cent off.

I'm not married yet, don't have kids, and am very happy with my job. Every day I come here, I get to chat with plenty of people, and see lots of people about. It's not too noisy out here on the street, it's alright – and don't think we're not professional!

I do this every day. I come at 12 p.m. and leave at 9 p.m. The company lets us have lunch, though, they aren't heartless. During lunch, we put our signs away or ask someone to look after them for us. Then we go to buy food, and find a back staircase nearby to eat it. We have to put the signs face down on the ground otherwise they're confiscated.

I'm paid HK$33 per hour. How much you get paid depends on which company you work for, and the more hours you work, the less per hour you're paid. The reason for this is that if you're working a short shift, of, say, three hours, you still need to pay for transportation, and it's not worth it if you're paid so little. If you have a longer shift, your pay is spread out more – so you get a lower per hour wage; but, you earn more in total which makes the travel expenses worth it.

What about the flyers? Usually, I hand out more than 100 of them a day. If I don't manage to hand out the entire pile, I take them back to the company… We don't

get paid more money for handing out more leaflets; and we normally don't get rid of them all. Whatever the agreed per hour wage is, then, that's it.

Sign language

There are many people holding signs here, and we're from different companies. I've been working for one particular advertising company for four of the five years that I've done this type of work. The ads don't change much; they advertise the same things they always have. I do think our signs are effective. See those shops located on the upper levels of the mall [points upwards]? Without these ads, no one would know that they exist. It's not like having a shop on ground level…

First, I did this job in Mong Kok, where I live, and now, here. I've been working in Causeway Bay for three years, in fact, and have been in this particular spot around Sogo [Department Store], though I've also stood across from here

in Jardine's Crescent for the longest of all of the locations. Wherever the company wants me to work, I go.

Across this line is the department store's property. As long as we don't step across it, we're fine. But, if it's raining or there's a typhoon, we do cross the line – to take shelter. Sometimes the security guards tell us to move away, because they have bosses too, but, when the weather's really bad, they normally turn a blind eye.

In my shoes

The reason we rest the signs on our feet is a sad story. Two of our friends were fined HK$1,500 because they put their signs on the ground. They took them to be litter bugs! In Causeway Bay, the Food and Environmental Hygiene Department says that sign holders who put their signs on the ground are littering, but, in Mong Kok, it's fine, because the head of the department there couldn't care less.

The Causeway Bay head is scared of people complaining so he makes us put the signs on our feet or else we get fined by the police. It's because we're holding ads. If we were to put anything else on the ground, like a suitcase, it'd be fine. Without the ad on the stick, we could also put the stick on the ground. There wouldn't be a problem with that either.

I used to be like the others, resting my sign on my shoe, but my feet hurt so much when I got home. So, I bought a sandal that's two sizes too big, and rest the sign on the edge of it. It really hurts to have to rest a sign on your foot for nine hours a day.

Shopaholics in Hong Kong

I don't think Hong Kongers live to spend, but Mainlanders do! Whenever they come to Hong Kong, they're on the lookout for brand names – LV purses or Gucci, and so on. For watches, they go for big brands like the ones at Shanghai [Shanghai Watch Company] or Prince [Prince Jewellery & Watch Co]… Our watches are not too expensive; they're more for common people. An ordinary citizen, even a student, can afford one.

Some people are shopaholics. In fact, there are quite a few of them. In the holidays, you see a lot of them out and about – their hands laden with shopping bags, especially in Causeway Bay and Mong Kok. Shopping makes them happy. If it didn't, they wouldn't do it! Also, people think 'You are what you wear'. You can't see how rich a person is, but you do see what they're wearing – and people like other people to think that they're rich. Maybe someone should tell them to go to see a doctor… If he can cure them, then that's okay!

Whether it's right or not, depends on how much money you have. Normally, if you're earning, it's not a big problem if you want to spend a bit of your salary. Of course, you shouldn't spend it all; but, just a little is okay. I'm personally very conservative. I only get a new watch after the previous one breaks down. I've worn this watch for two years, and it hasn't broken down once or needed to have its battery changed. It's quite long-lasting…

Telling compasses

If I could put anything on my sign, it'd be directions.

When people ask for directions, no one answers them – apart from us. Both Mainland tourists and foreigners ask us for help. They might ask where Times Square is or the World Trade Centre. Our job is quite useful. We're like a compass. We're not obstructing the street, we're contributing to society.

What kind of sign wouldn't I hold? It wouldn't be a political message – we don't intervene with that kind of thing; and there aren't any cigarette ads… I'd hold an ad for a sex shop – in fact, I'd hand out flyers for any business that the company asked me to, as long as it was legal.

I feel good about Hong Kong. It's a great place compared to other countries. People obey the traffic lights, and crossings are especially good. It's safe… whereas it's not in other countries like Vietnam or the Mainland. ■

ENTERTAINMENT

Chu Yin-Ping – Sampan tour guide
Selwyn Magahin – Street musician
Paul Garvis – Bouncer

"As a child, I was kidnapped and sold to a sampan woman, my adoptive mother, because she had no children of her own. Around the same time, she had given birth, but the baby had died."

— Chu Yin-Ping, 61, Sampan tour guide

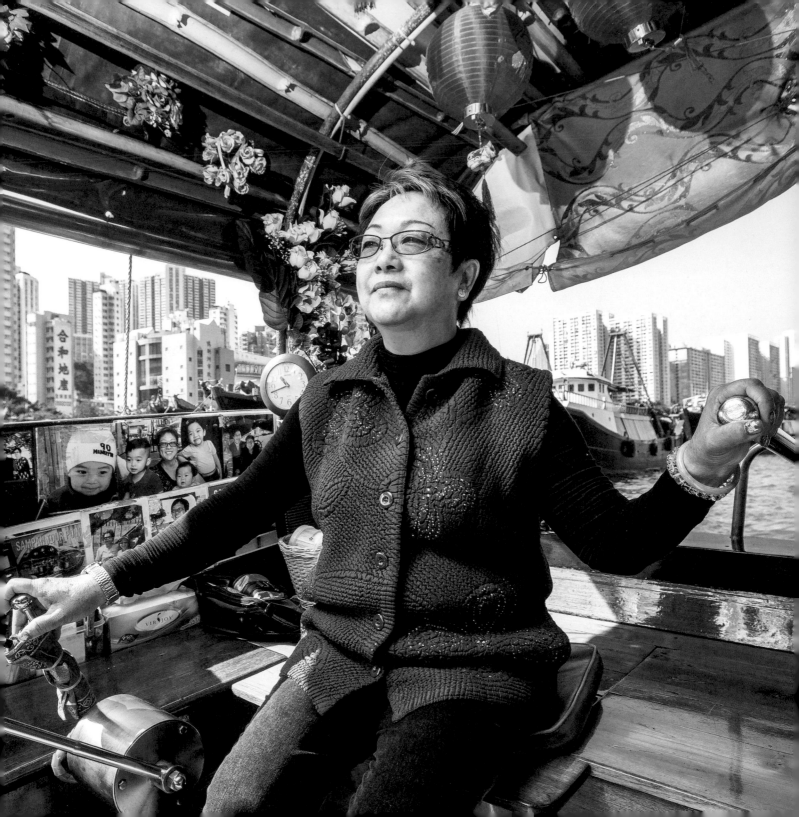

Chu Yin-Ping, Sampan tour guide

I'm in the sampan tourism business. I've also worked on the land as a fast food cook for students, and as a salesperson, but I enjoy working on the boat the most.

Stolen childhood

I grew up on boats. As a child, I was kidnapped and sold to a sampan woman, my adoptive mother, because she'd no children of her own. Around the same time, she had given birth, but the baby had died. Another boat person lent her HK$30 to buy me, because with no child my mother would have no one to depend on when she got older. You see, 60 years ago, boat people were too poor to get married. If a man came along and paid for your daily expenses, he was considered a husband. But he would leave when work took him elsewhere.

I have no idea who my real parents are, but I'm certain that my biological parents aren't boat people, because boat people don't sell their kids. Usually, boat people give their kids away to each other, if they don't have the means to feed them. Back then, a lot of boat people bought kids... The reason that I call Jun my sister is because we grew up together, and her mother fed me when my mother and I didn't have enough food. We called each other sisters as we still do to this day. There are seven 'sisters' altogether, all with different mothers. We're not biologically related. I am the youngest.

I had an adoptive father who gave me money for school. Because of this, I called him 'Father', and took on his surname. I was about seven or eight years old. As a Mainlander, he went to and fro for work, sailing around the South China Sea. Then, one day, he went to China and the border was closed, separating us. From what I know, father was a Western chef – meaning that he cooked for Westerners. He used to give us money each month for living expenses, and so when he left we had no one to depend on. We had no income, and so I ended up leaving school and rowing sampan with my mother.

Hard times

The old boats had no motors on them, they were rowed. That boat [points to an old photo] was owned by my mother and me, while this one is owned by me and my sister. It's 32 years old. Back then, there was no bridge to Ap Lei Chau, so we'd transport people across the harbour for five or 10 cents a time. Sometimes we wouldn't have enough to feed ourselves, and I would go to another sampan for my meals. Boat people are very nice people – if you didn't have enough to eat, and they did, they'd be happy to give you food. That's what life was like. The boat was our all, our livelihood. Everything was on the sampan, it was our home. Cooking, bathing – basically, everything happened on the boat. But there's a huge difference between the boats then and now. The old boats were much smaller. You could put very few things in them, and the passenger capacity was less too – you'd need two old sampans to match the capacity of the new ones.

We slept on the floor of the boat, and, I can tell you, it's much more comfortable to sleep on this one! There were no wooden benches on board, we only had wicker chairs. At night, we would stack up the chairs, wipe the floor clean, and then cover it with a bamboo curtain. We'd cover ourselves with blankets, close the curtains around the boat, and go to sleep.

The reason we slept on the boats is because we were 'Boat people', and very poor. We didn't even really bathe. We just had a pail of water that we used to soak a towel in, before rubbing down our bodies; the water we had left was used to clean the floor. Bathing and showering are relatively recent things, from the time when showers were built close to the docks…

'*Dai goo leung*'

Some of the females weren't literate, so how else could they make a living at times than to sell their bodies? The sex workers were called *dai goo leung*, meaning 'big sisters'. They weren't respected by land people who didn't know them, but after the exchange, the ones who did, the customers, would treat them to meals, and take them out to have fun. Those customers really enjoyed the company of *dai goo leung* because they were naïve sea people who made them laugh.

There were a lot of misconceptions about *dai goo leung* among non-customers – that *dai goo leung* were very bad people, who were ruthless for money and food. Selling bodies was, in fact, a way of feeding parents and younger siblings.

The *dai goo leung* were very different from the sex workers of today. There was no make-up or lipstick, because there wasn't the money for it. There weren't really nice clothes, just a traditional *cheung saam* type of outfit and hair in a long braid to receive customers.

Winds of change

Whatever our mother did, we followed, but once we grew up, got married, and had children of our own, we didn't want our children to go through the tough times we had had to.

The government gave our children free schooling, and we tried to earn as much money as we could for them. We didn't want them to live on the boat like we had. At the very least, land people usually have access to better education, and are more literate. Even if boat people can speak well, we can't read or write.

There have been huge changes in Aberdeen. For example, the typhoon shelter only came about 30 years ago, and back in the days before motorised sampans, there were few large boats here, if any. The water was normally very still, there were no waves. Now that there's been so much reclamation on both sides of the water, the channel's much narrower and the waves are higher and stronger, and no one's able to row here any more.

One year, back in the days before this was a typhoon shelter, there was a very strong typhoon that destroyed a lot of our boats, so we demanded that the government build an enclosure to protect our homes. Typhoons used to be very destructive here. We'd have to take down the

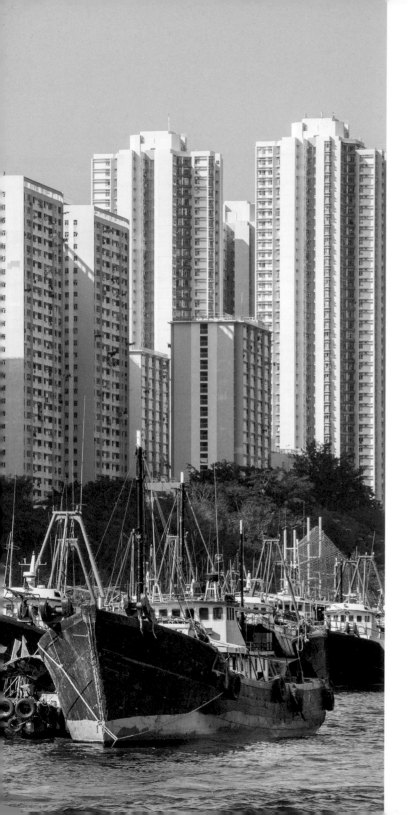

cover of the boat, fold it on the deck, then dock the boat. After this, we'd head to the land to take cover.

I remember us running into the Tin Hau Temple, to the goddess of the sea, who we boat people revere whether we fish at sea or pilot a sampan – but, if you were to ask me which religion I am, I couldn't tell you. We believe in Tin Hau and *Kwun Yum* [Kwan Yin, in Buddhism, an enlightened being who forgoes nirvana to help others become enlightened] but we're not an organised religion like Catholicism. We simply believe in our gods in our hearts – for peace of mind.

At the temple, there were people handing out rice and other foods. If our boats were destroyed in a typhoon, then Christian groups would come and help us, giving us food, rice, flour and a place to shelter on land. When Hong Kong was still a British colony, we were treated quite well.

Running a tight ship

In Aberdeen today, there are fewer than 100 sampan people, and in Yau Ma Tei and Sai Kung there are a few, though in Yau Ma Tei people are leaving. In today's money, it costs several hundred thousand Hong Kong dollars to buy a sampan, but back then, they were only a few thousand dollars.

Every three months, we have to maintain the boat, which costs about HK$3,500, and a month's worth of petrol is about HK$2,000. You have to keep the motor of the boat running when stationary, because if you were to stop the engine, the boat would be carried away by the

waves. If you don't have the engine on, you need to tie the boat to the dock. However, the harbour patrol fines us if we tie the sampan to the dock during the day. We're only allowed to do this at night.

You need a licence to pilot sampans and have to go through an examination. Without this licence, the harbour patrol will fine you. But, even with the licence we're not allowed to leave the typhoon shelter. The licence we have is only valid for the typhoon shelter in Aberdeen. In the past, when we still rowed the boats, we could go as far as Cheung Chau.

Seafood, glorious seafood

It is safe to leave the boat next to the dock at night. Other boat people won't steal from us. We're satisfied if we're fed, we don't want more. I buy crab for my kids, and still cook 'Typhoon shelter crab' for them, but not so much for myself… Perhaps it's because I've eaten so much of this type of food that I don't care to eat it much any more.

'Typhoon shelter food' got its name from land people who saw us cooking the fish, clams and shrimps that we know how to cook best. They associated our food with the typhoon shelter, so they named the dishes 'Typhoon shelter clams', and 'Typhoon shelter shrimps'.

Today, fish is our main source of nutrition. Even my grandchildren love to eat it. Being the most important dish at every meal, the fish dish is always first. Then comes the vegetable dish, and lastly the shrimp and crab dishes – which are extras.

Cooking on the boat is really simple. This, here, is our kitchen [she tells her husband to stand up, and lifts up the cover of a bench]. We have one pot, and a wok. Nowadays, we use gas stoves, but in the old days, we didn't have money for gas so we used firewood lit with matches, as there weren't lighters back then. Boat people who were a little better-off would burn coal, but us poor people would look for branches and dry them in the sun before burning them.

It was very simple. We cooked in a simple way, but the food we ate was no less tasty than the food that was cooked on land.

Joining oars

Another change that has occurred for boat people in Aberdeen has been getting into the tourism business. There are three docks that do business with tourists here. The other docks in Aberdeen don't just focus on tourists as we mostly do. Instead, they taxi fishermen, and others, around the harbour.

'Big Bus' [a well-known tour company] partners with us. A few of us older sampan ladies registered a company called 'Ocean Court' with the government, because we want to be independent and don't want to take pensions. But just because we're associated with them, it doesn't mean that we can't do other business. We aren't controlled by them, we're free to do what we want.

It happened like this: the person responsible for the tour company approached us, knowing that our business already consisted of tourists. He asked if we could give rides to their customers, who would already have paid by

the time they got into our boats. We said 'Yes', because we want to promote our culture, and preserve it. They asked where we would take the tourists, so I gave them a sample ride and they were very interested, and partnered with us as a business.

On the tour, we take the tourists to see places within the typhoon shelter that show the culture of boat people. We show them how boat people lived on the water, though right now, boat people live a much better life with TVs and washing machines – everything. Back then, we only had oil lamps at night. We tell the tourists how much our lives have improved.

We don't collect money from the tourists – the sampan tour is part of their package. The tourists hand us their tickets from the tour company, and at the end of the month, I take the jar of tickets to the company and collect our earnings.

Business has improved a little bit through the partnership, but if you talk about standard of living, I think it was better before. Comparing HK$100 I earn now with HK$50 before, the HK$50 was worth more 40 years ago due to inflation.

The good old days

A lot of these postcards on the 'wall' of my boat were taken a long time ago. Tourists who are visiting Hong Kong for the first time would never think that they show the same places that they see today; but people who were here 50 years ago, perhaps as sailors, might recognise the old Hong Kong.

Sometimes, when I give tours to the older cruise ship tourists, I feel nostalgic because some of them have been to Hong Kong, sometimes 40 years ago, and talk about what it used to be like. Usually, they say that they no longer recognise Aberdeen… It's actually possible that I did business with these people back then; and I feel very close to these tourists. There's a sense of familiarity as if we're old friends, because of the memories we share. Sometimes, they come back for another tour with their children before leaving.

Even though I'm not literate and have had no education, my understanding of the world is no less than that of my children who have. The reason is that we illiterate boat people interact with others. We can't read or write, but we can speak, and with foreigners who don't understand us we use hand signals to communicate.

All I want is freedom

I've always lived in Aberdeen, but we live in public housing now. We used to live in Wong Chuk Hang, but then everyone was moved out because of the MTR station they're building there. The housing estate I now live in is called Shek Pai Wan Estate.

I work on the boat during the day, and could sleep here at night; but my children urge me and my husband to sleep on land, saying it's more comfortable. If you ask me, though, I miss the freedom of the boat. Public housing is very small, about 300 square feet, and there's barely space for six to seven people. Nevertheless, most of the sampan people of my age do live indoors. We're the last generation

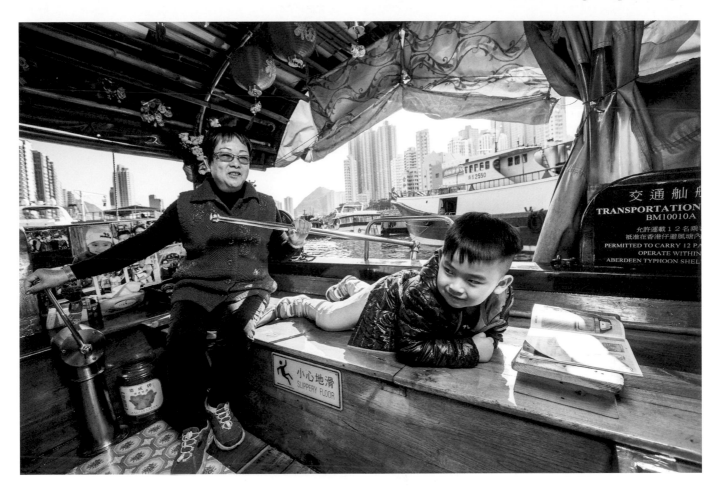

of sampan ladies. Mind you, my mother died in her 90s, and my sister's mother is 90-something and still alive.

If you ask many of us, we like being on the boats, because of the sense of freedom. We're a simple people, and have a hard time adjusting to the rhythm of life on the land. We aren't as stressed out, we don't scheme, and we aren't sly like land people. We're simply genuine people...

What inspired me to decorate the boat this way? In the front and middle, I change the decorations according to the festival. For example, when it's Christmas, I decorate the boat with Christmas decorations – anything suitable for the holiday season is fine. When it is Mid-Autumn festival, I hang lanterns.

Other than that, because fish and shrimps are auspicious to us boat people, I have those types of decorations as well, in the back of the boat. They are our 'cultural decorations'.

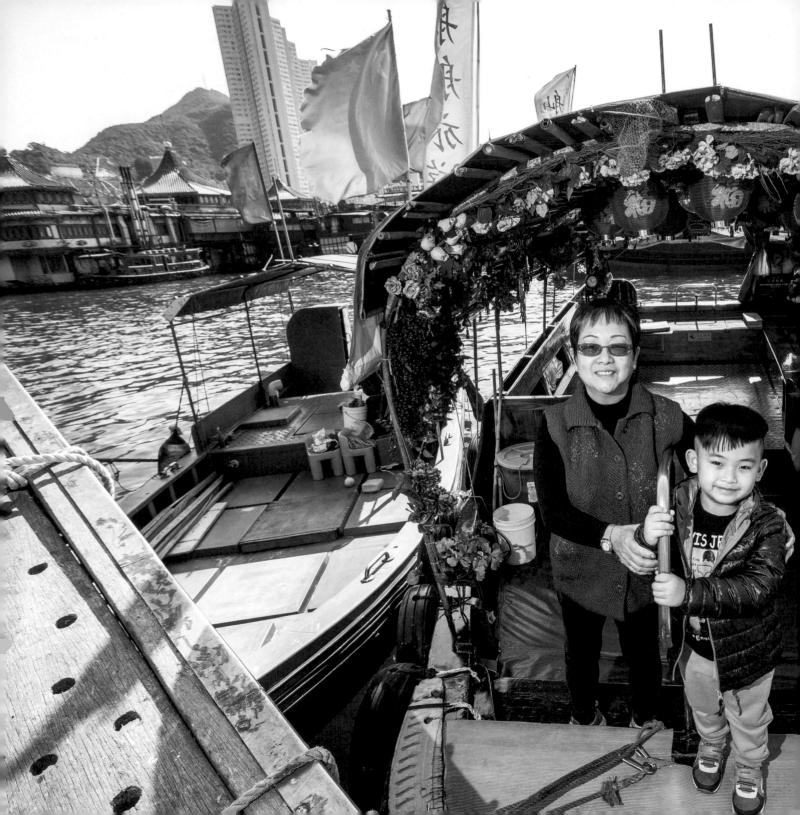

Looking to the horizon

How do I feel about the future of the sampan? I don't really think about the future. Boat people don't. We live for the present. For example, you see me now, I am healthy and lively. Tomorrow, I might also wake up healthy, and feel very happy that I can earn another day's money. But the day after tomorrow? I'm not sure. I won't ask, because I don't want to ask.

If we get sick, we aren't like other people who have enough money to go to private doctors. We need to depend on the government. With public healthcare, waiting times are really long and you're likely to die before you receive treatment…

So I don't think about the future. Boat people of my generation don't. Our children do, but we do not. ∎

"I busk for fun, and because I don't want my fingers to forget how to play."

— Selwyn Magahin, 33, Street musician

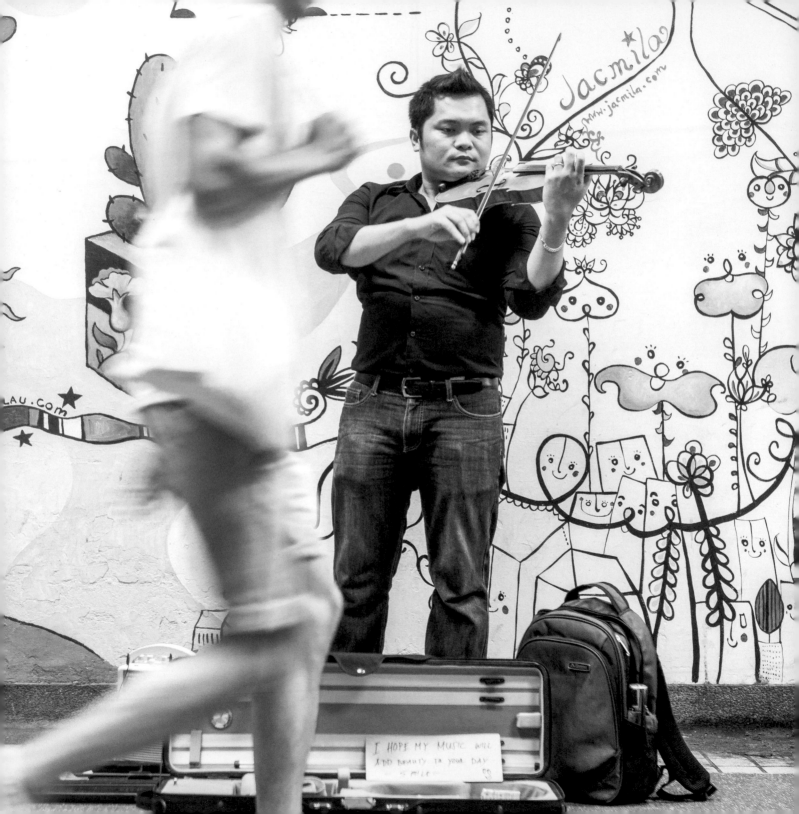

Selwyn Magahin, Street musician

Hong Kong is a much better place to earn money than the Philippines, so I'm here with my Filipina wife and our baby boy. I've been in Hong Kong for seven years, but don't have Permanent Residency. I work under contract for the boss I drive for – I'm a driver by day and a street musician by night.

For better or worse

I studied physical education, health and music at university. I went to Southern Luzon Polytechnic College, and have six units of a master degree from the Philippine Normal University. In Quezon Province where I'm from [three hours' drive south from Manila], I was a full-time music teacher to primary and secondary school students. In 2005, I left the Philippines for Macau with my girlfriend [and future wife].

As a Filipino in Macau, you can have a landed visa for 30 days, then 20 days, then 10 days. The application process is difficult, but there are lots of Filipinos – most of the workers in the hotels are from the Philippines; and lots of Nepalese. I worked for a cleaning agency, cleaning the windows of high-storey buildings. There was no training. Having enough strength to carry the bucket was considered to be enough. When my girlfriend got hired as a domestic helper for a Chinese family in Hong Kong, I followed her here. She and I had been friends in the Philippines, and had dated for almost two years before we'd left. We married in 2007 at our church in Sheung Wan.

My wife is a 'super mum', because she works as a helper, and takes care of our baby. She's now working for Americans, while I have been with a Chinese family for one and a half years. We are fortunate that my wife's employers support my wife and baby. My wife lives with them, though we also have a small apartment in Kennedy Town. As of now, we're not thinking about having more children. It's very expensive, but if it's God's will, then we're happy.

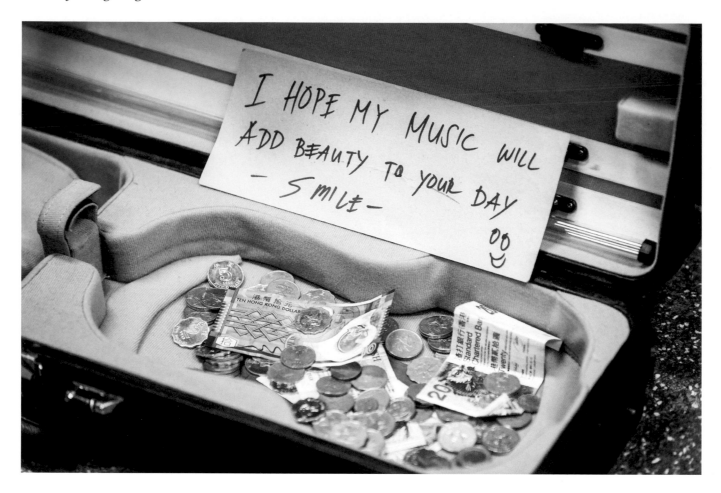

Prodigious talent

The first musical instrument I learned to play was the trumpet. I learned from a secondary school teacher when I was in Form One.

I started playing a lot when I was 13, and at 16, when I was converted to the Pentecostal Missionary Church of Christ, I prayed to God to give me talents to glorify him more.

God has given me these instruments and has multiplied my talents. Not only do I play the piano, but I play the guitar and the flute. He's also given me skills for the sax and violin. It's like magic, but that's how God is. Even I was amazed that I could play so many instruments. And the Chinese are certainly amazed, because learning how to play musical instruments is very expensive in Hong Kong.

But do I come from a musical family? Some of us can sing and my grandfather plays a small guitar, like a

balalaika… I have a brother who plays the guitar. I'd say that half are musical.

Musical arrangement

I've been busking with my violin for two months, but I'll bring along my trumpet or sax if I'm in the mood for jazz. If it's the sweetest of music that I think people want to hear, I bring my flute… I busk for fun, and because I don't want my fingers to forget how to play. The street is a practice room for my music. My wife is a soprano singer and has perfect pitch, so she shouts at me if I'm not in tune at home…

I busk from about 6.30 or 7 p.m. to about 9.30 p.m. on weekday evenings, before going home to help my wife with the baby, and sometimes I also busk at weekends, though if my wife requires a check-up then I can't.

Fridays and Saturdays are usually good days to busk, but there are times when Mondays to Thursdays can be good too… You have to look at the calendar. If there's a holiday, like the Moon Cake festival, then three days before it is good. December the 15th to the 25th is good, and New Year, and Chinese New Year too.

Tonight, I played the Canon in D, "Halleluiah" by Leonard Cohen – it's on one of the Shrek movie soundtracks – and then another five songs, from the soundtracks of different anime movies. You need to pick the music for the moment. Or if I have a new song I want to master, I'll keep on playing it too.

I use my phone for my backing tracks, and a small amplifier. Sometimes there are people who play with me.

There is a man from England, called David, who is a very good folk fiddler, or a cellist also from the UK. If they're accompanying me, I don't use the backing tracks from my phone.

Takings range from HK$200 to HK$400 for two hours, every time I go out; so, an average of HK$300, three times a week. But there are times when the police tell me to go home, because people are complaining.

The sound of music

People are very different. Some appreciate your playing, and others don't. But the people who get angry, saying that it's just noise, are nothing compared to the people who enjoy your music: who dance and sing along in front of you, or who slip you written notes saying things like, 'We would love to hear more. Thanks for your beautiful violin Canon in D', or this one [removes a piece of paper from his wallet], delivered with a HK$20 bill, 'Hi Stranger, thanks for making Hong Kong a better place'.

When I receive this type of thing, I feel like I have made a thousand people happy… You can see that kids really enjoy the music, and that most Chinese and expatriates like the violin… People coming from their offices feel down and are tired, but when they hear the music, their energy soars.

In the Philippines, busking is only for beggars, it's not a respected profession, but in Hong Kong the government has been reviewing its law about performing on the street, and says that it is encouraging performers.

Look at Central Market – look at the art. Music is also

an art. If you have an exhibition there, and music, it's perfect!

The market is one of the three places where I perform. I also go to the subway area near the City Hall, and the walkway towards the ferry piers. Sometimes, there are other musicians or beggars there, which makes me feel very uncomfortable. If I think I'm snatching money from people in need, I move elsewhere.

Ebony and ivory

In the Philippines, I was in a marching band with my colleagues, but I never busked. They would applaud me when I played well, but in Hong Kong, there's no applause. You have to swallow your pride.

There's also racism. Sometimes, when I'm driving I feel discriminated against. A Chinese will allow another Chinese to park sooner than they will let me as a Filipino. They can park – but you cannot. They call us *'Bun jai'* [a derogatory term for someone from the Philippines], and if you're in a crowd with them, they look at you and pull away, like you're a leper. It happens… Cities are very mixed and there is a clash of cultures, ideas and religions. But respect should be there for the sake of peace.

On a side note

Now we have the baby, there's no fixed time for sleeping or getting up, but I tend to take a bath around 6 a.m. and then start working between 7.30 a.m. to 5 or 6 p.m. You can only work 12 hours a day – that's all you've got.

There are days that the family I work for is very busy,

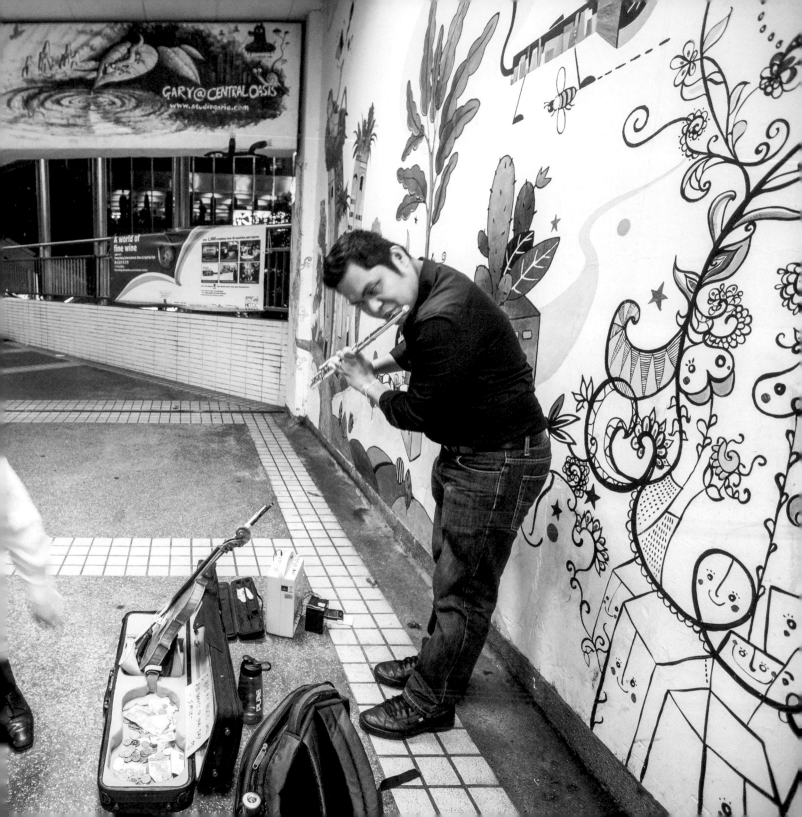

and there are days that are quite quiet. I've seen quite a bit of Hong Kong, driving between the New Territories, Kowloon and Hong Kong Island. This isn't a problem for me. It's good to have different employers and routes. If you were to stay 10 years with one boss, it'd be boring: just market, office and school – you wouldn't know anything about anywhere else. They know that I play my instruments at church, and because of this they tell me a week in advance if they need me to drive on a Sunday, so I can make alternative arrangements with my band mates. At church, I play the piano, guitar, flute and violin.

Time does not permit me to do more with music here. If you want to work in a band, you have to have a HKID card, and not be under contract like I am. As it is, I often practice trills and play my violin while I'm waiting in the car for my boss, and I play at church as well as on the street.

Busking on the street has taught me a lot. It's taught

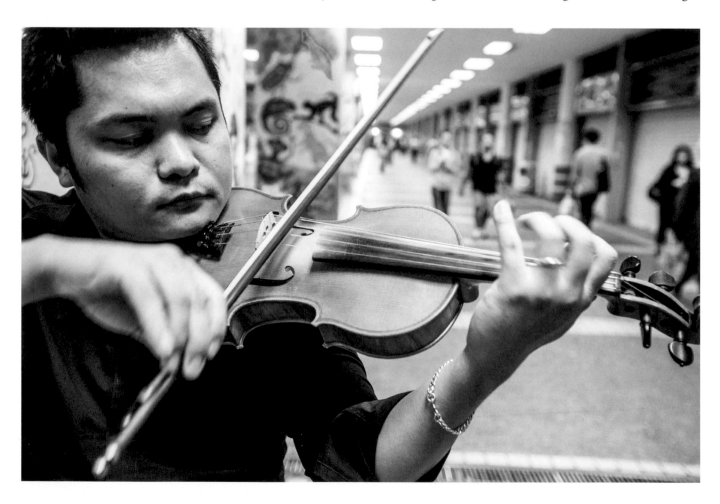

me to be even more passionate about my craft, and music, and has given me a lot of confidence. My passion is music, and my goal is to serve God with my family, and that's it.

Tuning out

The reason I am here is to earn money, but I want to go back to the Philippines in five years from now. It's just a plan, because life changes and maybe in the next two years things will change. But if I do go back in five years, I should still be able to teach music.

In my view, the happiest people in the world are people from Havana, Cuba – places that have a lot of music; and the saddest people in the world are the Chinese people. They have millions of dollars, but so many worries. ■

"Wan Chai is a place that attracts a lot of people from different countries. It's not a very Chinese place. I think it's one of the last places to retain its colonial character."

— Paul Garvis, 42, Bouncer

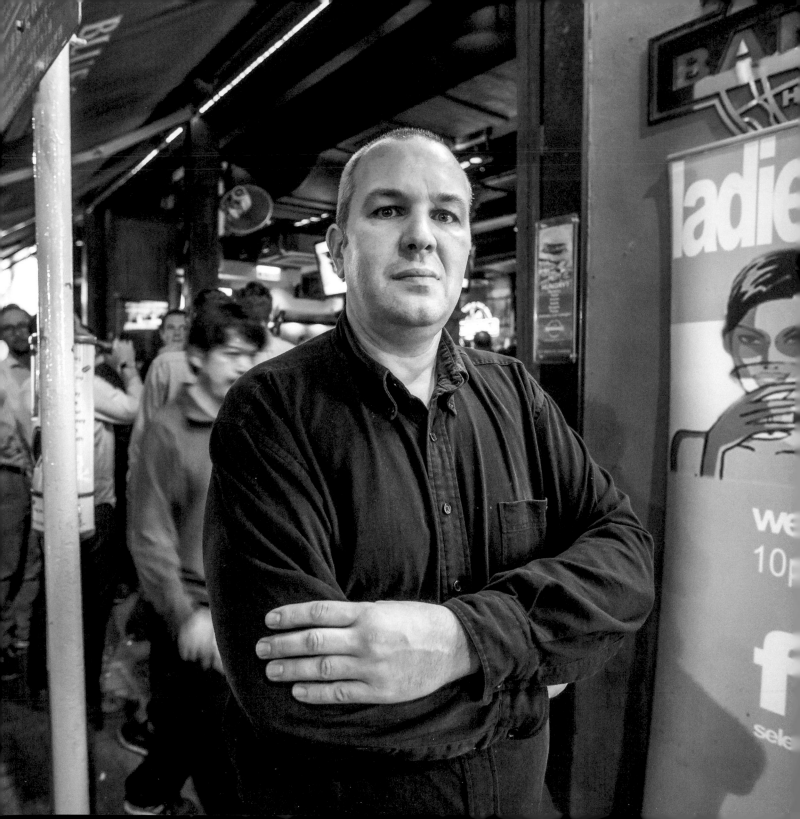

Paul Garvis, Bouncer

I'm originally from London, but with my father working as a diplomat with the UK Foreign and Commonwealth Office, he was posted to many different countries. We lived in Africa, the Middle East, America and Pakistan, but I did all my schooling and college in the UK. So, even though my family moved around, I had a sort of constant.

One of my dad's postings was Hong Kong. He arrived in 1990, and I followed a few months later. By then, I was about 19 years old. Originally, I was coming over for a six-week holiday, but I ended up spending 14 years here [1990-2004]. From 2004, I was out of Hong Kong for nine years, but I came back three months ago.

An Englishman in Hong Kong

I just seemed to like Hong Kong. It felt homely to me after the constant travelling of my parents – three years here, two years there, four years somewhere else. I had had friends, but I'd lost contact with them… Being in Hong Kong, I found that I settled down quite easily. It was new, it was an experience – and I liked it!

In those days, I was working at the British Trade Commission [now the British Consulate]. I started off as a driver for the British Diplomatic Service mail office, and then moved on to some clerical work. I was also in accounts, and then I did British Citizen passports, and British National Overseas passports. I was with them for 11 years, from 1993 to 2004, and was in my early 30s when I left.

Back in the early days of being here, being a British colony, there were lots of British people; but, as it got closer to the handover a lot of them left, not knowing what the Chinese were going to be like when they came in. It felt strange that Hong Kong was going to be changed into another country. Everyone was unsure. I wasn't sure if I would stay if the Chinese came in *en masse*, but the Chinese came in on the 1st of July 1997, and nothing happened.

Securing work

The work as a bouncer started in 1998. I fell into it by accident. Somebody said, 'Do you want some extra work? I know a company that's looking for some people'. So I went along, got my security licence from the police and started working.

To work as a bouncer you need this licence, and you have to renew it every five years when you also do a one- or two-day refresher course. Once you get the certificate from the course, you take it to the Hong Kong police, and they issue a licence a few days later, after they've done their background checks. It's HK$160.

The other thing you need to have as a bouncer is patience. Some people can be obnoxious; they can be difficult. But just because someone does something, it doesn't mean you have to throw them out. You only do that if there's a good reason for it – for example, if they're smashing glasses or disturbing other people. If they try throwing punches, then you really need to get them out.

You also need to be able to adjust to the work times, because we sleep by day and work by night. If you weren't able to adjust to the time difference, you wouldn't be able to do it.

In the line of duty

I live in Tuen Mun, and get a bus to work. I leave two hours prior to starting work. I get in, clock in and change. My hours are 6 p.m., 7 p.m. or 8 p.m., and can go on till 4 or 5 a.m. But because I worked for quite a few years as a night porter, I'm used to it.

My night starts off with seeing who's on duty, and seeing that everything's ready for the night. I start outside and wait for customers to come in, but I also work inside. There are two of us. Between us, we meet and greet, and watch, and make sure that everyone's alright, that there are no problems. I can tell how people are, though they have two sides to them… A person who comes in and hasn't started drinking is fine and makes sense. Later on, after three or four hours of drinking, they might start acting quite weirdly so I stand close by and observe them. They might keep moving a glass around or ordering a drink when they already have one; keep on repeating the same things or doing things like touching their hat or playing around with their pocket. They might be staggering…

Often, I stand by the door, and I walk backwards and forwards. I can flash my torch to attract my colleague's attention, and vice versa. The torch is handy to signal to colleagues or, because it's pretty dark, to see if someone's dropped something. I also talk to some of the customers, and talk to them for 10 or 20 minutes, maybe half an hour.

I keep on moving because I'd get stiff if I stood in one place. Sometimes when it's quiet, it can be a bit boring, but I'm used to it. I watch people walking up and down the street. I know a lot of people around Wan Chai…

Most of the time, I don't have anything to eat until I get in to work. There's a staff meal there – and so my breakfast is my dinner. We also get a 45-minute break to have a meal and a walk around. On this break, I have my dinner, and then when I finish work, I go to 7-11 and get a sandwich before catching the bus back home. My days are spent sleeping.

I work six days a week, and unfortunately in this industry we don't have statutory holidays. If I want a holiday, I put in a request and they find someone to cover me.

In years gone by

I solely work for Joe Bananas now, but from 1998 to 2004, I worked a few times a week for a company called Signal 8. At the same time, I was also doing my day job Monday to Friday at the British Trade Commission. We'd be seconded to a particular bar or club – it could be in Wan Chai, in Lan Kwai Fong, in TST [Tsim Sha Tsui]; or be asked to do close body protection, or big events. I've done big musical events – though some years ago now – for local artists and big top bands such as the Rolling Stones, Santana, Prince, Mariah Carey, Jennifer Lopez…

Each place is different. Lan Kwai Fong is a very small, tight area, with a lot of bars. TST is quite vast, with quite a few bars, especially if you go off the beaten track. Wan Chai is quite a large, open place, so there's a little bit of a walk to get to some of the places – but then again, you're not that far. The places I have worked at are Dusk till Dawn, Mes Amis, Carnegies – and some of the old places which are not here any more.

I quite enjoyed working at Mes Amis, where I was for four years on Wednesdays, Fridays and Saturdays. I liked being able to talk to people and make new friends – just be around people… A lot of the people I knew then are

still around. They come out, and sometimes we go out for a drink. I'm not really a drinker, but after work and clocking off I might have a couple of drinks before going home.

Dangerous liaisons

In the past, the girlie bars or 'Suzie Wong' places would have been all the way up and down Wan Chai. Most would have had girls tempting in the sailors. There's only about seven or eight of them left, and even those are closing down, maybe one a year, due to rising rents. Some are owned by foreigners or consortiums. There are a few places that are owned by one person.

Because they're so expensive, people don't want to go to them. The guy goes in and buys a drink, then the girl gets a drink, and then he finds that it's cost him HK$300 for two drinks. They do have price lists, but often the customer gets tricked. Sometimes he gets drunk, and then he finds he has a credit card statement for a few thousand dollars.

A lot of the customers who come into Joe Bananas say that they've been ripped off, and it does sometimes happen that men are drugged by those who are really desperate for money. The girl flaunts herself, takes the person back to a hotel, drugs them – and then the next day everything is gone. The girl just moves on to another location like LKF, TST, Mong Kok... The drinks of more men than women are spiked in Wan Chai, because some of the girls are doing it to the guys, whereas in other countries, it's the guys who are doing it to the girls.

One night in Wan Chai

Wan Chai is a different experience if you're a man or a woman. I think for a Western woman to be around here is a bit unnerving, especially when you see all the girls [sex workers] in the bars, not knowing what they are there for. The men know full well what they're there for – and that's why they come. If you stay out here until 10 or 11 p.m., you start to see the nightlife change. That's when everybody starts coming out. The girls come from the Philippines, Thailand, Vietnam. Those are the main areas. The girls move around from bar to bar, going in to see where is busy. The bars in Wan Chai have an open policy towards the women. Anyone can go in, within reason – except for some of the African girls, because a lot of them are actually refugees.

We have police raids – when the police come in and you have to turn the lights on and the sound off, and they check everybody. Normally, it's just the tourists – the 'girls'.

They're checking to see if any of them have overstayed. Some of them are police, some are immigration officers, and some are environmental health officers, because they check the premises as well. They're also looking for under-age people, and sometimes have dogs with them to sniff out drugs.

From what I've seen, there's not much in the way of competition between the girls. I think everybody knows the rules of the place: go in, sit down, have a drink. Then, a customer goes over and talks to them. They're not going to go up to them and grab the person. That's soliciting.

But…

Wan Chai is probably a lot calmer than other red-light districts around the world. People are civilised, and you can go out and just have fun. Local people come to Wan Chai in the late afternoon or evening after work to have a couple of drinks and then move on, and then the next wave comes in – the nightlife crowd.

I don't worry about things like firearms. The only people who have firearms in Hong Kong are the police. The tricky thing is, of course, the bottles – a person taking a bottle and smashing it. Before, when the British forces were here, and they allowed the American sailors and all the other ships to come in, there were guaranteed to be a couple of fights in Wan Chai or Lan Kwai Fong that would end up with someone hurt. Sometimes it would be a fight between two ships or the British forces, with two parties testing their strength against each other.

Most of the time, alcohol was the problem, and being a long time at sea. Often, they were fighting over a girl. I've seen people outside, punching each other endlessly – and about 12 to 15 years ago, there was a fight inside Joe Bananas. Somebody smashed a bottle in someone's face, and their face was half off so they had to go to hospital. But this rarely happens nowadays.

Window on the world

The Rugby Sevens [in March] is quite an exciting time because there are a lot of people inside and outside the bars. But we can't always predict the numbers or the atmosphere. You have thousands of people around Wan Chai, and they're all different nationalities. Are they rival groups? Maybe one set is German, and another set is English. You don't always know how they're going to get on, or if they are going to behave themselves.

Wan Chai is a place that attracts a lot of people from different countries. It's not a very Chinese place. I think it's one of the last places [in Hong Kong] to retain its colonial character, and the British made Hong Kong what it is today. Hong Kong is fortunately still open compared to China. Nothing much has changed here since the 1960s and 1970s. But in the 50s, 60s and 70s, it would have been local Chinese in the girlie bars. Now, it's the ethnic groups.

You'll see Chinese during the day, but at night, unless they've got friends out, you won't see many of them. They might be out in a big group, but when they come in they want to be somewhere quiet. We might have the disco music blaring and offer them a table, but they don't want

it because it's too noisy and they want to talk and sit to eat, so they move on elsewhere.

Occasionally, we see Mainlanders – but not often. Sometimes the tour guides take them over to the shops in Wan Chai. They're probably getting a commission from the shops over on Johnston Road…

Cultural understanding

Because I'm white, a lot of people are unsure about who I am. Some think I'm the owner of the bar, and others think I'm the manager. Other people think I'm just someone in a black shirt – a customer. A lot of people expect you to have loads of money and a high-end job if you're white. But no, I've never liked being in an office, and although I did work in an office, I felt confined. There were more Caucasian bouncers in the past, but a lot have retired or moved on to other jobs, and I might now be the only Western bouncer left in Wan Chai.

In 2004, I decided it was time to move on, but not out of Asia, so I lived in the Philippines for four years. I operated a small bus, a *jeepney*, and employed a couple of drivers in the Luzon area. I operated that for about four years, but the costs were going up, and I had to sell up.

Then, I went back to Tavistock in Devon in the UK for five years. It was very strange. I felt like a tourist in my own country. I got a job in a hotel, working as a night porter, and then after a few years I started helping with their outside catering. At one point, I was doing the logistics for weddings of 200 to 250 people, gathering all the plates and cutlery and so on, and shipping it over in a vehicle, and then travelling up to the location, setting it up, doing the service. I'd studied catering for two years before coming out to Hong Kong as a teenager.

I don't really feel like I'm a minority in Hong Kong – and I feel like I'm a Hong Konger more than a British person. I've had three kids from a previous marriage. My former wife was from the Philippines, and my current girlfriend is from the Philippines too – I think Chinese women still keep to themselves, perhaps because of ancestry and family pressure.

My son is 21, my eldest daughter is 19, and my youngest is 14. The two daughters are in the UK. One is at university and one is at school. My son lives with his mother in Hong Kong. My parents now live in Devon, and I have a brother who works in Dubai, and a sister who lives in Ottawa in Canada. So we're all over the place. This background has probably given me a better understanding of different cultures, and that the UK is not the only place in the world.

A lot of people have never been abroad, so they probably don't understand the behaviour of certain people. Some might find someone's behaviour strange, but I would probably think it normal – unless something else was involved, like alcohol or drugs. ■

SERVICES

Yam Man-Hong – Chop & business card designer
Chan Shu-Tong – Watch repairman
Dai Xiao-Qin – Shoe shiner
Arhin Francis Mensah – Security guard
Ng Siu-Wah – Gas delivery man
Harinder 'King' Singh – Pizza delivery man
Chiu Koo – Villain hitter

"Because chops are etched by a particular artist, no two chops are ever the same – they're like signatures."

— Yam Man-Hong, 35, Chop & business card designer

Yam Man-Hong, Chop & Business card designer

I grew up on this street [Man Wa Lane in Central]. My dad had a shop here and when I was little, I helped him. So I'm no stranger to these stones or printed materials… I'm very familiar with them.

My dad's still working… he works on the street adjacent to this one. He wasn't actually the first in the family to work in this profession – that was my grandfather on my mother's side; then my father, and now me. Previously, dad was working in the 'back end' of the business, but now he works in the front end. Now that I also have my own shop front, I sell as well.

Something for everyone

This street is known for its business cards, and personalised letterheads and envelopes. However, my wife and I focus mostly on stone chops. Here in the front are ordinary chops for the tourist on a tight budget, who's pressed for time. People who buy these usually want them ready in one or two hours. To my right are higher-grade chops in different styles. Behind me are more expensive chops made from precious materials, though they're smaller in size; and lastly, to my left are rare and large-sized chops for the collector.

There are quite a few collectors in Hong Kong. The stones are collectible because they come from Fuzhou [the capital of Fujian Province] in the Mainland, which is renowned for producing stones for chops called *Shau Shan Shek* [mountain carving stone]. The central government has banned the mining of these stones in Fuzhou, so the ones which were brought down here to Hong Kong before the ban are what remain.

Shau Shan Shek is becoming more and more expensive, because people are speculating on it. The same product can be sold many times over, and they become more expensive every time. It's a bit like real estate in Hong Kong.

An authentic signature

Chops originated in the Qin Dynasty [the first imperial

dynasty of China from 221-206 BC]. Back in the days of the Qin Emperor, only royalty or magistrates used chops. Chops were used for authentication purposes and symbolised authority, but metals were used rather than stone.

Up until the Qing Dynasty [1644-1912], artists used chops for authentication purposes, like a signature, and ordinary people began to use them as well. Other than the Chinese, the Japanese use them too. At one point, the Japanese imported high volumes of the chops into Japan, and since then, using chops for authentication purposes has become very common there…

When Japanese tourists come to buy chops, they intend to use them for these purposes on their return. The Japanese preserve their traditional chops really well – chops are passed down through the generations, and grandfather to grandson use the same chop engraved with the family name.

Hong Kong also supports chops as a valid system of authentication. Some elderly people use chops instead of signatures to withdraw money from the bank, because they're not able to hold a pen any more. You see the groove on this chop? It's there on purpose – hammered with a mallet to go through a carbon copy.

Because chops are etched by a particular artist, no two chops are ever the same – they're like signatures. When people lose their chops, it's like losing a credit card; and they have to cancel their chop's legitimacy.

There's also the aesthetic value of chops. Stone chops are like jade. The colours and texture of these rocks vary, and they change colour and texture with different owners… Once I got into the profession, I really began to appreciate the art side of the business. But I think that Hong Kongers usually only care about money… If they were to buy a chop as a collector's item, they would sell it if it were to increase a lot in price. They wouldn't keep it just because of its craftsmanship.

Modest to top-dollar items

An inexpensive chop costs about HK$100 to HK$500. The price reflects the size of the chop. If the chop is smaller, it's faster and easier to etch. They're not necessarily harder to etch – though this depends on how many words you're etching. The bigger ones are more intricate and involve more material.

The most expensive one we have, with the texture and quality of *Shau Shan Shek* stone, is the Louis Vuitton or Gucci of chops. The supply of this is very low. It's rare and it's immaculate. There are no scratches or cracks. It's worth HK$38,000, and comes with a stand and a box.

Another kind of chop is called *bai keen*, which are for more artistic purposes. You see these square chops? A lot of stone needs to be shaved off, so there's quite a bit of waste when creating them… It's a real test of the artist's imagination to carve something that closely resembles the shape and colours of the stone. These chops are carved in Fuzhou. The artisans there have different ranks, with the top ranking being '1'. People can participate in competitions and win a name for themselves.

If you want to order a chop carved to your own design,

it's very expensive. People generally want something carved in the shape of a zodiac sign, or from Chinese folklore. I don't do the carving here – I have to send them back to the Mainland, which takes a long time and is costly. But the engraving, we [he and his wife] do here. We have many different types of scripts, some of which are cursive fonts. There are *Jin* characters [family surnames] as well. Nowadays, people want to use characters that are not easily recognised.

We'll have to see if our children have an interest in learning how to engrave, but it'll also depend on whether they have a talent for it. Handwriting and engraving are very different. To engrave, you need to be able to control your strength…

I use computer printers, for example, for businesses that want to order a huge volume of chops; I tell the client first, of course. If you take a close look at a chop made with a 3D-printing machine, it's not as refined – it's coarse and

there are lines on it. Nowadays, in the Mainland, they're also moving towards using the machines.

The letter of the law

There are Chinese Arts & Crafts department stores in Tsim Sha Tsui, Wan Chai and Central which sell the stones, and offer engraving services. They're a bit less expensive than we are, but I think they're closing the Tsim Sha Tsui outfit in September. It's the same situation with the China Resources Vanguard. Apart from these department stores, this street is the main cluster where people can buy chops.

This street is under the jurisdiction of the Urban Council. I think it's the Urban Council… [in fact, the Urban Council was dissolved in 1999 and replaced by two government bodies, the Food and Environmental Hygiene Department and the Leisure and Cultural Services Department]. There's a hawker licence that's necessary here, but no craftsman licence for our trade.

In our case, the licence holder is the stall owner, not us – officially, I am the assistant of the stall owner who has the licence. The government no longer issues these licences, so if the stall owner didn't want to operate any more, we would have to close shop. If I had to move to another place, it'd be Tsim Sha Tsui, or the West Kowloon Cultural District.

Some of the shops don't open often – perhaps only a few times a year. Other shopkeepers only come on Saturdays or Sundays. Many of them are semi-retirees who only come here to pass the time. If they have business, then they do it; if not, no problem. They are the licence holders, so their costs are not at all high. They only need to pay for utilities, and renew their licences.

There's some degree of friendliness between us; but mostly, we mind our own business, and rarely interact with each other apart from with our direct neighbours. Even though we're in the same business, we sell different chops. Because I don't want any direct competition, I sell higher quality chops which aren't sold in any of the other stalls around here.

Demand will be there as long as there are artists who need to use chops. There's also demand from the students of painters and calligraphers – Chinese and Japanese. European tourists like to give chops as souvenirs to their friends. In fact, a lot of demand comes from tourism.

On the negative side, our costs are going up. The Chinese yuan is rising against the Hong Kong dollar; and carving labour costs are going up, as are wages. Lastly, stones are becoming more and more expensive, particularly with supplies drying up, and a strengthening currency.

Hoarding the stones before they become unaffordable is a problem of capital. Some of the more expensive are HK$100,000 upwards. The most expensive ones that I personally buy are HK$20,000. But if I purchase some that are really valuable, and am unable to sell them here, I can still sell them at a higher price on the Mainland. So you can't really lose money in this business.

A diversified trade

To diversify our business, we also do business cards. This is actually in keeping with this street, which has always specialised in font stamps, and other printing goods. Stamp chops fall into this category, as do business cards.

My clients give me a design, or I design the business cards for them on the computer I have here. Pricing depends on the amount of colours, and how many sides of the card are printed. For one colour, one side, you get 200 cards for HK$120, but every stall has different prices.

Our strength is that we draft the cards ourselves on the computers, and offer many possibilities. Some customers have special requests, such as really thick card, which are turned down by many of the other places. Some companies are regulars; whenever they hire new employees, they need new business cards printed.

Signing off

Let me find a HK$100 Standard Chartered bank note… You see this depiction of the chop on the back of the bill? It's all wrong. This is called a *Gau Dip Mun*; and there

are usually only nine rows of lines. Here, though, there are more than a dozen. Also, the character here is written incorrectly… We really wish they would correct it. The bill has the four characters for 'Standard Chartered'. Supposedly, an artisan on this very street designed the chop for the bill. But I'm not sure that this is true. ■

"Everybody in Hong Kong cares so much about time, and most people are in a rush – they can't be without a watch! Time is expensive here."

— Chan Shu-Tong, 58, Watch repairman

Chan Shu-Tong, Watch repairman

People come to me to get their watches repaired; and when I do my job, everyone's happy. I've been in the business for about 20 years and do a bit of everything, but most of the time, I'm changing batteries or watch straps. I also sell watch straps, and multi-purpose batteries that you can use for car keys, and remote controls. What the percentages of sales and repairs are, I'm not sure…

My line of work probably involves the smallest type of shop in Hong Kong. With just a box [counter] like this, I can do my job. There are no standard dimensions for these units; you order them from carpenters who make them for you. It really depends on how much space you have.

I rent this outside area from the shop next to me [on Great George Street in Causeway Bay]. I know them from way back, and since nobody was renting the space, he allowed me to. It's much too expensive now – HK$15,000; very steep...! If he increases the rent again, then I'll have to increase my prices again; and if my supplies get more expensive, I also charge more. There are lots of suppliers who deliver the goods. We've worked together for a long time, and I have confidence in them. We want quality goods – not cheap or fake things from the Mainland.

All walks of life

The benefit of this particular location is that it's quite busy. People from all around the world walk these streets – Americans, Canadians, Taiwanese, Indonesians… I have customers from many, many countries. People bring their families' and friends' watches all the way from places like Canada and Australia, because it's cheaper to get them repaired here. If the customers speak English, I'm able to understand enough to get the idea of what they want. It's usually just a change of strap or a new battery. In fact, many of our friends actually refer foreigners to us. Some are tourists who've used maps to find me!

Usually, people come here on the weekends when

they're shopping in Causeway Bay; and, during holidays, people come and leave their watches with their phone numbers. Once I've finished working on their watches, I call them, and they come back to collect them. Some bring 10 or 20 watches for me to look at. Once, one guy brought over 40 – but they took me only slightly more than an hour to handle. He just left the watches and went about his business; he wasn't in a rush...

The number of customers varies. At the very least,

though, I serve between 20 and 30 customers each day. Still, it's difficult to be in this business as you can't earn much… Right now, it's as if I'm working for this shopkeeper [gestures to the shop next to him]; and sometimes it takes a really long time to earn the rent that I pay. I profit a little bit – if I didn't earn anything, then there'd be no point… I'd like to work in Mong Kok where I live, but there's no space to do it from. You can't always get what you want.

I know a few other people in the same profession quite

well. We're in many different locations, because we have to be scattered. It wouldn't be good if we were clustered together, because there'd be less of a stream of customers. It's also better that we work outdoors. There are no licences for this profession; and working outside, you have more visibility, and more new customers approaching you, as well as your regulars. Outdoors, we're affected by the weather, though, and in extreme weather we need to close altogether.

Changing batteries

There are many different batteries, and so there are different prices. When watches are more complicated, they're a bit more of a hassle, and so I charge about HK$10 to HK$20 more, but I tell people what I'm planning to charge them right away, before starting the job.

I usually know what battery I'm going to need just by looking at a watch; and there have only been a few times when I haven't had the right battery to hand. To change one, you need to unscrew the watch, use an air pump to remove the dust, replace the battery, and then lock the watch lid back on. After putting in the new battery, I also adjust the time on the watch.

It's not that I find watches fascinating – I just like them, and like working on them… I've been working with them for so long that I suppose I do have an attachment to them. My customers are fond of their watches too – otherwise, they wouldn't want me to repair them.

The Rolls-Royce of watches

Sometimes people give me expensive watches – all sorts of brand-name watches such as Baume & Mercier, Rolex, Longines, Tudor, and so on. There are warranties for these expensive watches, but some have expired. Other cases involve just small repairs, because the owner doesn't want to send the watch to the official repairers, as it'll take them two weeks to a month to do the job.

The most expensive watch I've ever repaired? Rolex. With the more intricate watches, you have to be meticulous with them. For Rolex, it's gold alloys [to replace the strap], there's no *chuk kam* [24-carat gold] because *chuk kam* isn't strong enough. If I know I can't do the job, I won't take it.

Only twice have I accidentally broken someone's watch, though neither of these situations involved brand-name watches. You need to have steady hands to do this work. Good eyesight is also important… I've been working for so long that mine is no longer as good as it used to be, but my vision's still passable, and doesn't affect my work much. I use a magnifying glass for parts that are too small to be seen.

Trust is everything

I've been here for a long time, and have lots of regulars – if you have a good relationship with them, then they'll return; if you have a bad attitude, then they won't. Some of my regulars have been with me a decade, some of them 20 years. People used to come here with their children; and now these children have grown up and come to me

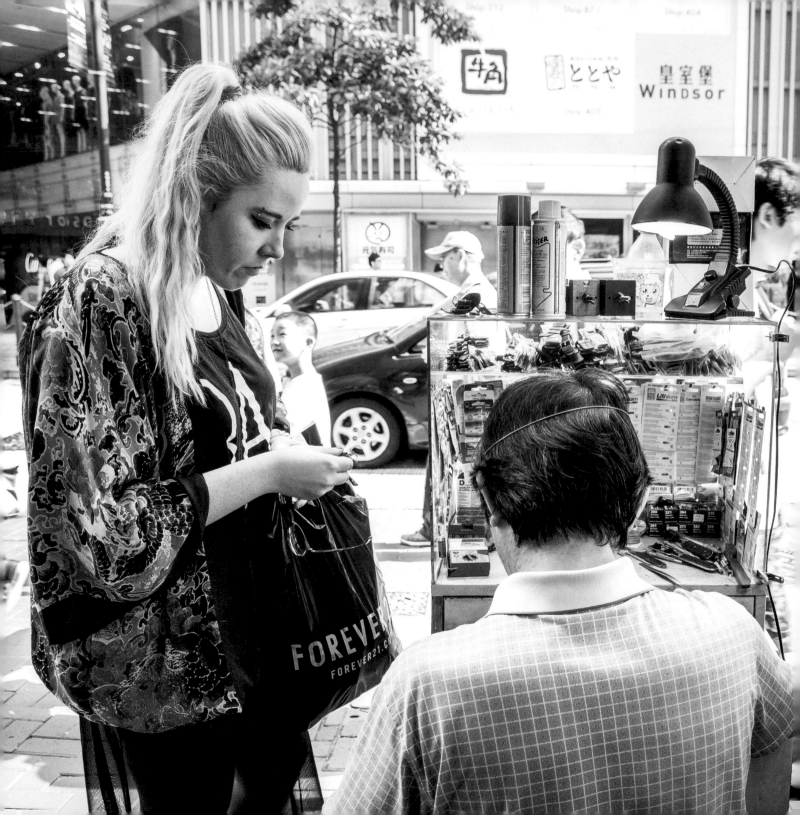

on their own. They recognise me, though I might not know them, because they've changed. They usually say, 'Mum used to bring me here'…

There's one customer who came to me with a broken watch that belonged to his late father. He asked me to fix it at any cost, but I told him there was no need to say that. 'However much it'll cost me to fix it, then that's the amount I will charge you', I told him. 'I won't charge you more'. I managed to repair the watch, and he was very, very happy. It was his father's, and has a lot of sentimental value for him.

Because they know that I won't overcharge, many customers leave their watches with me without asking how much it'll cost. I don't swindle people, and people come to me because they know this about me, and respect me for it.

Some of the regulars live nearby, and drop by to say hello, or sit down and chat for a bit longer. There's one woman who buys me lunch every now and then; and others who bring moon cake during the Mid-Autumn festival, or sweets. There's an old lady who gives me *lai see* [red packets containing money] every few months.

When I don't have customers, I tidy the merchandise and listen to the radio, usually the FM88.1 Lui Ting channel, the news, or *Ah So* [a radio personality also known as So Sze-Wong]. When I'm working I don't listen to it; it's just on in the background.

You are what you wear

Everybody in Hong Kong cares so much about time, and

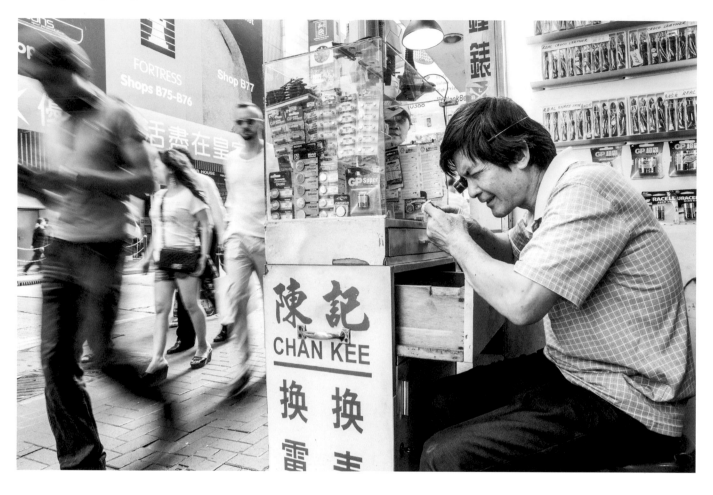

most people are in a rush – time is expensive here. But this depends on what job you are doing.

I can tell a few things about a person by the watch that they wear, but some people own a lot of watches, especially females. They use them as a fashion statement, and wear a different watch each day to match their work and leisure outfits. Men usually just have one watch to keep track of time; and younger people wear trendier watches. Some people just wear the shell of a watch, which doesn't tell the time – they just like to wear it as an accessory.

It doesn't say much if a person doesn't wear a watch. A lot of people don't wear them because they use their phones to tell the time. But just because you don't wear a watch, it doesn't mean you don't have one at home. Some people leave theirs at home. For example, I have a few watches which I'm not wearing, because I have a skin irritation at the moment.

The clock is ticking

The activity on this street has changed a huge amount over the years that I've been here. There used to be many more people working in the streets, but now there are fewer and fewer. Traffic-wise, generally, there are a lot more people in Causeway Bay, and much more traffic than before. There are a lot more Mainlanders now as well. There's not much drama around here… there was a huge banyan tree in front of the Wellcome [a supermarket], which snapped; once, somebody stole something from that supermarket, and was chased as he ran out of the shop…

Sitting here, witnessing these changes, and just having been alive for a while, I've learned a few things: Don't take things so seriously, don't get caught up in your worries. If you can care less, then do. Also, don't be stubborn. As you get older, you see things in a more carefree light.

Do I see myself as more of an artisan or a craftsman? I see myself as a craftsman. This is a trade to earn a living. When you get a watch to repair, then you repair it – that's all.

Nowadays, it's really hard to get into this business, because the old craftsmen are all retired and there are not too many masters left to teach people. If you don't know anyone in the trade, you can't get into the business. I learned my craft from a master, a friend of mine, and I was an apprentice for three or four years. How much longer I work, depends on my mental health – because physically, I'm still quite strong. ■

"This job is tiring, but it's also quite free. If I don't feel like coming, then I don't come."

— Dai Xiao-Qin, 40, Shoe shiner

Dai Xiao-Qin, Shoe shiner

Sometimes I feel that people look down on shoe shiners, but it doesn't really matter – I'm self-reliant; I use my hands to earn a living. This profession is really tiring, but if I work hard, I get tips, sometimes HK$5 or HK$10 a time. Along the way, I've cried a lot of tears and have really struggled.

But I'm not too tired today. There hasn't been much business; I'm not sure how many clients I've had, but more than 10. They've been all sorts of people – some white people, some old, some young, some regulars. I have a few regular clients; and I've been shining the shoes of my longest for more than a year. There have been other regulars before this, but I can't really remember…

It's a long story

My story is very long, we won't be able to finish it… but, anyway, I'm an immigrant. My hometown is Chongqing in Szechuan Province. Before I moved to Hong Kong, I thought Hong Kong was a good place, which is the reason I came. I got married and moved. But when I first arrived, I didn't like it at all.

There's not much space here, everything is expensive, and work is very stressful. Of course, there's also the discrimination. Some Hong Kongers look down on us. But it's all the same to me, however they see me. Now that I'm more used to being in Hong Kong, things are better; and if you don't want to be here, you don't need to be…

I live in Cadogan Street, in Kennedy Town, and have lived there since I arrived from Szechuan, over three years ago. I've been working as a shoe shiner ever since. I actually got into the business because of my late husband who used to work in Hong Kong too. His parents came to Hong Kong back in the 1950s, and he was born here. He worked in Hong Kong for more than 10 years.

But, 10 months after getting my Hong Kong permanent residency, my husband passed away, leaving me and my son. It was a very difficult time, and the shoe shiners beside me were horrible. There are a few of us here. The

others also come from the Mainland. This one is from Dongguan, the other from Harbin [she points to either side of her]. There's definitely competition between us shoe shiners, and that woman over there loves to steal customers!

I am the newest here, so the others bully me; but there are good people in Hong Kong as well – people who have been really kind to me. A lawyer once helped me, without asking for payment, and someone else, hearing that I was widowed with a son, gave me HK$3,000. To be honest, Mainlanders are not as nice…

Back-breaking work

This is the only job I have, and I'm here all day. I work five days a week, and take Saturdays and Sundays off. It's very tiring; my neck hurts, my waist hurts, my spine hurts – everything aches. But, I'm happy. Sometimes people tip, which is just as well because costs are going up.

It costs about HK$20 per container of polish, and each container is used up after just a few pairs of shoes. Everything is getting more expensive, which is why we've had to raise our prices from HK$30 to HK$40 – and it's HK$80 for boots. We started with the new prices in August 2013. Business is so bad right now. There aren't a lot of customers, but things do get better in the winter. [She receives a HK$70 tip from a customer, and is very happy].

A lick and a polish

At the moment, I'm preparing the shoe polish for my

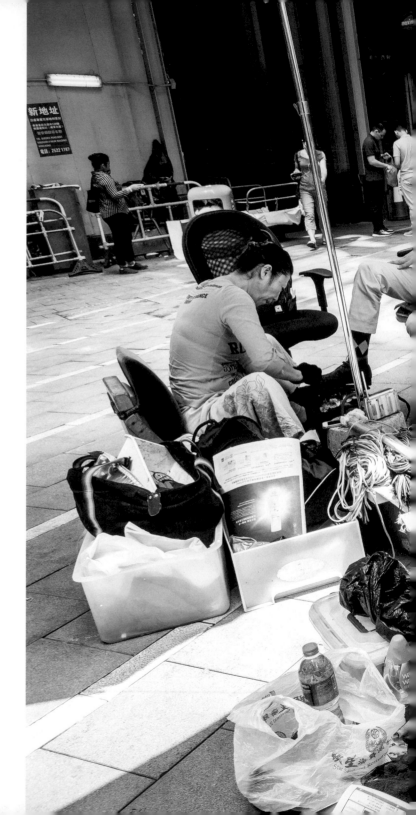

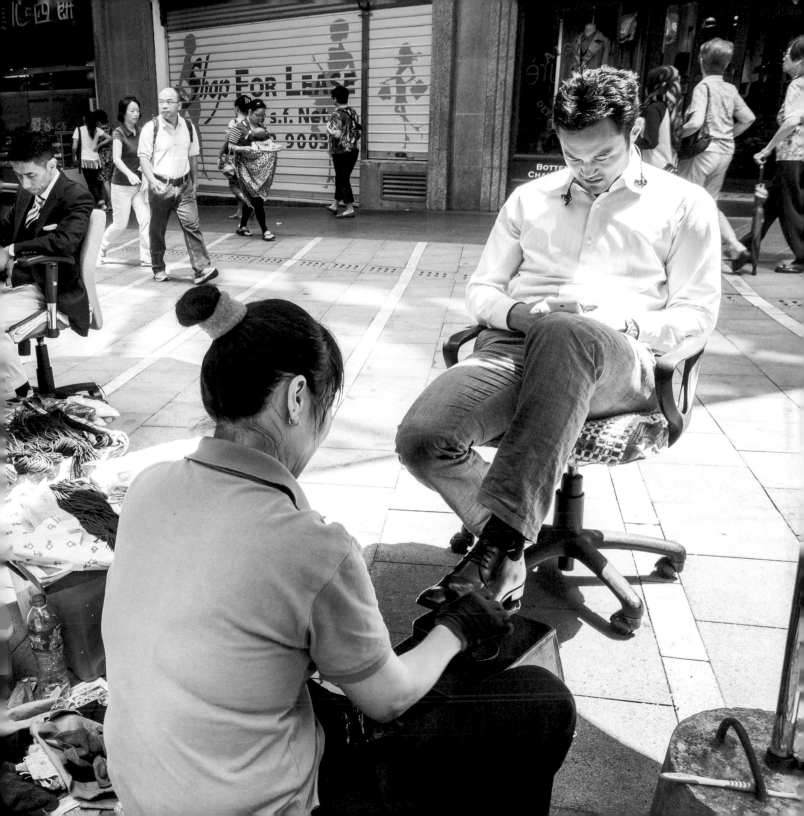

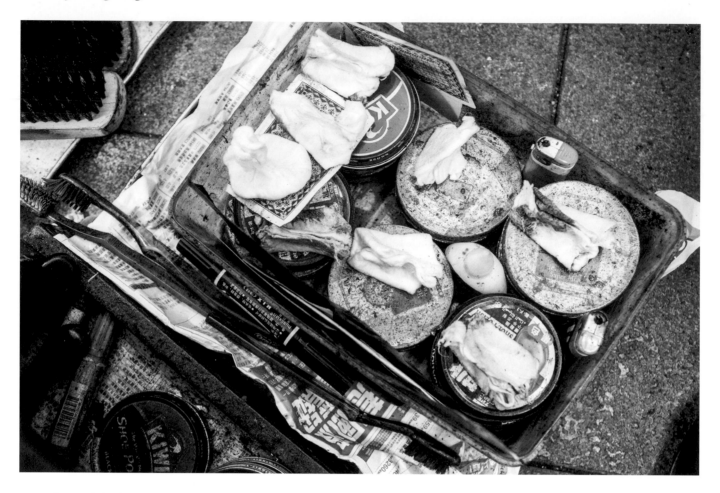

next clients. This big container here is almost used up, so I'm refilling it with polish from the other containers. This toothbrush is used to brush the seams of the shoes; and I have two bigger brushes. One is to dust off the shoes, and the other is to polish them.

These different containers have different colours of polish in them: blue, black, red, all sorts of colours – even transparent. At the end of the day, I store my equipment over there [she points to her left, against a wall].

Once a customer arrives, I put polish on the shoes, and then oil. This customer's shoes are soft leather, not 'shiny' leather. This type of leather is easier to work on, but doesn't look as nice. All the same, I need to do a good job!

There are more male than female customers. In fact, nine out of 10 customers are men; and I haven't had even one female customer today. Hong Kong males are very concerned with their appearance, especially this customer here. I also get a lot of celebrity customers.

A good tip

When I have time I go back to Chongqing, but I don't go very often because it's really expensive to go back. You have to spend a lot of money! I don't even go back for Chinese New Year... Anyway, it's colder at New Year in my hometown than it is here. Sometimes, I go back for festivals such as Ching Ming [a public holiday when people worship their ancestors], or Christmas.

I want to say that it's important to do your job well. I'm servicing Hong Kong people, and trying to do a good job. Also, when people help me, I try to help others as well...

I don't have anyone to rely on, so if I didn't work, I'd starve, right? This job is tiring, but it's also quite free. If I don't feel like coming, then I don't come; no one deducts my salary here, though I won't earn anything that day from customers. If I feel like leaving early, I can; there's no one to stop me. If I want to start working a little later, then this is not a problem either. ∎

"This job is a standing job, and if you don't do things to keep yourself active, you'll be very tired. If you move, talk to people, welcome people, before you realise it – the time has gone."

— Arhin Francis Mensah, 53, Security guard

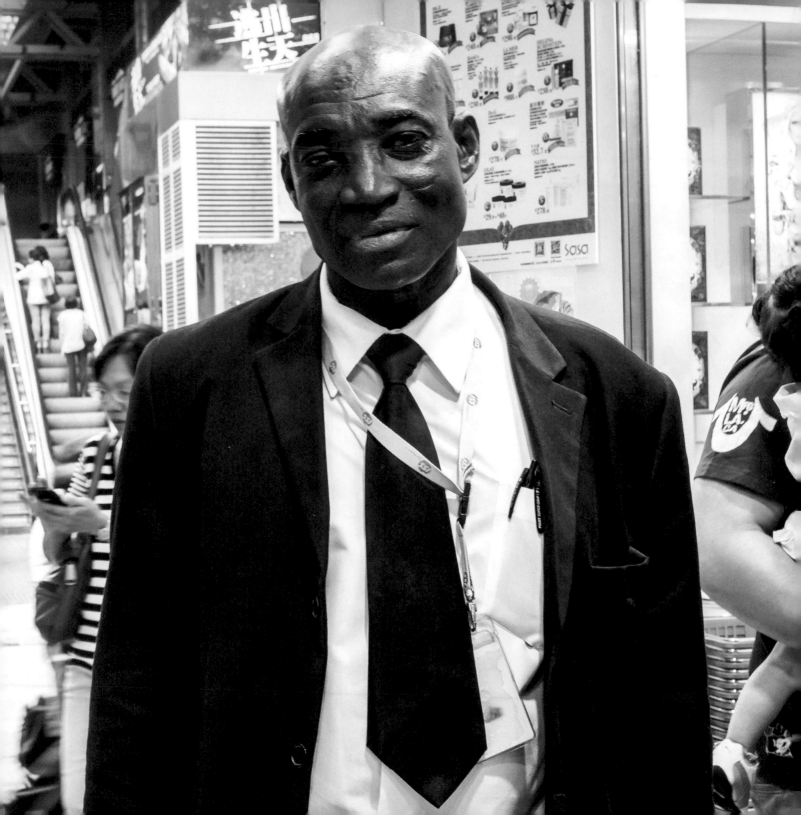

Arhin Francis Mensah, Security guard

I've been in Hong Kong for almost 10 years, but was born and brought up in Ghana. My father was a carpenter, and as a carpenter myself in my early 20s, I left for Nigeria. I later returned to Ghana only to leave again during my 30s for South Africa; and then, later, to Switzerland.

When I returned to Ghana from Switzerland, I decided to start a business, and in 2001 I started travelling to Hong Kong, focusing my attention on Asia because Hong Kong and China were booming. My business dealt in general goods like garments and electronics; and sometimes home electronics and DVDs. I'd buy them from Sham Shui Po, and export them back home.

I travelled up and down between Ghana and Hong Kong for four or five years. But, later, when I came to know that most of the items in Sham Shui Po were actually ordered from China, I thought, 'Why wait?', and went directly there. Then, the RMB rose, and the dollar became less strong. Also, when I sent the goods to Ghana, the people there thought I was 'okay', so they could rip me off. Things were going down, so I needed to stop the business.

Securing new opportunities

I met my wife in Hong Kong during my business days, and in 2008 we got married at the registry office in Tsim Sha Tsui. Originally, we were friends because at the time she had a husband, but four years after we met, her police officer husband died. One day, he went out for a drink with friends, and collapsed. He was pronounced dead on arrival at the hospital.

Before we married, I was living in Hung Hom, but afterwards I moved into the government flat in Kwun Tong that had been transferred into my wife's name after her husband died. If you leave a place like that vacant, the government will claim it from you.

After getting married, I decided to take a security course, and was given a permit. I've worked for about

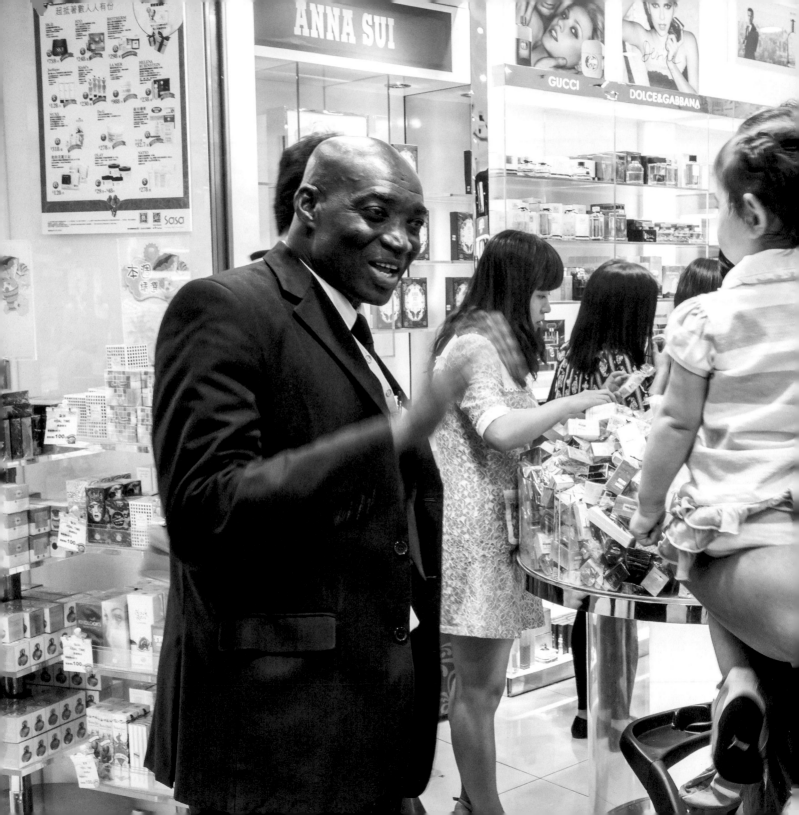

four security firms, but none of them for very long. First, I registered with Signal 8. Sometimes they'd tell you to go to a bar in Wan Chai, because they handle the security jobs there, and at other times they'd put you at upscale bars and clubs in Central or Lan Kwai Fong. Later, around 2008, I worked at a disco in TST. I worked there for almost a year, but then, due to licensing problems, the club shut down. After this, I went to another security company in Jordan for about two months. It was also a nightclub posting, but, then, they too had permit problems and terminated the contract with my company.

From there, I applied to another company, ISS [International Security Service], but because of my colour – they don't know the value of black – they didn't want to employ me. They tell you, 'We'll call you later', and then they don't. Because the man on the phone could hear that I was black, he didn't want to attend to me, but later on he said 'Okay', and transferred me to someone else, who told me to turn up.

When I got there, the man said to me, 'Let me tell you, many companies in Hong Kong discriminate, but I will employ you. Your performance will prove if you're any good'; and I laughed, because I know myself. Then we did a briefing, and the next day they gave me a uniform to start here in Causeway Bay. At that time, June 2010, they didn't have permanent security, and could call the office to change you whenever they liked. I was taking over from a Filipino who wasn't performing very well.

I came in the morning and was taught about the book to write records in, the time to go for breaks, and so on.

Within three days, the management came up to me and said that they'd read about me on a Chinese internet site. They said 'We read about you, and we congratulate you!'.

It was all in Chinese so I couldn't understand, but they knew what it said. They gave me a small note of congratulations, and shook hands with me. I've been here for over three years now.

Sounding the alarm

It's not just locals who shoplift in Hong Kong, but Mainlanders too. Every week, we have three or four incidents. The minute someone enters the shop, I usually know if they're likely to be a shoplifter. Some people come in the morning, and then come back in again later. I say, 'You're back', to which they say, 'How do you know? You've got such a great memory'. My memory is very, very sharp.

We're judged on our performance. In other words, the number of people we catch… I watch people, and we also have an alarm system. When the alarm goes off, I tell the customer they need to go back to cancel the alarm. Then, they either pay, or they don't – but I have done my duty.

What some of my colleagues might not know is that you have to apply experience. This is a big shop, so if you're standing here and someone's standing there, you cannot see them. So, I talk – because if someone is taking something and hears my voice, they'll stop because they think that I'm coming. So I'm here to do a lot of things.

Last man standing

In the contract for this company, it says you can be changed to any post, but because the people like me here, they don't want me to leave. I want to stay here too. This is my everyday routine – Kwun Tong to Causeway Bay, and back to Kwun Tong.

This place is a difficult spot for the company… More than 10 security people have been here, and haven't lasted. There was one Chinese guy who was listening to music on the job. I told him he shouldn't do that. Within a few days, they'd called the office to change him. I have been with these people, and I know their characters – if they don't like your performance, they'll make the call. The security company won't sack you though… it has lots of contracts with shops, hospitals – even the airport.

When the man at the security company employed me, he told me, 'You aren't a soldier, you shouldn't stand still'. But this is exactly what most security guards do. He said,

'Please try to be cheerful. Welcome people, say goodbye'. This isn't any trouble for me, and I do more than is expected. This job is a standing job, and if you don't do things to keep yourself active, you'll be very tired. If you move, talk to people, welcome people, before you realise it – the time has gone.

Within a few months, they promoted me. I have one dot [an industry accolade] from a long time ago, but I don't wear them on my shoulder because I don't wear a uniform, I wear a suit. Those who employ me know my work performance.

Because I'm always on my feet, I usually eat oats and bread for breakfast to sustain me; and sometimes I eat beans so I don't get hungry. I do the same hours every day from 10 a.m. to 10 p.m. – Saturdays are my only days off… Sometimes, my wife tells me to set the alarm, but I am the alarm! I always wake up on time. Even if I sleep at 1.30 a.m., I always wake up at 7.30 a.m. or, at the latest, 7.40. I need to make sure I get the 8.50 a.m. bus.

I arrive at 9.40 a.m., and start work at 9.50. I open the shop, and my colleague from Pakistan does the close. I have two breaks – usually at 6 p.m. or 6.20 p.m., and then a dinner break at about 9 p.m.

Out of Africa

The problem with Hong Kong is that there's too much discrimination. I feel the discrimination of Chinese people – both men and women, and mostly older people.

When I first came, it was very difficult. If you sat down next to a woman, they'd get up and move; but now,

Chinese women are after black men! I don't know why this is. Many of my guys have married Chinese women. But, when we came it wasn't easy… I think it's a lack of civilisation and education, because most of them have never travelled before. I know that they haven't been exposed as I've been. This is why I ignore them. People who have travelled aren't like this.

Ethnic minorities such as Pakistanis and Nepalis don't face as much discrimination in Hong Kong. Even if a Pakistani is illiterate, the Chinese prefer to deal with him than a black man. The solution is education. The Hong Kong government needs to educate these people who are still asleep!

Caucasians aren't really discriminated against, but from what I observe of Hong Kong people – if you're not Hong Kong Chinese, they look down on you. They even look down on Mainlanders, though they're the same people! They think they're superior.

A father's responsibility

My wife is Chinese from Hong Kong. She's almost 49 years old; and we don't have children. I told my wife, 'We are old, and to bring a child into the world of Hong Kong isn't easy'. I have one daughter of my own, who's 28. She has a marketing degree, and works in Ghana... and my wife has a son from her previous relationship. So we decided to live as man and wife and just forget about kids.

When we met, I told my wife that every child in the world must go to university. Though I was good at school, I ended my schooling at secondary level. I'm still angry with my father about this, because he preferred to marry another woman than think about my education! A responsible father makes it easier for his children, by putting them through university...

Both of my parents are still alive, but they've never been to see me in Hong Kong, and my father's almost 80 years old. There were eight of us kids before, but now we are four sisters and two boys. I am the eldest boy, and the only one who's living abroad. ■

"I'm a happy worker. The boss treats us well, there are end-of-month bonuses for high-performing workers, which I've received, and at Christmas and Chinese New Year, the boss takes us out for dinner."

— Ng Siu-Wah, 48, Gas delivery man

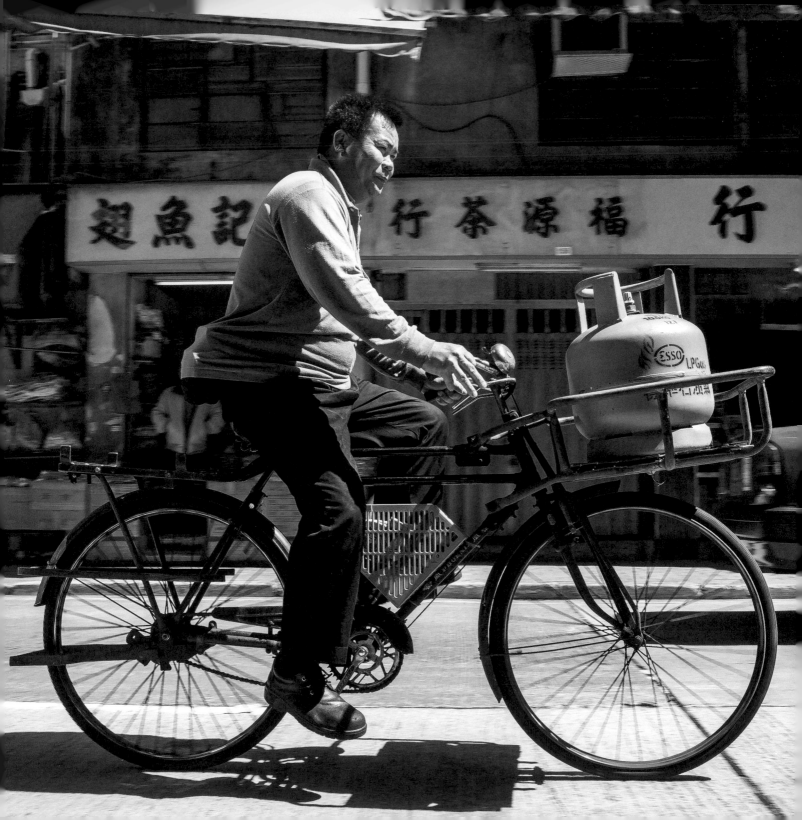

Ng Siu-Wah, Gas delivery man

I deliver gas canisters of LPG [liquefied petroleum gas]. LPG accounts for about one-third of the market in Hong Kong. The rest of the market uses Town Gas [also known as coal gas]. The difference between them is that LPG is cheaper. Only LPG comes in canisters; Town Gas is connected through pipes.

Tour of duty

I wear a work uniform, which the boss gives us the freedom to wear or not to wear. It has our company name, Tai Yick, on it. It's a very big company with branches all around Hong Kong, though I'm not sure how many people work here. We deliver to homes and restaurants.

In the mornings, we go from Central to Aberdeen, and after lunch, we go from Wan Chai to Chai Wan. So we pretty much do a circuit around Hong Kong Island each day. We sometimes deliver to places further afield [from the Sheung Wan-located shop], which are closer to the company's other branches, if the order has come in through Sheung Wan. We deliver about 60 canisters in a day. A restaurant might need a few canisters, while most homes only need one, so we go to around 40 places. Usually, we deliver to older buildings with no lifts. Residents of the newer buildings normally use Town Gas and, if at all, only use LPG for barbecuing.

There's a big variety in people's kitchens. Some are very clean, others are dirty – I have seen cockroaches. Old people and people from the Mainland usually have dirtier kitchens, while local Hong Kong people and foreigners have cleaner ones. Apart from delivering the LPG, we also carry out the simpler installations, for example, the installation of two-burner stoves. Anything more than this requires a licensed professional.

I myself use LPG at home, and get a 50 per cent discount from the company. I have a two-ring Japanese Taada stove that I cook dinner on, though it's my wife who's the one who works at a restaurant, as a server at the Star Seafood Restaurant!

I have two kids who also work. My son has his lifeguard licence, and works at a resort; and my daughter works in Causeway Bay at a coffee shop.

Fuelling Hong Kong

If the delivery address is nearby, we use the trolley. For destinations further away, we use the trucks; and for 'in between' distances, we use the bicycle. It's all the same to me – but you can go further with the bicycles than the trolleys, so you don't need to walk so much. The company only owns a few trucks, but they're all the same... Each can fit about 60 to 70 gas canisters. Mind you, there are different sizes of canisters. The smallest are 2 kg, and the largest are 20 kg; and there are also 8 kg, 10.5 kg, and 16 kg canisters.

When taking the truck, we work in teams of two. One person drives, and someone else accompanies. Right now, I'm not the truck driver; I sit in the passenger seat and

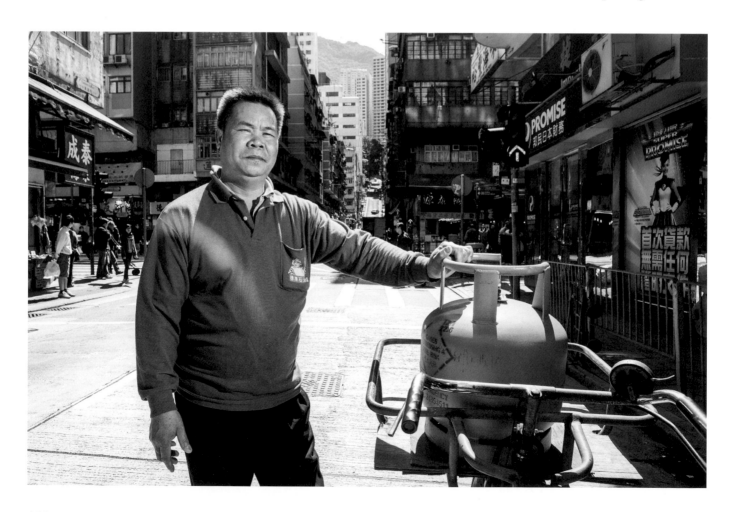

transport the canister upstairs. When there are lots of orders, the driver will help out.

We're usually very careful. In the truck, the canisters are tightly secured with ropes and belts so that none of them fall off. As for the trolleys and bicycles, they're specially designed to secure the canisters. If there's anything wrong with one of the trucks, we tell the boss, and he finds someone to fix it; likewise with the trolleys.

On the trolleys, you can pile up three or four of the canisters, which makes them quite safely secured. Trolleys can take two to three canisters, and bikes can take three to four. On a bicycle, you don't stack the canisters up, but hook them to the side of the bike.

The more experienced you are, the quicker you are. There's no special way of doing the job, it's just self-explanatory; it's routine! You just have to be careful. We're really careful about the way that we work, and I haven't had any injuries. But sometimes people do bump into you, or you bump into them…

I am off work on Sundays and holidays. The rest of the week, I wake up at 7 a.m., eat breakfast at 8 a.m., and get to the company by 8.30. I work until noon, eat lunch, and then work until 7.30 p.m. If we don't have too much to do that day, then we take a bit more time over lunch. I eat wherever we've ended up on our delivery route. Sometimes it'll be a restaurant; at other times, in the vehicle, if we've taken the truck. We load up the truck at the station near the harbour, and at the end of the day we exchange the empty canisters for filled ones for the following morning.

It's a gas, gas, gas

I'm pretty happy – I'm a happy employee. The boss treats us well, there are end-of-month bonuses for high-performing workers, which I've received, and at Christmas and Chinese New Year, the boss takes us out for dinner.

I come from Jiangmen [a city in Guangdong Province], and was also in the delivery business when I lived there, driving a truck and delivering goods. But not everyone who works for the company comes from the Mainland – a lot of the staff are actually from Hong Kong.

I've been doing this particular job for seven years. It's the first and only job I've had in Hong Kong. I saw it advertised at the Labour Department, and thought it was suitable for me; then I came here for the interview and they hired me. I'm a newcomer here, but we're happy working together. We get along well, and don't argue, so it's fun.

Power to you

Both security guards and residents seem to recognise me. Some customers tip, others don't. Mostly, they don't – very few give us money. The ones who do, tip us because they see how tired we are. These are usually local Hong Kong people. The smallest they will tip is HK$2 and the most, HK$50. Because the company doesn't want to take it from us, we get to pocket the tip. My monthly salary is HK$11,000 to HK$12,000.

I've ended up doing this work because I have a low level of education. There's not much difficulty in my job, everything is self-explanatory – but you need to have

strength. Some of the flats in Hong Kong don't have lifts, which is tiring, but I'm used to it. Sometimes my shoulders ache, but there's no time to worry about this!

Busy or not busy, we have to work. Working outdoors is probably a bit more tiring than working indoors, but my education is low, so I couldn't work in an office. ■

"Our customers are mostly white people, because Chinese people don't normally like this type of food."

— Harinder 'King' Singh, 50, Pizza delivery man

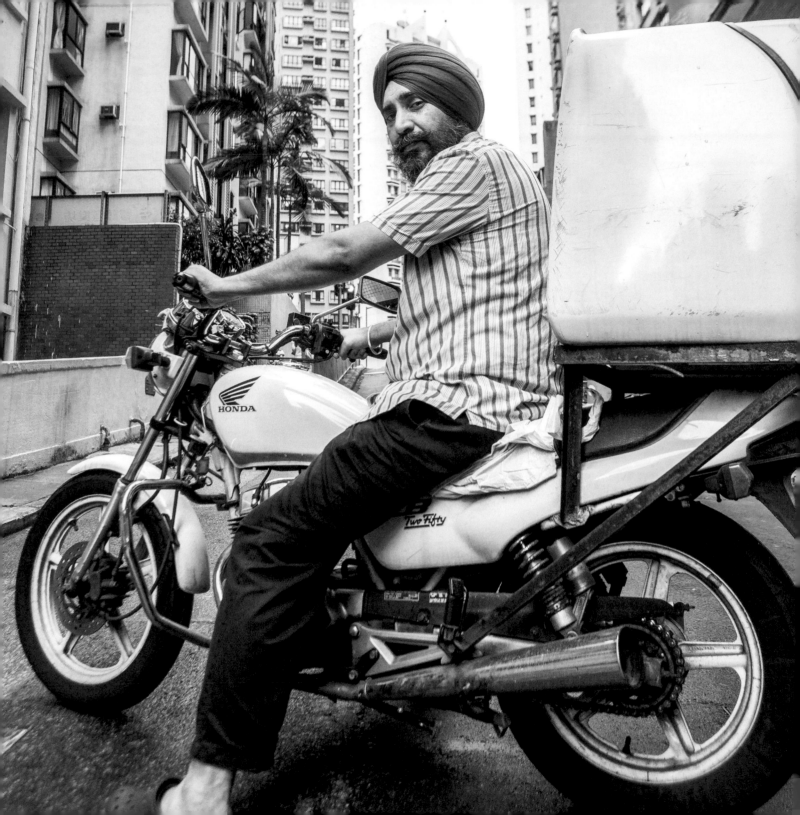

Harinder 'King' Singh, Pizza delivery man

My name is Harinder, but I use the name 'King' at work, because it's easy to say and remember. I come from Punjab in the north of India, and came to Hong Kong in 1993. Because one of my sisters was here, it was quite easy to move. I just applied for residency at Immigration, and after eight or nine months I made it through.

I came alone, but I have family here. My mother's in Hong Kong; and my father was as well, until he passed away. The sister of mine who was originally here is still in Hong Kong. She's married to an Indian and works in a restaurant; I have another sister who lives in the UK.

I also have a wife here, and two boys, aged 20 and 16. The 20-year-old has completed his Form Six education, and I am applying for him to go to university in Toronto. At the moment, my younger boy is in Punjab, but I think both of the boys will settle in Hong Kong, and have children here later on.

The life of King

Of course, I miss India, but I made the decision to come to Hong Kong because of the job situation. Life is better here – you can find work easily, and the work is much easier than it is back home.

I lived in the countryside in India, working on the family farm, and even as a 10-year-old, I was driving a tractor to help the adults cultivate the land. There was a lot of machinery, but we also used buffalo to plough. We ate the things we farmed and sold rice and wheat at the market. But I didn't make a lot of money there; and there was a lot of corruption…

I've had a few jobs in Hong Kong. I worked in an electronic parts factory in Tsuen Wan, and as a security guard at a bank. It's been more than 12 years since I started working as a driver for this pizza company. The days are quite long – I start work at noon and finish at 10 or 11 p.m., but I'm paid about 17k a month.

I'll have the usual, cheers

The job is very simple. If there are orders, I get on my bike to deliver the pizzas, and, if there aren't, I sit around [in a little alcove with an assortment of chairs] and wait. I have one full-time colleague who also makes deliveries, and sometimes we use a part-timer. There are also the people who work in the shop who make the pizzas, answer the phone, take orders and handle payment from walk-ins.

I deliver about six, seven or eight pizzas in a normal day; but on busy days, like Saturdays and Sundays, maybe 20. I deliver all over Hong Kong Island, even to the south side, and drive a Honda motorcycle that the company provides, though I used to ride a scooter for work. I had a licence from India so didn't need to test again.

Our customers are mostly white people, because Chinese people don't normally like this type of food. My youngest customer is around 20 and the oldest over 60. The regulars usually order the same pizzas they always do. A lot of them are quite fat – like a lot of white people. You couldn't eat this type of food every day; it's junk food!

As for me, unlike many Indians, I'm not a vegetarian, but I don't eat pork or beef. There isn't much 'veg' [vegetarian] food in Hong Kong, and even Indian restaurants here are mostly 'non-veg'. If I didn't have a job with the pizza company, I'd definitely deliver for an Indian restaurant – why not?

What are they thinking?

I've only ever lived in two different places in Hong Kong: in private accommodation in To Kwa Wan [in Kowloon City district], and now in a 500 square foot apartment in Tsing Yi in the New Territories. It's a modern block subsidised by the government, and has about 35 floors.

I had to wait for more than three years to get the government place, but we've been there for about 10 years. It's a two-bedroom apartment, and has everything I need – even a flat-screen television.

We usually watch an Indian TV channel on satellite, and like Bollywood movies, dramas and the news. We eat Northern Indian food at home, although I do like Chinese food…

Like me, my sons are Sikh, but they prefer to cut their hair, and not wear a turban. Chinese people don't like the turban, though educated Chinese know more about it.

It's because of my religion, you see, that I wear a turban. Some Sikhs don't like to wear a very big one, but I do, and I wear turbans of different colours. When I go home, I take off my turban and wear my hair loose.

Being Sikh is definitely part of my life in Hong Kong. Every week, on Sundays around 10 a.m., I go to pray at the Khalsa Diwan [a Sikh temple in Wan Chai]; and sometimes, if it's not busy at work, I also go on other days.

Hong Kong people are quite friendly, but some, usually older people, do discriminate against Indians, and don't like sitting beside us on the bus or MTR. I'm not sure what they're thinking – but it's better than it used to be. The Hong Kong government is very strict about discrimination, saying you cannot discriminate against others – and the Chinese are becoming more educated.

When I'm discriminated against, I feel homesick. Our language, and everything, is there – we speak Punjabi at home, and though I also speak Hindi and English, I don't know how to speak much Cantonese.

One word, many meanings

If I improved my Chinese, living in Hong Kong would be better. If you're here, I think you should learn the language. It's very difficult though; that is, difficult to pronounce the words with the right accent. One word has many meanings. If you work with Chinese people, you can pick it up, but, if not, then it's hard. Most of my friends in Hong Kong are non-Chinese – Indian, Pakistani or Nepalese. It's different for my sons. Both of the boys went to English-speaking schools in Hong Kong and also speak Cantonese.

Hong Kong-born Indians who can speak Chinese understand things better here. They consider themselves

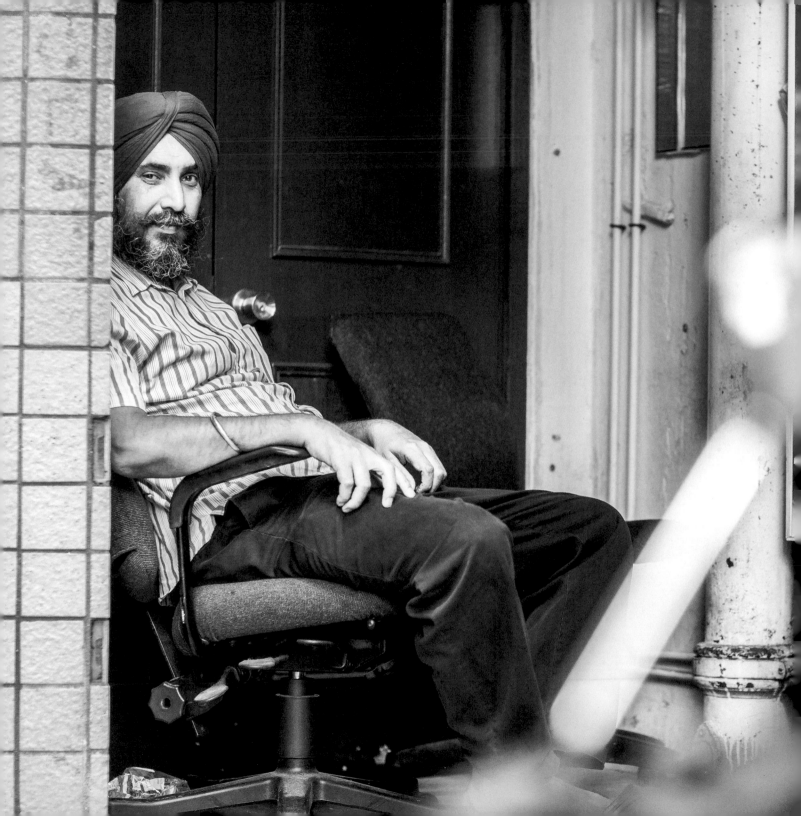

to be local and Indian, and have Chinese friends who they speak Cantonese and English with, though their Punjabi is still much better. Although my boys can't write Chinese, they do write in Punjabi and English.

Back to the farm

I go back to India once a year, either alone or with family members. We have relatives there and a very big property with land, where we grow rice, tea, wheat and vegetables. Do you know how big one acre is [one acre equals 43,560 square feet]? Well, we have around 20 acres there...

It's a very different life in Hong Kong – good and bad, but I think I'll be staying on. ■

"People come here because doctors and other professionals can't help them. No medical doctor can help those who are possessed."

— Chiu Koo, 62, Villain hitter

Chiu Koo, Villain hitter

Villain hitting [exorcising bad spirits] isn't a bad deed. I help people cast out their poor fortune and bring them peace, health and prosperity. Office issues, health problems, expelling evil spirits… I do it all.

I started doing this when I was 32. I'm now 62 years old… If a bad person wants to take revenge on a good person? Of course I won't 'hit' the good person.

A new vocation

I'm originally from Dongguan [a city in Guangdong Province]. When I was in my 20s, the gods started revealing themselves to me, talking to me in my dreams… I wasn't afraid that they were doing this, but my mind felt foggy and I wasn't sure what was going on around me.

I went to see a doctor, but he told me there was nothing the matter with me, and so I went to the temple. There, the old ladies told me to worship the gods. After a while, the gods told me that Bodhisattva [in Buddhism, an enlightened being who forgoes nirvana to help others become enlightened] wanted me to bless the villagers, and solve their problems.

I had no idea how to do this, but the gods said I should go to the temple more often, and offer incense. They said that they'd teach me how to help people. I felt shy about chanting, because I was afraid that people would laugh at me. At the time, a lot of people were already complaining about my farming skills, saying that my mind wasn't on it, and that I wasn't any good at it.

Different folks, different strokes

Villain hitting was not a family tradition, and almost everybody disapproved of me becoming a villain hitter. In fact, they yelled at me! Not before long, though, enough people were coming to me for help that I started making money; and once I did, everyone stopped yelling.

I had a few friends from my village in the Mainland who did the same work, but now it's only me who's left;

and none of my descendants do what I do. During the time of Mao [Chairman Mao Tse-tung, in power until 1976], communism abandoned religion, but after Mao, everyone went back to believing in the gods again; villain hitting belongs to Buddhism.

In the Mainland, it's common but the practice is also different from how it is in Hong Kong. In Dongguan, people really believe in the gods, and villain hitting is a more expensive service. It's HK$100 for a session, and it's done for a whole family at one time, whereas in Hong Kong, it's HK$50, and it's done on an individual. I've lived in Hong Kong for over a decade, ever since my parents applied for me to come to help them in their old age.

It's hard to say how much money I make, because business goes up and down. Sometimes I have just a few customers; at other times, more than 10. Saturdays and Sundays are the busiest days. Some people come when they're holidaying in Hong Kong. They might have my card because they've been referred to me by their friends. Others might have seen me on television.

There are more customers during disasters such as SARS, or at times of financial distress. At times like these, more people seek Bodhisattva's help; and I think people in Hong Kong are generally becoming more superstitious…

It's a ritual

Of course, it works! This is a candle, and this, incense. When we 'hit' the villains, we use paper on which you write the name of a person. These are mortals, and this, here, is a male villain, and there is a female villain. [She describes the people drawn on the paper].

This is called *chiu choi chun po* [welcoming wealth and treasures]. You put the good person's name on it and it absorbs the bad spirits and gossips – protecting the person and making sure they're healthy and well… These statues are Bodhisattvas, while this is Wong Tai Sin, and this is *Chai Tin Tai Shing* and *Suen Ng Hung* [Monkey kings; the Monkey King is an old Chinese fiction about a monkey that becomes a monk].

This, here, is a paper tiger. After you hit the villain into pieces, the tiger devours him or her. Once this is done, you burn the paper. The red tin can is a *yuen po poon*, in which you burn things. Each ritual is 15 to 20 minutes long, and afterwards people sometimes want to talk.

Those in need

I think of myself as a Bodhisattva, or an 'immortal sister'. I have an eye to discern ghosts and bad spirits; I can see 'demon auras'… Yesterday, there was one customer who was totally surrounded by dirty energy – ghosts…

I've had many, many customers during my career. There are people from the New Territories to Taiwan; and lots of people from Shenzhen come to me, and advise others to look me up. That 26-year-old girl who was just here? She was from Shenzhen, brought by her mother. But I don't just help Chinese citizens; I've also helped Americans.

Sometimes, students aren't doing well at school, because they're not able to think clearly. I help them to think more clearly, and their studies go smoother. It's the same with those who are working. One unemployed guy

who I helped, came back a month later, after he'd found work, to thank the gods.

People come because doctors and other professionals can't help them – no medical doctor can help those who are possessed! For example, there was a baby whose mother had taken him to see a doctor. He had a fever, wasn't eating, and was crying and scared. Once he was brought here, he had absolutely no problem any more. Another of my customers was a 15-year-old mental patient, who the mental hospital couldn't help. I helped the girl get better.

I help people with any and all problems. Last August, someone in their early 20s sat in front of me crying. I asked him, 'Why are you so sad? Wipe your tears, and tell me about your problems. I'll do whatever I can to help you.' He said, 'Old lady, I've been framed. I need to go to court soon, and if I don't win the case I'll have to go to jail.'

I asked him when he was due to appear in court, and told him not to fear, because Bodhisattva would help him. Sure enough, after the trial, he came back with a moon cake for me. He said, 'I was the crying boy. I won the case, thank you.' I help people – not just that guy. Lots of people come crying.

Location, location, location

My Hong Kong 'villain hitter' colleagues and I happen to be here in one location, but we're not really friends. We each mind our own business. There's a villain hitter licence that the government gives us, which allows us to be here. They come here to register us, and used to come

every year – but now it's a permanent licence. There are three of us now, but there used to be six. One returned to her village, one became sick, and one just left…

I work from here [under the Canal Road flyover in Causeway Bay] every day, and even if Wong Tai Sin [a popular local god] told me to work at the temple, I wouldn't, because I wouldn't have the same freedom. For me, working outside is good. I can do whatever I want, and can come and leave whenever I like.

Mostly, it's women who do this, though in the temples in Dongguan, there are male villain hitters. Men don't like practising the trade on the street, because they feel embarrassed.

Will of the gods

I'm an 'immortal sister', but I'm also a normal person. I live in Kowloon Bay, and have a son and daughter. My son works in electronics and is married, and has given me three grandchildren who are all at school, while my daughter helps her sister-in-law take care of the grandchildren.

I'll be working in this job until I'm no longer able to. Even if I didn't want to, I couldn't not do this work – it's what Bodhisattva wants from me. It's divine will to end up a villain hitter – I've never invited anyone to be my apprentice.

I also enjoy helping people who are suffering. It would be nice if there were more people in Hong Kong helping others like I do. If villain hitting becomes a lost tradition, it won't be a good thing. ∎

HEALTH & SAFETY

Yuen Pui-Yin – Ambulance woman
Cheng Mui – Toilet attendant
Law Chi-Hung – Lifeguard
Danny Chan – Pest controller

"Often, we go to cases that we've never experienced before, and this can be scary and stressful. Before each job, we have to have the worst case scenario in mind, so there are no surprises."

— Amy Yuen Pui-Yin, 35, Ambulance woman

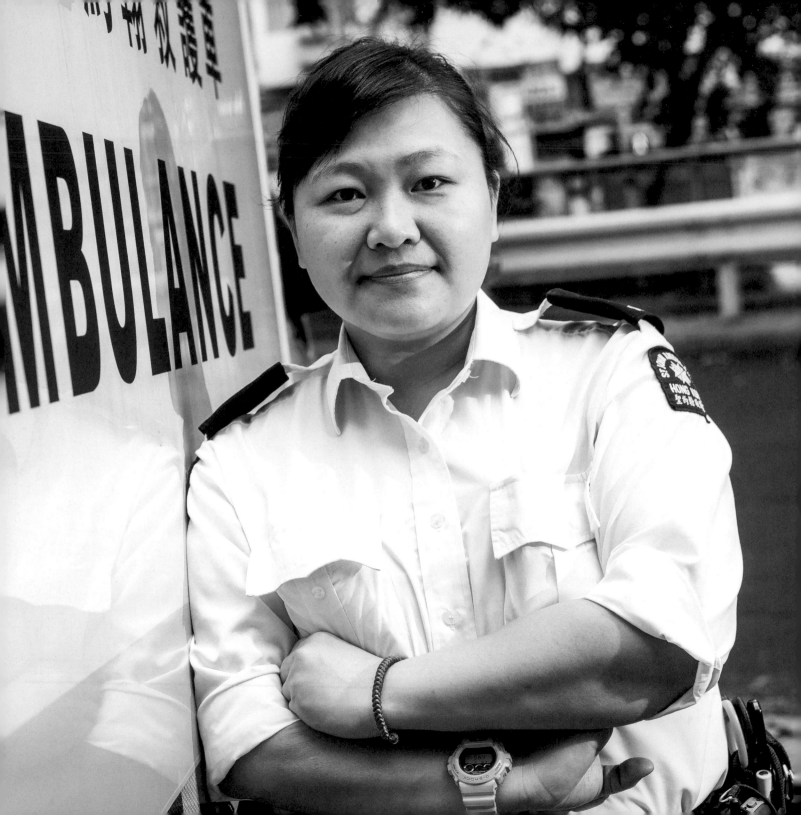

Amy Yuen Pui-Yin, Ambulance woman

When I was young, my father suddenly had a heart attack. We called an ambulance, and seeing the paramedics giving treatment to him, I realised that if I'd known how to give first aid, I could have helped him sooner. Because of this experience, I went on to take a first aid course at 22, and started volunteering with St. John [St. John Ambulance]. In schools abroad, kids are taught first aid, and in some companies in the US and Canada and Europe, employees are taught too. I think everyone in Hong Kong should be taught first aid…

After I passed the course, St. John was, by chance, recruiting. 'What a great idea! I want to help others', I thought. Today, I'm one of 18 paid staff. I've been here for 13 years, and am a full-time paramedic. I'm the only paid female employee – maybe because not too many women take the recruitment test. But I'm no different from any other paramedic – I drive an ambulance, pick up patients, and take them to hospital.

May the force be with you

There are three different ambulance providers in Hong Kong: the Fire Services Department, St. John Ambulance, and the Auxiliary Medical Service [AMS], and we provide different services. The Fire Services Department is only responsible for emergency cases; AMS provides care for non-emergency cases; while St. John takes care of emergency cases, non-emergency cases and hospital transfers.

The government [Fire and Auxiliary] services have to take patients to the hospital that's closest, but some people in Hong Kong have private health insurance and can afford to go to private hospitals, which actually lessens the load on public emergency rooms. This is where St. John comes in; but we only take patients to private hospitals if their condition is stable, and patients have to sign their consent – that they want to be taken to a private hospital. If anything happens on the way to the private hospital, it's the signee who's responsible.

Some patients really want to be taken to a private hospital because they have private health insurance, and if they want to get a check-up, then private hospitals are much more efficient. Secondly, there are more people in public hospitals, and waiting times are very long. So splitting patients is a good thing. Those who can't afford private hospitals and don't have private health insurance don't have to compete with those who do, and this shortens the waiting times in emergency rooms.

The Fire Service and AMS have the same uniforms, and the female uniforms for St. John are similar to those of the government, because we also wear a short-sleeved shirt and dark blue pair of trousers. This number on my shoulder is my staff number. Salaried workers start with the digits '99', and the last two digits go from '01' to '50', '9901' to '9950' for paid workers. People identify me by my number, and if people want to take my name for reference, then I give them these digits. I also wear a 'speciality belt'. This is the 'glove compartment' of my uniform: this is to house the radio which we use to talk to Control; in here are scissors which need to be accessible, because they're often needed; here is a flashlight, and this is my private mobile phone.

A little help, a long way

The reason Hong Kongers call an ambulance is because they need our help. However, some people think they're bothering us by calling! They think they're getting in our way. Sometimes, though, you need to call, for example, when your relative has passed out and fallen on her head,

and you don't know what to do. You certainly can't lift her! If you call an ambulance, we know what to do, and at the very least, won't worsen the situation.

I personally really like driving the ambulance. But in an emergency you need to be safe, not just fast – otherwise, you'll crash. As long as we don't affect the safety of the streets, we're allowed to exceed the speed limit. But this has to be due to an emergency call.

We don't have emergency ratings. All cases are viewed the same way – as urgent, and we take patients to the hospital as quickly as we can. The cases we get are quite random. We get 'respiratory', 'heart', accidents. There are about 30-something calls each day around the clock… in the weekends, sometimes less; I don't know why. There are 20-something on the weekends, mostly in the daytime.

In fact there isn't really any pattern, but there is less activity in the night-time. In the summer holiday months, there are more calls, and respiratory emergencies happen more in spring and autumn. There have been cases of prank calls, and certain addresses are known for these; but even if we suspect false alarms, we still go.

The ambulances can carry eight people, including the three of us, but only one relative can stay with the patient in the ambulance. You won't have separate patients on the same vehicle. The only instance where we might have more than one patient is if there is more than one casualty in each case. In fact, if you have one patient on a stretcher, there's not much room for any more patients.

Previously, people had to call the individual depots if they needed help, but now it's very centralised. Control

has a hotline, 1878000, and we have regular exhibitions to inform the public about our services; and sometimes we go to old people's homes and schools to give them our cards. The hotline number is beginning to be better known now, and the telephone operator actually gives it out to people in need.

St. John had 10,000 cases last year, while the Fire Services Department had 800,000. However, the Fire Services Department has 200 ambulances, while St. John only has three! I don't think we'll be able to expand in the short run, because we'd need a lot of money, resources and support.

Saving lives

We have a day shift and a night shift. Every shift is 12 hours – the same as the Fire Department. Fortunately, I live in Tai Po, and the station is nearby, in Sheung Shui, so I get to wake up at around 5 a.m. I leave home at 6:15 and arrive at the station just before 7 a.m. Work starts at seven in the morning and ends at seven at night; but if there's a

call at 7 p.m., I'll do the job before I go home. The night shift is also 12 hours, but from 7 p.m. to 7 a.m.

On the day shift, we start from Sheung Shui, and get called out across Hong Kong through the radio by the control centre. Because we don't have a lot of vehicles, we drive to Sha Tin for standby when the Kowloon-stationed vehicle is busy. Sha Tin is a much more central location to travel from than Sheung Shui. During the day, we have three staff members in each vehicle. First, there is the IC [in-charge], a senior person. The role of the IC is to assess the patient's condition when we arrive at the scene, and make decisions and treatments. He might also write up notes and fill out forms for the hospital on arrival. Then, there's a driver, but he doesn't just drive; on the ground we all do the same work, including treatment. The third person is the 'attendant'. He helps the IC treat the patient in the ambulance. Whoever's most senior on any particular shift is the IC. We rotate as the driver day-to-day, because it's quite draining to drive for long.

The number of staff aboard an ambulance depends on

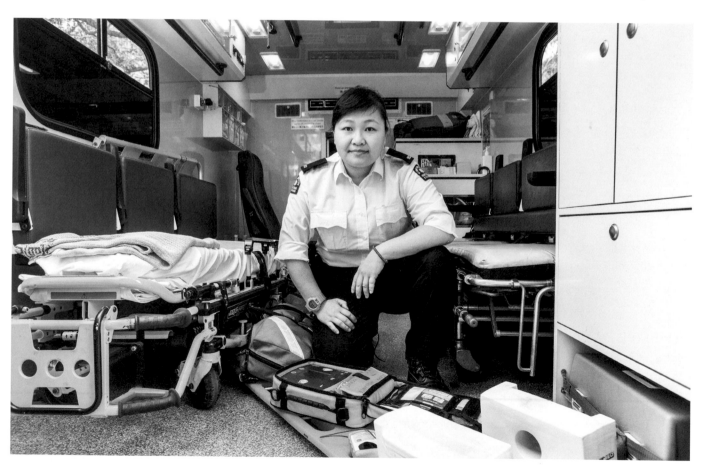

the environment. In Australia, Canada and the US, each ambulance is manned by only two people; but because there are so many skyscrapers in Hong Kong, nearly all stretchers are designed for three. In fact, in Hong Kong, it's quite common for one paramedic to take care of the patient, while the two others carry the stretcher.

All blood types

Each of the depots has five paid staff to make up every 24 hours, but as this is not enough, we use a lot of volunteers. For example, on the night shift, I am the only salaried staff. I drive, and there are three volunteer staff. To become a volunteer, you first have to enrol in a first aid class, and pass. We then provide further training, and if you pass this, you can enter the force at a location close to you. You have to accumulate some practice in the field to get adequate experience.

Volunteers come from all walks of life and all professions. They're not necessarily unemployed, they offer their services when they have time. For example, they volunteer at night after work, and go back to work in the morning – it can be difficult. They get a bed in the depot, but when there's a call they have to wake up. Sometimes there are events, like fun runs or sports days, that St. John sponsors and which call for fewer hours, and volunteers can sign up for these too.

A 17-year-old can be recruited as a volunteer, and by 65 you are supposed to retire, but if you pass a yearly physical examination, you can continue till you're 70! In my view, if you are with St. John you have a lot of heart, because most of us are volunteers and therefore genuinely want to help.

Meaningful work

Frankly, this job does involve long hours and is very tiring. Often, we go to cases that we've never experienced before, and this can be frightening and stressful. Before each job, we have to have the worst-case scenario in mind, so there will be no surprises.

There are two very memorable experiences I've had on the job. One was racing against the clock at the Lamma Island shipwreck [in October 2012]. At the time, I was focused on helping, but when I read the news afterwards and found out that 30 people had died, I felt really upset. Another time was helping an elderly lady. When she thanked me on arriving at the hospital, it was a really defining moment. Nothing can beat the feeling of being thanked sincerely. When someone says 'Thank you,' it's very rewarding.

I do sometimes wonder what happens to the patients after we hand them over to the triage nurse at the emergency room, but I don't follow up. We're professionals. We can't keep going back to old cases, because if we did, we wouldn't be able to move on to the next one! Fortunately, I've never had to revive anyone with CPR, and I've never had anyone die on my watch – but if these things were to happen, I know there's post-traumatic support. Some people feel guilty, you see, that they haven't been able to do more. ■

"When no one's here and nothing's broken, I sit and listen to the news on the radio… I'm most interested in why some people can't think it through, and jump off a building; and why others go to the sea to swim or surf when there's a typhoon."

— Cheng Mui, 53, Toilet attendant

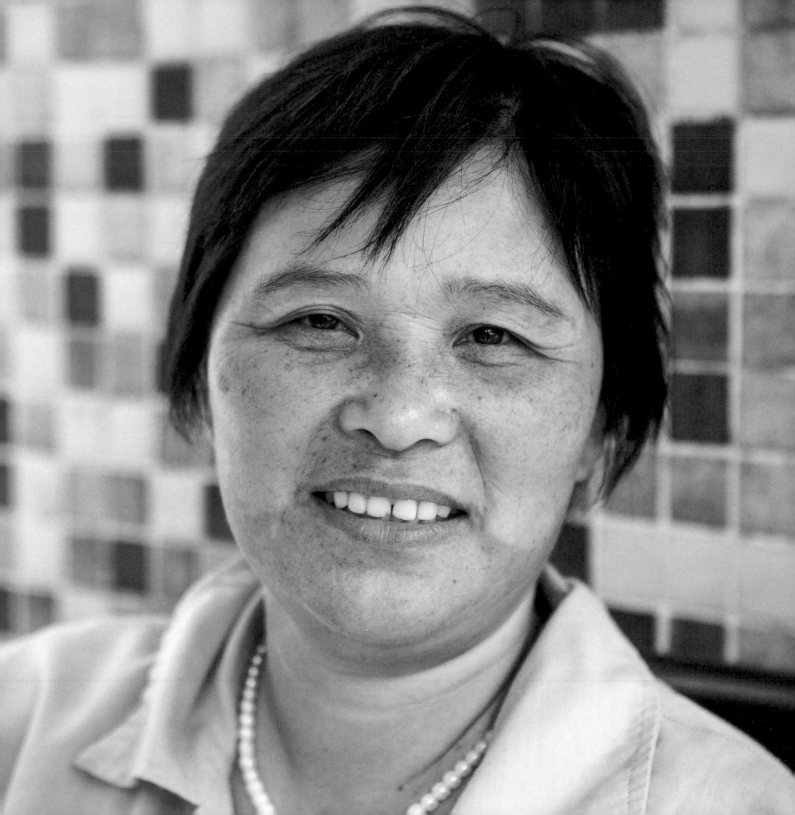

Cheng Mui, Toilet attendant

Cleaning is my job, cleaning toilets, and I've been doing it for two years. Before this, I worked in construction for 10 years, but that was a really tiring job.

It wasn't a problem being a woman. We were responsible for collecting rubbish and taking out nails from wooden boards, and earned well – HK$600 to HK$700 a day [men earned about HK$800 to HK$900]. Four children, and rent to pay – if I hadn't worked, what would have become of us? You need to sustain a living. But it was really tiring work being in the sun all day...

The company I now work for does three things: toilet cleaning, street sweeping and outdoor cleaning. Job seekers have a choice, and I chose toilet cleaning because it's less tiring. We work about 9.5 hours a day, and get HK$30 an hour. We're paid monthly; if you get sick, they deduct it from your salary. Some customers give tips, but you get fired if you accept them. You already get paid to do your job, so why do you need them?

Doing the rounds

Every morning, I come here [to Repulse Bay, a popular beach] at 8 a.m. I bring my own boots to wear, and the company provides a uniform, gloves, and a mask which I change every day. After cleaning, I tidy, and clean some more. Then, the tourists start arriving, and I have to clean up after them. There's not really a schedule... If a group of people come in to the toilet, then I go in and clean it, that's all!

It's usually tour groups from the Mainland that use these toilets. They get off their coaches right outside the toilet, and in they come. Then, they head to the beaches. The tour guides tell me, 'It's quite clean', and I reply, 'You people make it dirty, I have to make it clean'.

I have to watch in case they ruin the place. They don't flush, and they wash their feet in the sinks. Once, they were so dirty, there was waste all over the floor... They're really dirty, but in the Mainland, it's even worse. I'm from Zhuhai and from the age of 12, I was working in the fields,

spreading fertiliser. Then I got married and came to Hong Kong. The only things I ever wanted were a roof, food and to be healthy. Having a house was the most important.

I think of myself as a Mainlander, yes, though I've been in Hong Kong since 1997 and this is my home. I have a husband and four children here – one works as an 'admin' in a school, another works in cosmetics, and another works as an evening newspaper distributor. The youngest isn't working yet…

When things break, they have to be fixed. The Food and Environmental Hygiene Department comes in to do the repairs. They come in every morning at 8.30 a.m., and check everything in the toilets, before signing off. On Tuesdays and Fridays, they also come in at 4.30 p.m. to check the WC, and to sign it off.

On my own

When no one's here and nothing's broken, I sweep the place or I sit and listen to the radio. I listen to the main news, whatever's special. I'm most interested in why some people can't think it through, and jump off a building; why others go to the sea to swim or surf when there's a typhoon; and why some drivers run red traffic lights and knock people over.

I don't pay much attention to politics. Universal suffrage or not, things are just the same – whoever gets into office in Hong Kong! People only care about themselves – even if Leung Chun-Ying [the current Chief Executive] quit, the next one would be the same. There'd be no difference.

At noon, there's a one-hour break to eat. I go to the beach or to Aberdeen to buy things, and have a walk around. I like to be in the sun, but don't know how to swim. Not that this stops me when I've got time – I still like going in the water. I grab a float and wade in. I leave at 6.30 p.m.

A flush job

I've only ever worked as a toilet attendant here, but working in Southern District is good. Transportation is convenient, and the commuting costs aren't too high – we only earn a few thousand dollars a month, you know, so it's good to work close to home [Wah Kwai Estate in Aberdeen].

Also, the air quality here in front of the beach is good, and better compared to where I live. The people who clean the rubbish off the beach are stressed out though. They have to work really quickly to pick everything up before people start arriving in the morning.

Happy or not, you still have to work. I can say that I'm happy though. This job is good, because it's not as tiring as the one I had before. It's more relaxing, and I'm in contact with more people.

Toilet rules

There was a three-month probation for the job, and I try to do my best. If you do your job well, the company won't move you, but if there are complaints they will. In fact, they rarely do move anyone… My contract is for two years. I don't know if they'll move me after this. But, if they do, and I don't like the place – I'll just quit.

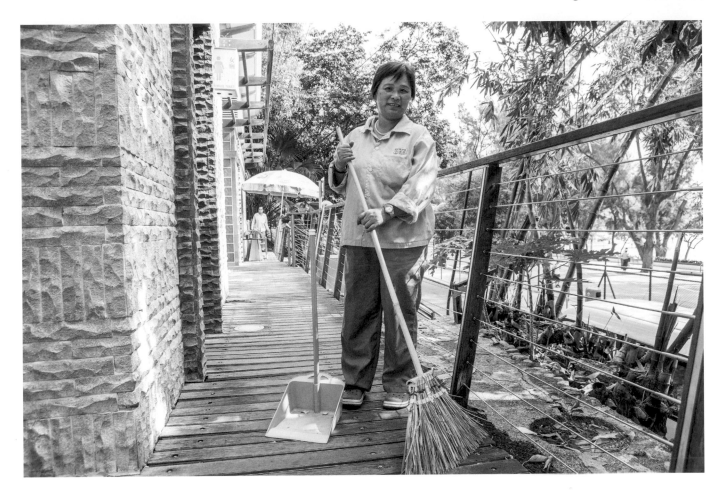

Rule number one is that you can't be lazy – you have to be clean, and you can't leave your post while on duty otherwise they fire you.

Public hygiene is important. If you don't clean the place, and there's waste everywhere, it's no good. This is a public place, not a private stall. If no one cleans, it's really terrible… Look how many people come here. In five to 10 minutes, there could be 30 people! This toilet is a very important one. How could we not clean it?

I don't know where the cleanest toilet is in Hong Kong. There are so many public toilets, so who knows? I only know about this toilet!

As for the dirtiest toilet… Aberdeen? The toilets there are old and dirty. They can't get rid of the smell, no matter how much bleach they use. Aberdeen's toilets are the smelliest of all the toilets in Hong Kong. ■

"Every day, I take the ferry to Central and then the bus to Repulse Bay, which means I pretty much spend the whole day on or by the water."

— Law Chi-Hung, 20, Lifeguard

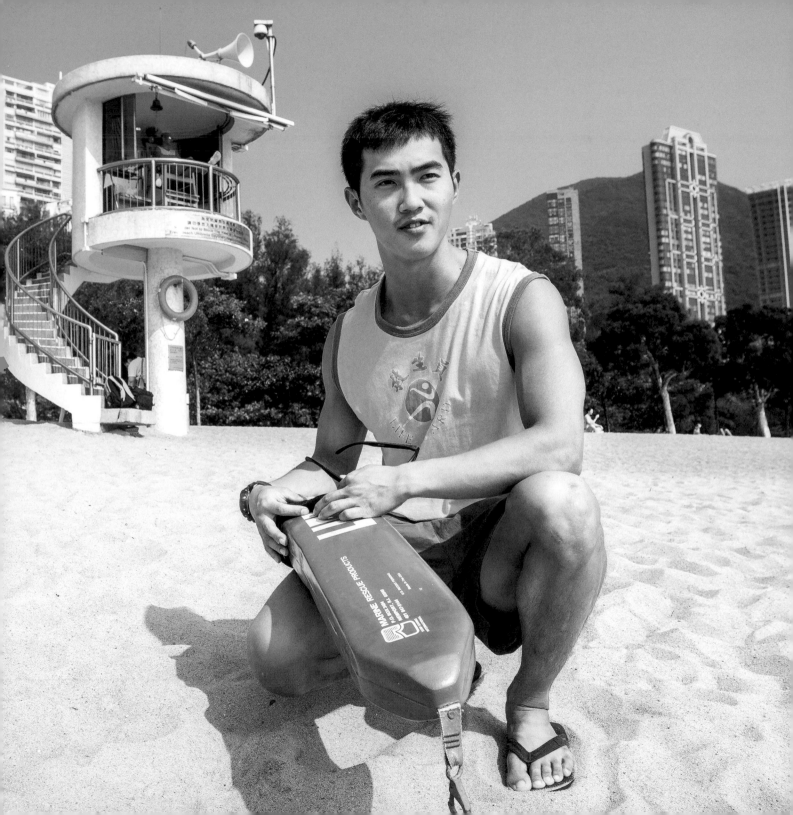

Law Chi-Hung, Lifeguard

This is the fourth year that I've been a lifeguard. I got into it by chance... It started off as a hobby in a school club, after which I took some of the exams for the lifeguard badges.

It was like this – in Form Three, there was a summer course on life-saving. I registered for it, and then kept on going for tests and earning badges. There are different badges: there's a basic one, a life-saving bronze badge, and then you have two options – either a lifeguard badge for swimming pools or a lifeguard badge for beaches. After taking the HKCEE [Hong Kong Certificate of Education Examination], I applied to the Leisure and Cultural Services Department which recruits lifeguards every season, and started working on Hong Kong's beaches.

A seasonal lifeguard

As a beach lifeguard, you get to choose the district you want to be in, though you can't choose the beach – but if you have an indoor pool licence, you can choose the pool.

The beach is physically more demanding than the swimming pool. Among other things, the beach involves swimming longer distances, and in Hong Kong the water is quite polluted. At Repulse Bay, where I work, the pollution is sometimes okay and sometimes not. It depends on the weather and is a question of wind direction. If the wind is against you, then the garbage gets blown towards you. The lifeguards do have a feeling of responsibility to clean up. If we see rubbish on the water, we pick it up, and if we see it elsewhere, we normally do – though there are designated cleaners who do this.

In the four years that I've worked as a lifeguard, I was in Deep Water Bay for two years, and last year I was stationed on Lamma Island. The higher-ups move you. Right now, I'm a 'seasonal' lifeguard, so every year I'm positioned somewhere new.

Slow living

My family doesn't feel particularly proud that I'm a

lifeguard – it's just another job to them. They have a *wonton* noodle shop on Peng Chau, and I have two older sisters. One of them works as an estate manager in the IFC, and the other works in the cosmetics industry in Korea. We live in a four-storey building on the island, and everyone in my family, except for the sister in Korea, lives in the 700-square-foot apartment. Each family lives on one level, though some people own a whole building.

Life on Peng Chau is slower than elsewhere in Hong Kong – it's more leisurely. It has a retirement feel to it, and there are quite a few old people there. There have been more foreigners in recent years, perhaps because they like the quietness, plus the rent is a lot cheaper than in the city, but there are few tourists in Peng Chau because there are barely any places to rent.

The ebb and flow

Every day, I take the ferry from Peng Chau to Central and then the bus to Repulse Bay, which means I pretty much spend the whole day on or by the water. It's convenient getting to Repulse Bay, and the beach is quite big – one of the bigger ones in Hong Kong.

The shifts start at 9 a.m., but everyone gets to work at 8.45 a.m. We get changed, eat breakfast, and do a random draw to see who takes which post first. For example, if you draw a number '1', your first assignment will be on a boat on the water. Your next assignment could be patrolling the beach, working on a watch tower, or at the first aid station. Each assignment takes half an hour before we rotate to the next, and eventually everyone will work every post each

day. I don't have a favourite post, but my least favourite is the watch tower because when there are lots of people on the beach, there's a lot of pressure to spot problems.

At Repulse Bay, there are the lifeguards, and then there are two senior lifeguards – there are also the people in the office. There are lifeguards sitting on the crafts, at the first aid station, on the watch towers, patrolling… There is also an outpost station, where lifeguards are on standby. When someone on the megaphone announces a 'situation', then the people at the outpost rush to help…

At this time of year [October], there are 20 lifeguards working at the beach. But actually on the beach at any given time…? About 15 or 16, because some people are on breaks. During the summer season, from June to August, there might be 30 of us… The red and yellow uniform is the same for all lifeguards across Hong Kong – maybe because the colours of the international flag for lifeguards are red and yellow, and the colours make us easy to spot.

Baywatch

I think Hong Kong is quite different from overseas – and it's less exciting to work as a lifeguard here.

There are also many more male than female lifeguards, though sometimes we do talk to the girls on the beach, and on a few occasions we've been out to eat together. The tests are fair – there may be fewer girls because they're afraid of tanning… Few girls like to tan, and the girls who come to the beach usually bring their beach umbrellas and sunscreen.

I myself do like girls with a bit of a tan. It looks healthier.

But very few Hong Kongers feel the same way, and it's mostly foreigners who like to catch the sun… As for us lifeguards, we don't usually put on sunscreen at work, and we do sometimes get sunburnt – though rarely. I'm a little afraid of skin cancer… but putting on sunscreen insulates your body, which is really oily and uncomfortable.

I'm not sure if there's a lifeguard test in English, because I did it in Chinese… and I've never actually seen a non-Chinese lifeguard, though there was one Indian guy who trained with me. He grew up in Hong Kong, though, so he spoke and understood Cantonese.

Better to be safe than sorry

I don't really care, but a lot of people think that lifeguards do nothing but hang around all day. They know about our occupation, but don't really know what it involves.

We actually have a lot to do… Almost every day we do exercises: running, swimming, weight training, and every

month there is a lifesaving simulation. Luckily, I've never seen any deaths. The most memorable experience I've had was seeing a non-responding old lady in the water. She had her face in the water and wasn't breathing. My co-workers leapt in and brought her to land. Then they gave her CPR [cardiopulmonary resuscitation], and it was like a miracle seeing someone coming back to life.

When someone's drowning, two lifeguards usually jump into the water. If the victim is close, we drag them back to shore easily, but if they're far we grab them and put them on a boat. Sometimes the victim grabs onto you from behind – they're usually in a state of shock or panic, and don't know what they're doing. But I push them away first, and normally go behind them to rescue them.

I've had to save people about 30 times. Not only old people, but kids and other people too. Sometimes, when people are playing next to the shore, they don't realise that they're next to a steep drop. They step a little too far, and end up with water over their heads. The problem is that they don't know how to swim. Another problem is when people accidentally slip out of their inflatables…

There are very few sharks in Hong Kong, and the barriers are enforced quite well to keep them out of the bay, but sometimes accidents happen when people step on sea urchins on the sea bed, or cut themselves on large stones. In these cases, they usually limp over to the first-aid station for help, and we normally just wash their wounds with antiseptic.

There are also people who pretend they need help, who scream 'HEEELP!' for the fun of it. We don't kick them off the beach for doing this, but we do remind them not to fool around like this. Though lifeguards are not particularly respected, we are considered an authority when it comes to the beach. If we tell people something, they don't answer back.

Beach boy

There's not a big difference between how I feel in and out of the water, but I like being close to the beach. I feel more relaxed that way. Maybe it's because I'm used to it – I grew up in areas close to the sea, and a lot of our activities were done in or on the water like going to the beach, swimming and water-skiing. I still enjoy these things, and going snorkelling to look at the fish. I went to Phuket when I was young, and would love to go to Bondi in Australia… I'll get there one day. What's stopping me for now? Time and money…

Like me, my dad was also a swimmer in his day. I haven't seen any awards or anything, but mum tells me he was good at swimming, and it was he who actually taught me how to swim. I was really young – about three or four years old. The whole family would go to the beach to swim. We'd take our dog with us as well. We did this quite a bit – maybe two or three times a week.

Beachcombers

Like we did, some people come to this beach often. Most of them are seniors and I don't really talk to them much, because I don't know what to say. There are also a lot of expats… Some of the lifeguards speak English, but if

there's still a communication problem, the foreigner can be taken to the management office.

Different beaches attract different people. Hong Kong Chinese like to go to Shek O – I don't know why, maybe because the sand there is finer? But it's quite far. Discovery Bay is quite pretty and leisurely; Repulse Bay has a lot of foreigners. As for Filipinas, there are lots of them everywhere during the holidays.

Apart from people, there are lots of crabs on the beach, though by noon they're hiding. They only come out in the morning. You can't eat these crabs, but there's lots of fish so some people come here to catch them. When I was a lifeguard on Lamma, I'd catch sea urchins to eat, though I'm not actually a big fan of seafood.

A watery fate

If you want to become a lifeguard, you need to find a swimming club. They offer a one-stop service where you can take all the exams for all of the badges. For the bronze medal, you need to be able to swim 200 metres in about two minutes and 30 seconds. You also need to be able to drag a person through the water for 50 metres, and know how to throw a lifesaving rope to drag a person back to safety. All of these tests are timed. You need to learn first aid and CPR as well.

The minimum age to be a lifeguard is 16, since you need to be at least that old to test for the badges, and the oldest is something like 55 or 60. On average, the lifeguards I work with are about 30 – meaning that the beach where I work is considered a 'young beach'. You

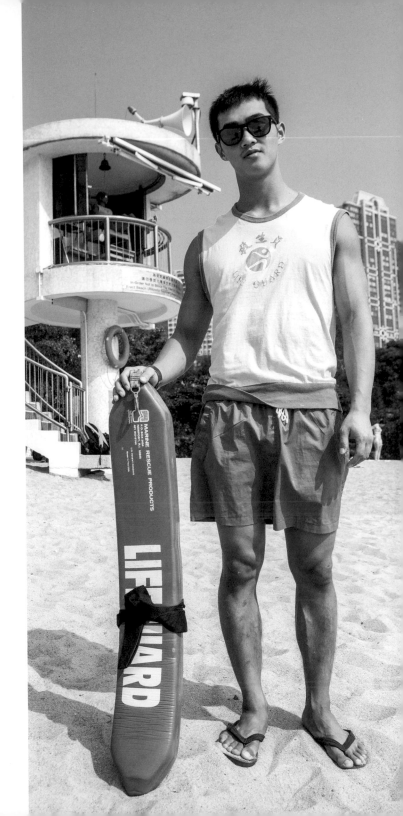

can wear glasses, but you need to get your eyes tested. You can't have myopia worse than -200 or -300, or be colour blind.

Lifeguards get a monthly salary. Half of us are full-timers hired by the government, while the other half, including me, are seasonally contracted. As a seasonal lifeguard, you are employed three to eight months at a time. Nowadays, full-timers are seldom hired because there are enough hands, and because in the winter, the beaches close so they don't want to pay more people than they have to. Apart from winter, beaches in Hong Kong are also closed during black rainstorm warnings and typhoons. Who knows if people stay on the beach to sleep, since we're off work by about 6 p.m. But I don't think it's a problem – lots of people camp out!

When seasonal lifeguards aren't on the job, we have to find other work. Some of us are salesmen, some work in inventory, and we often work in physical labour.

Only rarely do I help at my parents' noodle shop, though I wouldn't mind working on Peng Chau as a lifeguard – if there was a beach there which actually had lifeguards, that is.

Back to shore

I didn't intend on being a lifeguard, it was simply a summer class. But once I was in the class, I realised I could if I wanted to – and after taking the tests, this is what I did. If I hadn't become a lifeguard, I don't know what I'd be doing. Maybe I'd still be studying, something like exercise science… Apart from swimming, I like playing football and as a boy I ran.

I probably won't be a lifeguard in the future. Lifeguarding is just temporary, it's not my goal – and, as a career, being a lifeguard isn't stable and the salary is quite low. ■

"If I was scared, I couldn't do the job. I've done this for so long that I'm used to it. We view rats and mosquitoes as our bosses... without them, we'd be out of our jobs."

— Danny Chan Yui-Ping, 60, Pest controller

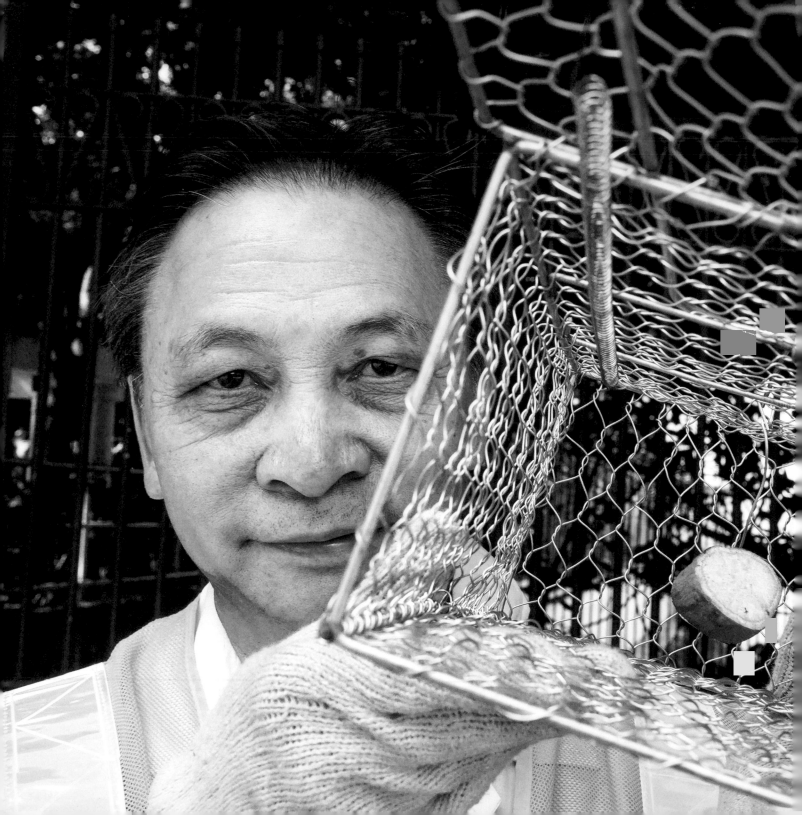

Danny Chan Yui-Ping, Pest controller

I am a pest control contractor for the Hong Kong government. I've been in this job for eight years. Before this, I was a government-hired pest controller for the Food and Environmental Hygiene Department. I've also been a garment worker, and street cleaner.

When I say pests, I mean mosquitoes and rats, wasps and cockroaches. We don't touch geckos and lizards… In fact, as a kid, we used to catch lizards and put leashes on them! We don't deal with snakes either, which have to be referred to a snake expert; but we do advise people to put sulphur down or call the police.

I studied till Form Three, and started working in 1968. Back then, we graduated from primary school at 14 years of age, because we went to school later. In 1983, when I was 29, I started working for the Hong Kong government. From 1983 to 1988, I worked for the Housing Department. Then, I was transferred to UrbCo [the Urban Council], which is now the Food and Hygiene Department. I made the transition from garment worker to pest controller because government jobs provide a much more secure salary. As a garment worker, you couldn't work even if you wanted to, when there were no orders. With the government, it's different. You get the same salary every month, and can plan your expenses.

All operators great and small

There are eight to 10 big operators in pest control in Hong Kong, and many smaller ones. The smaller ones employ one to three people, who might specialise in white ants, for example. The company I work for, Waihong [Waihong Environmental Services Ltd], provides cleaning and pest control services.

Each contract with the government lasts for two years. At the moment, Waihong has the contract for Wan Chai District. But I've moved around Hong Kong. I used to work for Baguio [another contractor], in Central & Western District, and apart from Central & Western and Wan Chai, I worked a year in Tai Po in the New Territories.

Each location is different. In the New Territories, there are villages, and more 'common house' mosquitoes, but in Hong Kong Island, there are fewer of these but more 'tiger' or 'forest' mosquitoes.

There are lots of things you have to watch out for in the New Territories, like where to move things, because the villagers complain about us ruining their *fung shui*. When we work there at Chinese New Year, we need to be careful not to be seen with brooms, because this is unlucky for them. It's best to keep workers in the same location, because then they know the landscape well.

Knowing the enemy

Handling pests depends on the landscape and season. Some work 'zones' are on the mountains. There, there are definitely fewer rats, but at the same time, there are more mosquitoes. In the inner city, on the other hand, there are more rats because there are a lot of restaurants – especially in the SOGO area of Causeway Bay. Rats don't move around as much when it's cold, though they're still around in the winter; and there's a 50 per cent decrease in mosquitoes then.

Bees are the least harmful of all of the pests, and we don't normally kill them, though we do kill wasps. Don't assume wasps are harmless! The first time they sting you, you might just swell up. The second time, though, you're in trouble. Doctors tell us to stop working in this profession when we're stung, because the next time we might die. It's something to do with the immune system.

The worst of the pests are the rats and mosquitoes.

Rats are really dangerous because they spread disease. If a rat with rabies bites you, it can make you start coughing blood. Mosquitoes spread malaria and dengue fever.

In the zone

From 1 April to 31 October, Waihong has nine teams with six people per team. There are about six people on holiday at any one time… so, in total, there are 60 of us. Each team does the same thing, they just happen to be in different locations. Right now, we only have eight teams because once mosquito season is over, one team is cut.

There is one foreman, three pest control officers and two general workers. The pest control officers are responsible for spraying pesticide, sweeping, cleaning and preventing the infestation of pests; and the general workers clean out garbage and inspect drains for blockages. There might be food waste, containers or lunch boxes blocking the drains.

If there's an infestation, then the pest control officers spray pesticide, because the general workers haven't yet been trained to use pesticide. Pest controllers don't have a licence, but do need to take a 40-hour course on insects and pesticides.

Usually, each team works in a few locations and goes to the same location twice a week. For example, Mondays and Thursdays we go to one location, Tuesdays and Fridays another, and Wednesday we go to yet another. We go to six different locations: two each day, morning and afternoon. Some of them are Stubbs Road, Bowen Road and the Peak. The areas are divided into zones. In addition

to us contractors, the government has its own teams of pest controllers as well, but they take care of their zones, and we take care of ours.

Rats!

I haven't been to a lot of countries, and it depends on the food chain and ecology, but rats are pretty much everywhere that there's leftover food – though cooler places have fewer. There are different sizes of rats. The rats in the sewers of Hong Kong can be as big as a grown man's forearm, not counting the tail. The body can be eight inches long, and the tail four inches, and they're really fat.

There are two kinds of big rats, one we call 'R2', which live in the beams of houses, and 'RN', which live in sewers. There are also the smaller rats that you see on the streets and in houses. This makes three different types of rats in Hong Kong.

A deadly business

When we're in the back alleys of the city, we take larvacidal oil with us, rat poison and warning signs. We look in drains to see if there are any blockages, which attract rats, and we look for rat holes. Then we lay down the poison.

The government doesn't want us to use cyanide, because it's very poisonous. There was an incident in the Mainland once in which many people died, so the rat poison we use is an anticoagulant, which is safer. Those who accidentally swallow it can use vitamin K1 as an antidote. You have to be really careful. Because there's more transparency now, people scrutinise a lot about how much pesticide is used, and over the past few decades, the chemicals we use have changed…

When the rats are poisoned and begin to die, they experience internal haemorrhaging, because the poison is an anticoagulant. Within five to six days, they die due to the internal bleeding, but before this they become really thirsty and try to drink as much as they can. They end up dead and bloated in the alleys, which really stinks.

We need to 'take care' of them when we go back to the alleys. Sometimes we wrap them in plastic bags, but most of the time we add an extra layer of newspaper before dumping them into the bags. We dump them in the RCPs [rubbish collection points], not in the bins, and we bag them one by one.

It's disgusting. After the rats have died, they bloat up and their stomachs explode with maggots. Sometimes, the head is split off from the body. It's quite disgusting… but we're used to it.

Without us, there'd probably be rats everywhere. Rats have a very short lifespan of about three years, but a breeding pair can reproduce 800 rats. The largest amount that we've ever caught was 108 live rats in one month in Central & Western District. Cats and dogs in Hong Kong don't catch rats; they're merely pets, and the rats can be so big that the cats are too scared to touch them, though the dogs might sometimes chase after them.

Ordinary people can use rat cages and rat glue, but rats are smart. They'll leave when they see you and if you use the cage too much, they adapt to it, and learn not to get tricked. Once, when I was working in High Street [in Sai Ying Pun], a colleague caught a huge rat behind a wonton noodle shop which was more than a foot long! It started screaming in the cage, and we weren't able to catch any others for a whole week. They're clever, adapt as a group, but have poor vision.

If rat cages and glue don't help, you can seek out private pest controllers. If you're a shopkeeper, let's say, you can call the Food and Environmental Hygiene Department.

Population control

Although the government doesn't set quantifiable goals for pest control, you can see government surveys of the pest population in the newspaper. Every year, a survey is carried out by pest experts hired by the Food and Environmental Hygiene Department to see how big the populations are.

It's hard to set a goal though... Pests are creatures that negatively impact the lives of human beings. That's why we kill them. However, up to a certain point, even mosquitoes and rats aren't necessarily pests... for example, when there's food waste in the rubbish, they clean it out. I think that wiping out any pest completely might actually be bad for us. If you see fewer pests, you feel like hygiene is good, and things are fine, but if you are stung all the time by mosquitoes, let's say, then that's not good.

Public education is better, and hygiene is better than it used to be, though certain places are very difficult to clean entirely, with old ladies bringing cartloads of cardboard to the back alleys, and so on. Where there's garbage, food waste or containers, there are infestations, but we can't really tell them not to do it. There's not much we can do about it.

In fact, Hong Kong is quite good. If the pest population stays at about the same figure, then we are in the clear. I'll say again, though, that mosquitoes and rats will never disappear – a baby rat is fully grown in four to five months, and they spread and grow very quickly.

Other than pest controllers and street cleaners, there are Food and Environmental Hygiene officers who check to see if restaurants are clean. There are also other departments responsible for cleaning the city, such as the Leisure and Cultural Services Department, Highways Department and Water Supplies Department. There are also privately hired cleaners for private properties. So, there are many bodies which are responsible for the cleanliness of Hong Kong, and they contribute to its environmental hygiene – though most people only know about the Food and Environmental Hygiene Department, which means that they get all the complaints, even if the issue isn't theirs.

A willing employee

In this profession, the salaries are not attractive at all – general workers are paid HK$7,500, pest controllers are paid HK$8,400 as a lower limit, and a foreman earns HK$10,000. Right now, the government is hiring, but people don't want to work in this occupation...

It's only us 60-something-year-olds who don't care. I've done this for so long that I'm used to it. The pests don't seem all that scary to me now. If I was scared, I couldn't do the job. We view rats and mosquitoes as our bosses, and without them, we'd be out of our jobs.

I'm satisfied with my job. When we limit threats and infestations, some people are very thankful. But it's funny... others don't think of it this way; they think it's something we should do because it's our job. If they were to see me standing around on a break, they might even file a complaint against me! ■

Acknowledgements

In addition to our interviewees, who so generously shared their time, we would like to thank:

Ken Cheung Hang

Charles Kwan

Rachel Cartland

Leo Goodstadt

Jessica Perini

C.K. Lo & S. Lam Ltd.

Hong Kong Tramways Ltd.

Joe Bananas

St. John Ambulance

Star Ferry Company Ltd.

Tai Yick Chan's Co Ltd.

About the authors

Nicole Chabot is a Hong Kong Eurasian author and journalist. Her first book, *Kowloon: Unknown Territory* (Blacksmith Books, 2012) explored themes of community, consumerism, art, food, fashion and sex, and received a four-star rating out of five in the *South China Morning Post* for its detailed interview material and sympathetic documentation of personal stories. The book also received coverage in *Time Out Hong Kong*, RTHK's *Morning Brew* and *Hong Kong Heritage* programmes, the *China Daily* and *Ming Pao* newspapers. With *Street Life Hong Kong*, Nicole's fascination for Hong Kong continues. She is currently at work on her next 'valentine' to the people and city of Hong Kong.

Michael Perini is an Australian photographer with over two decades of experience. He has worked at News Corporation in Sydney, covering events such as the 2000 Olympics and the 2004 Asian tsunami. Assignments have taken him across the world, from Pakistan to the Rocky Mountains, photographing an array of issues as diverse as East Timorese orphans and teenage heroin addicts. Michael has carried out in-depth profiles and produced photo-essays on subjects including the last outback flying postmen. He has photographed well-known personalities including Queen Elizabeth II, Imran Khan and Tom Cruise, but is now based in Hong Kong where he works full-time as a commercial photographer.

EXPLORE ASIA WITH BLACKSMITH BOOKS

From retailers around the world or from *www.blacksmithbooks.com*